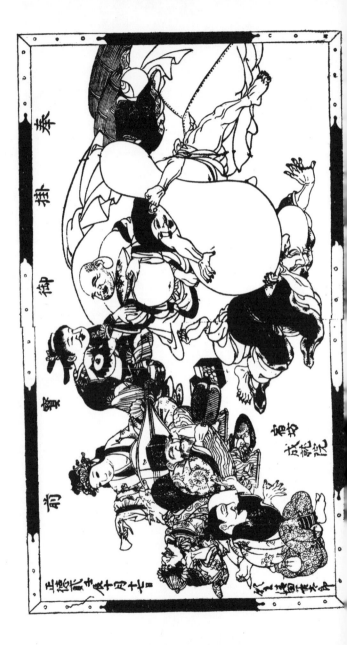

A GLIMPSE AT THE ART OF JAPAN

by JAMES JACKSON JARVES

I.C.C. LIBRARY

CHARLES E. TUTTLE COMPANY
Rutland, Vermont & Tokyo, Japan

Representatives

Continental Europe: BOXERBOOKS, INC., *Zurich*
British Isles: PRENTICE-HALL INTERNATIONAL, INC., *London*
Australasia: BOOK WISE (AUSTRALIA) PTY. LTD.
104–108 Sussex Street, Sydney 2000

N
7350
.J38
1984

Published by the Charles E. Tuttle Company, Inc.
of Rutland, Vermont & Tokyo, Japan
with editorial offices at
Suido 1-chome, 2–6, Bunkyo-ku, Tokyo, Japan

© *1984 by Charles E. Tuttle Co., Inc.*

Library of Congress Catalog Card No. 82-50327
International Standard Book No. 0-8048-1446-5

First Tuttle edition, 1984

PRINTED IN JAPAN

To

H. D. J.

AFFECTIONATELY INSCRIBED

BY

J. J. J.

CONTENTS

——◆——

SECTION I.

PSYCHOLOGICAL AND MATERIAL BASIS AND HISTORICAL ORIGIN OF THE ART OF JAPAN.

SECTION II.

THE RELIGIOUS ART OF JAPAN. — ITS DIVINITIES, MYTHS, AND HEROES.

CONTENTS.

SECTION III.

THE LITERATURE AND POETRY OF JAPAN.

SECTION IV.

THE CONDITIONS OF LIFE OF THE JAPANESE ARTISAN AND HIS WORK.

SECTION V.

CONTENTS. xiii

LIST OF ILLUSTRATIONS.

———•———

NOTE. — It was my earnest wish to give correct designs of some of the principal bronzes, ivories, majolicas, porcelains, and other objects mentioned in this work. After trying such means as I had at my disposal in Italy, I was forced to give up the project, as I found the drawing became too much Europeanized, and therefore. however well done in this style, practically useless for my purpose. Invariably, the native *life* of the object was obscured or obliterated, so far as the genuine Japanese accentuation was concerned, be it for the better or worse as art. Unless the specific objects were accurately given, my descriptions might seem to many as the ravings of an over-heated fancy. But what I failed in doing in respect to certain branches of decorative art, I hoped would be beautifully executed by Messrs. Audsley & Bowes, of Liverpool, in their "Keramic Art of Japan," now publishing in numbers at a cost of seven guineas for the complete work. This gives in full colors and gold superbly printed chromo-lithographs of fine specimens, ancient and modern, of this attractive handicraft. But if the criticism of Mons. Ph. Burty, of Paris, in the London "Academy," of August 21, 1875, be correct, even these gentlemen, although sparing no expense and drawing to fullest extent on the resources of English and French Art, do not do complete justice to the Japanese originals. M. Burty writes, "The ornamentation is drawn with great exactness, but the figure-drawing is less characteristic. The draftsman is evidently afraid of just that point of exaggeration which marks the difference between his own school and that of the empire of the rising sun." He recommends "fresher and more decided tones," etc.

Precisely so! It is in rendering the characteristic meaning and technical force. the gradations, purity, and limpidity of tones, the subtle whole of Japanese Art, that the European copyist always fails. His tints are certain to be crude, muddled, if I may use the word, and his drawing hampered by his own system of training and peculiar fancies, aggravated by his ignorance of those multifarious, versatile, and mobile models drawn from the minor forms of nature, so profoundly but delicately comprehended by the Japanese artist and workman, who are in general identical. Every effort I have yet seen on the part of their European rivals to reproduce Japanese decorative art in the style and spirit of the original only serves to show there is still an impassable gulf between the technical elements as well as ideas of the Asiatic and European art-work. This is not always discernible at once by an inexperienced eye if the objects are not in juxtaposition, but very appreciable as soon as they are, by any one of the least artistic discernment. Unless we can treat the artists of Japan fairly in so nice a matter, it is better to let words do what they can to record their merits, subject to the test of such of their best works as may be seen in public museums and private collections.

But as the above objections apply in a limited degree to reproductions of designs and compositions from their books and albums by means of photo-lithography, I have liberally drawn on its aid to give fac-similes in black and white, of a sufficient variety of Japanese decorative, humorous, and illustrative drawings taken from old and recent works, as to graphically illustrate — barring the somewhat crude ink impressions and broken out-lines — the Japanese system of design in general, so far as it can be done without the magic help of delightfully tinted, delicate papers, and the skill-ful coloring of some of the original drawings. It must be admitted that not a little of their æsthetic personation depends on these points. Artists and amateurs, however, who have access to the originals, will not fail to make due allowance for all irremediable drawbacks in these otherwise literal reproductions. Perceiving also those radical artistic qualities which distinguish best Japanese art, they will bear me witness that I am not without solid proof of the eminent merits which I have sought to point out in some of their more important productions, and which are based on the same class of motives and similar artistic treatment as the minor. It must not be overlooked either that even in selecting from this latter class these pictures for reproduction, I am debarred from attempting its finest because of the sheer impossibility of giving their subtlest qualities and strongest effects. But limited as I have been in this matter, I trust that this brief treatise and its illustrations may help enlarge our own Anglo-Saxon art-horizon and give us new sources of artistic enjoyment.

PUBLISHER'S FOREWORD

———•———

James Jackson Jarves was described as "perhaps the best American art connoisseur of his day" and it is regretful that the great scholarship of this original and vigorous thinker should have been neglected for so long.

Jarves was an unusually cosmopolitan figure. Born in 1818, the son of a Boston glass manufacturer, he began his travels through Mexico, Central and South America at the age of sixteen, publishing accounts of his wanderings in three volumes in later years. After a period in Honolulu, where he established the first Hawaiian newspaper, he visited Europe. He found Italy so congenial that he lived there for thirty years, settling in Florence, where he counted among his friends the Brownings, the Trollopes, Landor, and George Elliot, as well as Ruskin and Hawthorne. We may be sure that he was in constant contact with the most respected art critics of his time.

While in Italy, Jarves' interest in art matured and bore fruit in a series of perceptive writings on the aesthetic issues of his day: *Art Studies; Art Idea;* and *Art Thoughts* rank among the most important. Yet Jarves did not confine himself to a purely esoteric life. He was

an ardent leader in the "museum movement" in the United States, deeply involved in the often depressing and occasionally sordid business of raising funds for the purchase and exhibition of European old masters; battling with a suspicious establishment and an indifferent public. However, the fruits of his tireless efforts for the promotion of art still remain. His collection of early Italian masters is now at the Yale University Art Gallery and the Cleveland Museum of Art.

A Glimpse at the Art of Japan, first published in 1876, is a characteristically erudite and sensitive work which has too long been denied to students of Japanese art. The publisher is delighted to remedy the situation.

PREFACE.

———◆———

THIS small volume is what its title says, — a brief look, *for the reader*, at the art in question. As regards the writer, however, it is the gist of ideas and facts of several years' study and experience, becoming more intense with time and reflection. ' His purpose is not to give, even if competent, a dry nomenclature of dates, names, varieties, and localities of manufacturers, lists of trade-marks, artists and artisans, and like data, interesting and useful in themselves, especially to collectors. To do this, besides a knowledge of Chinese and the two written languages of Japan, one must make a special study of the numberless ciphers and inscriptions, which are found on many of the better objects, to distinguish their makers or places of fabrication. A general critic has not time for this investigation; it is not necessary, either, for the author's aim, which is psychological and æsthetic, rather than realistic and statistical. He wishes to detect beauty and truth under all guises, believing that the character more than the mechanism of any art confers the highest pleasure, and is the most profitable to know. Besides, the Japanese

guard with great care their technical secrets. They will not commit to paper knowledge which might lead to the loss of their artistic or industrial monopolies. In one of their treatises they frankly say the "painting and gilding of vases are secrets which it is not permitted to be disclosed;" also, the making of their inimitable bronzes, lacquer, etc. In prying into these things, a stranger is more likely to be misled than put on the right track, from motives appreciable to every manufacturer.

We all admired what was lovely or characteristic in the famous Henri Deux ware, or *fäience d' Oiron*, long before our curiosity was satisfied by the discovery of how and where it was made. Doubtless we should have gone on admiring it, possibly even more than now, had the mystery of its fabrication never been broken; for the romance of the unknown and unknowable would have steadily increased its æsthetic glow in susceptible imaginations.

Somewhat of a similar mystery is likely always to surround a great deal of the art of the Orient in occidental minds. No idealisms, human or material, will bear too analytical a scrutiny on a purely realistic basis, without loss of some of their fine intellectual down, which, like the bloom of luscious fruit, or the faintest blush of maiden cheek, lifts the senses above an anatomical range of sight into the ethereal spheres of omniscient beauty, and suggests that which is superior to the cravings of carnal appetite. Without disparaging those studies which peer into the

glazes of pottery, the patinas of bronzes, secrets of coloring and substance, epochs of invention, or any technical knowledge whatsoever, the writer cares more to lead others to enjoy, as he does, the purely æsthetic features of art, and to unravel the tangled skeins of thought which have led to the development of its various mental phases. He is an enthusiast by conviction as well as feeling in these matters; and believes, unless he was one, it would be worse than useless to write on art in any form. His desire is to be explicit, direct, and intelligible, without overflowing into word-painting or profound theorizing, which is the province of abler pens. If he has been tolerably clear in presenting the fundamental principles and facts of his topic, thereby rendering the enjoyment of those who love Japanese art more thorough and orderly, he will have succeeded in his wish, and all the more, should his readers make Japanese art, as he does, their familiar, household friend.

The orthography of Japanese proper names varies considerably among writers, but the author has followed those who seem to be the best authority; and the objects described or engraved are chiefly taken from his own little collection. It has been the unexpected interest shown in the few slight sketches of Japanese art, which he published in English and American journals several years ago, that has led to this fuller treatment of the topic.

Florence

A GLIMPSE AT THE ART OF JAPAN

"*Ai nostri occhi l'artista o è un sacerdote sublime, o non è che un ciarlatano più o meno esperto.*" — Mazzini

A GLIMPSE AT THE ART OF JAPAN.

SECTION I.

ITS PSYCHOLOGICAL AND MATERIAL BASIS AND HISTORICAL ORIGIN.

AN inquiry into the art of any people is not unlike feeling the pulse of a man to ascertain the state of his blood. Thus, by watching the *Art inquiry.* currents of art we learn how it succeeds in disguising the prosaic exigencies of human existence, to what height it lifts a nation's ideal, and the wholesomeness or unwholesomeness of its general or special movements. Michael Angelo rightly said the intent of fine art " was to raise our intellect from earth to heaven." But it is equally true that low or base art, in fine, all that which establishes its idealism on gross materialisms and flippancy of any sort, runs to evil, blighting the intellect with corroding sensualisms and atheistical conclusions. Dutch art is of the earth earthy, but not necessarily ignoble ; for amidst its sheens of satins and bouts of boors, there is that which is rightly enjoyable and humanly helpful after its sort.

Although the office of art is to excite spontaneous enjoyment, yet its final effect should prompt *Office of art.* to a critical examination of the nature of

our pleasure, what it reveals of the character of the
race that creates it, and its psychological meaning as
a distinctive idiom of the universal language of our
species. Any less mental analysis reduces art to the
level of sensuous gratification as transitory as the
chance melody of the passing bird. And when we
find ourselves in an altogether new field of observa-
tion, although at first more liable to err, the novelty
adds to the charm of the pursuit and incites to greater
activity. For a brief moment there is a
new world to explore.

A new world.

This has been emphatically the case with the coun-
try which, until a few years ago, was almost
as much unknown to us as the interior of
Africa; I mean the land of Nipon, " the sun's source,"
by Europeans baptized Japan.

Japan or
Nipon.

In entering the new world, familiar ideals and or-
dinary rules must be cast aside. Instead
we must accept new ideals and rules, and
try to enjoy everything good in its principle
and sound in its manifestation after its kind, however
much it varies from the forms and laws which we
have been trained to esteem as the only correct ones.
It is with art as with religion : if we brand a rite as
foolish, simply because of its strangeness, we may
shut ourselves unwittingly out of a new phase of
truth and source of happiness. Indeed, it is incum-
bent to examine it, if but to add to our knowledge of
humanity. Besides the æsthetic delight of finding
real beauty instead of anticipated ugliness, the respect
which thus supplants prejudice born of ignorance,
begets a more fraternal estimate of our fel-
low-men whatever their creeds or colors.
But the lesson is even more impressive, if besides

New ideals
and new
rules..

A new
lesson.

strangeness of aspects and ideas, we discover a superiority in any point to our own standards, requiring a mental revolution to attain to the level of æsthetic perceptions and knowledge of those on whom we venture to sit in judgment.

Some preparation of this character is emphatically needed as regards all oriental art, and chiefly the Japanese. Almost every one is struck with its more obvious qualities of brilliant color and consummate finish ; but few persons at first glance adequately appreciate its diversified, subtle harmonies of tints and designs, its exquisite delicacy of sentiment and execution, and its wonderful facility of invention and expression. When we come to know its best characteristics the marvel increases, that a nation of nearly forty millions of semi-barbarous heathens — as our school-books have taught us to view the Japanese — could have attained to such degrees of taste and skill as to make its prolific art possible at all. For it is one thing to produce a Michael Angelo, whose works isolated by transcendent genius are above the comprehension of the multitude, and quite another to invent innumerable lovely objects which all can appreciate and enjoy, but which could not have existed unless there were numberless competent artists and a national capacity of invoking their happiest efforts. There is, too, all the more need for us promptly to inform ourselves of the character and history of the art in question, because it is rapidly losing its best original traits, and is even in danger of extinction, gradual if not immediate. The same fatal decadence into mechanical uniformity and poverty of ideas and invention which European commerce has wrought in

Preparation needed for oriental art.

the art of China, now threatens that of Japan, only its

The true artistic instinct. power of resistance is greater. The true artistic instinct still lingers, and indeed Japan yet remains (1872) the sole country in which it retains much of its pristine vigor. For awhile longer the Japanese may represent a stage of civilization, once universal, which took more delight in delicious ornament than in prosaic utility and comfort. Our modern life tends to the obliteration of local and individual distinctions of taste and character, replacing them by a cosmopolitan uniformity of manners and ideas. It is a powerful solvent, pitilessly consuming all that which is most fascinating in the past without so far yielding in return any adequate artistic compensation.

Once each European school of art had a local

Local stamp of European schools. stamp as sharply defined as the idioms of the parent country. Now the fine arts everywhere affect the same general characteristics as do the fashions of civilized peoples, whilst the strictly decorative have succumbed in spirit and form to the purely industrial. The dis-

What is fatal to artistic thought. position to cheapen and multiply the minor arts by mechanical processes of uniform application is fatal to artistic thought. It effaces our intellectual convictions, blunts the desire for beauty, or else gives it an appetite for the gross and showy. As the æsthetic consciousness becomes deadened, we lose our capacity of appreciation of refined harmonies in forms and colors, and in time actually learn to prefer a monotonous multitude of cheap and ugly objects to master-works of art, the feeling for which becoming as inscrutable as their laws are incomprehensible. If stinted in wholesome

æsthetic diet, our senses degenerate without our perceiving the change. Any race which systematically neglects or misapprehends art, gradually weakens its cognizance of æsthetic law, and ends in confusing its ideas and practice as regards art with other and opposing matters. The primary instinct and experience being thus lost, education has to begin its work anew, and on a different basis, in order to revive even the wish for the beautiful. At first the natural craving of men for ornament suffices to excite in them a love for beauty. Then comes a period of indifference or absorption in other and more pressing interests. Afterwards, as a people matures its civilization, culture begins anew to affect the beautiful, and talk the language of the ideal. But we now must be taught to enjoy objects to whose beauties we have long been callous, or which perhaps actually offended our senses. Education, not intuition, becomes the new motor in art.

As regards Japan, the first consideration is to know what *not* to look for; next, what to expect. Every race has its specific ideals. These types may have a realistic or idealistic physiognomy, or a mixed one of both features. An artist conceives a supernal being, but clothes it in the lusty charms of earth, as did Rubens and Rembrandt, the thought only being born of the spirit while the model is of the flesh. Others, like Civitali or Angelico, eliminate material grossness and leave a clear apprehension of spirit-life so graceful and pure as to make it impossible to draw the line between its mixed motives. In fine, there is an endless variety of idealisms, from the sublime eternizations of matter by a Buonarotti to the impish extravagances of

oriental designers and the foul sensualisms of Doré's "Contes Drolatiques." We are to keep in view the impressions which each school or race, or indeed individual, wishes to make, and also what are the technical means employed. In the art of Japan one must not look for the metaphysical abstractions of that of Egypt, — forms of mysterious and awful import ; nor yet for the aim of the Grecian, — perfect sensuous types of mental and physical beauty ; and still less for the even more difficult ones of mediæval Christianity, seeking to bring down to the level of mortal recognition the celestial types of immortality. Each of these great schools in one form or other took the human figure as the point of departure of their varied conceptions, all striving to lift the earthly finite into the spiritual infinite.

The Japanese, on the contrary, manifest no such inclination. Nevertheless, they have an unmistakable ideal of female loveliness and manly vigor. But the results are unpleasing to European eyes as artistic types. By no charity of taste can we train ourselves to admire their effigies of cumbersomely dressed men and women with their narrow, elongated eyes, noses, mouths, and chins, false eyebrows, hideous toilets of hair, ungraceful contours and movement, and deficiency of elevated sentiments in their features. These types are the every-day ones of the street, plebeian or noble, but, intentionally or not, burlesqued and exaggerated. Instead of attempting to idealize forms, actions, and ideas or emotions, there is an irresistible artistic impulse to see life on its humorous or ridiculous side, and to convert humanity into anything but a phase of beauty according to our notions. Their pictorial

Japanese ideal.

standard of the human figure seems based on the savage taste of transforming the natural into the unnatural, if not by the direct mutilation of separate features, by giving to them as a whole a deformed or impossible aspect. The public taste has been so long trained to view the human form from this point of ideal ugliness that it takes its most popular gratification in those types which give it greatest emphasis. Added to this, the Japanese artist knows nothing of anatomy as a science. Indeed, merely to touch a corpse was to be defiled. Consequently, while their powers of observation as regards general action are wonderfully acute and correct in expression, they utterly fail in truth of anatomical details, such as rightly rendering joints, muscles, etc., foreshortening, and those elementary facts of design, without a knowledge of which European art would seem woefully imbecile. As the Japanese artist has never sought æsthetic instruction in this direction, we must observe and judge him only by the amount of success he obtains in what he actually studies and practices. Their gods and heroes impress chiefly by the extravagance of their postures and costumes, their intense action and passion, or the grotesqueness of their symbolizations, in which the elements of the ridiculous or jovial appear almost invariably united or confused with the terrible or hideous, as if fear must be tempered with fun, or a blind materialistic faith in the Japanese mind was ever married to a sense of humor begotten either of a national levity or absolute skepticism. There is no modeling in these pictorial figures. They are perfectly flat, shadowless, angular, and sharp in outlines ; faulty as can be, if judged by

Ideal ugliness.

How their gods and heroes impress.

the canons of a Leonardo da Vinci, but, as we shall
see by and by, full of merits of other character not
less requisite in the construction of a perfect artistic
whole, and in sculpture or casting almost perfect as
to general proportions and forms.

It would be interesting to note how the best Gre-
cian forms would impress the Japanese cul-
tivated mind. Apparently the race is as
callous to these works, and the principles
and ideas which underlie them, as the common sav-
age is to the music of Beethoven or Wagner. A cor-
rect idea of the beautiful in our species as an art-
motive does not exist in the Orient, for reasons besides
the above, and which will appear further on. At
present it is enough to state that the Japanese have
never sought to develop art in the direction of the
chief aims and triumphs of our own. Yet it would
be unfair not to give them a hearing as regards what
they do most admire. One of the Japanese tales
translated by A. B. Mitford thus describes
a belle of sixteen : " She was neither too
fat nor too thin, neither too tall nor too short; her
face was oval like a melon seed, and her complexion
fair and white ; her eyes were narrow and bright, her
teeth small and even, her nose was aquiline, and her
mouth delicately formed with lovely lips; her eye-
brows were long and fine ; she had a profusion of
long black hair ; she spoke modestly with a soft, sweet
voice, and when she smiled two lovely dimples ap-
peared in her cheeks ; in all her movements she was
gentle and refined." Not an unattractive damsel, cer-
tainly, despite the narrow eyes and melon-seed shaped
face, and a description which tallies with the best fe-
male types of the artists, barring their propensity to

[margin note] How Gre-
cian forms
impress the
Japanese.

[margin note] A Japanese
belle.

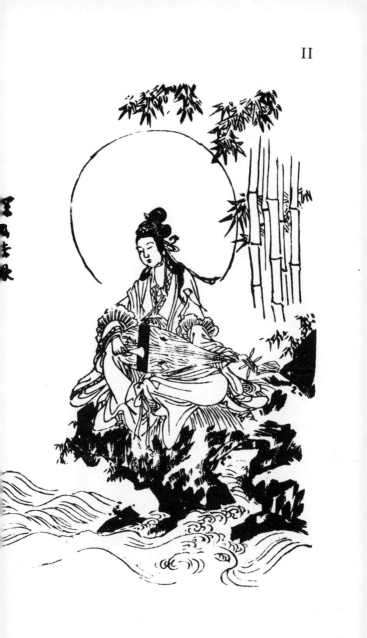

elongate features. The hero " Génzuburó " fell in love with her at first sight, and she, " seeing what a handsome man he was, fell in love with him ; " but as the novelist does not recount his good points, we must accept the male ideal as given by the pencil of the artist.

Architecture, in its noblest condition, is equally unknown in Japan. There is shown no elaborate attempt to develop it, either in intellectual or spiritual shapes. Instead they erect temporary homes or shrines, tent-like in principle, *bizarre* in construction, mostly of wood or frailer material, and in nowise responding to that fine instinct of immortality which materializes itself in our finest religious edifices, or even those aspirations which find vent in our ambitious palaces and public buildings. The frequent earthquakes are a serious obstacle to architecture of any sort. Whatever was built had to be either extremely broad, low, and massive, like the stone basements of temples, castles, and fortifications, with sloping walls to resist the throes of the earth, or structures of wood, light and open, with paper or mat partitions which would bend but not break, and, if destroyed, were readily and cheaply rebuilt. Moreover, as with their ethnic kinsmen of remote antiquity, the Egyptians and Etruscans, the temple proper was holden second in esteem to the tombs of their forefathers, where were held the most solemn rites in commemoration of their disembodied spirits. Hence the sepulchre was even a more sacred place than the temple, or became so conjoined that they were virtually one edifice. In Japan, the most attractive shrines are those consecrated to the interments of the Shôgoons and Mikados, but their

Architecture unknown.

Temple held second to the tomb.

beauty is more due to the taste displayed in the selec-
tion of the sites of these sepulchral temples, and the
adornment of the grounds, than in their architecture,
which, setting aside the gilt and carved ornamenta-
tion of certain details, is extremely simple and nomad-
like in general aspect.

Indeed, painting, sculpture, and architecture, in
The fine arts their supreme significance, — the *fine* arts,
in Japan. with the human soul and form as their fun-
damental motives, and human excellence or spiritual
loveliness as their distinctive aims in expression, — are
not found in the æsthetic constitution of the Japan-
ese. Keeping this fact in sight, we can profitably
study what they have done. Whenever their rule
departs from ours, the result seems to justify it.
Within their own scope they display a *finer* art of its
kind than we have ever imagined, based on a keener
sense and delight in nature apart from man himself
as the chief object of art. They do make an object-
ive use of man, but with a different appreciation from
ours. Having no passion for plastic beauty, they can-
not replace the Greeks, but they give what these did
not care to bestow. In many important respects, Jap-
anese art is a fitting and pleasurable supplement to
the European. Far narrower in range, unscientific
in our meaning, less profound in motives, unambitious
in its aims, less fettered by technical rule or transi-
tory fashions, it is more subtile, intense, varied, free,
and truthfully artistic in decorative expression ; more
abounding in unexpectedness and delicious surprises,
in æsthetic coquetries and charms of æsthetic speech
intelligible to every degree of culture. Its good things
never grow stale, or seem monotonous and conven-
tional. They are a *spirituel* rendering of the real-

isms and naturalisms of the daily life, intercourse with nature, and imaginings of a lively, impressionable race, in the full tide of an instinctive, passionate craving for art, while yet in the infancy of its religious faiths and material civilization. This judgment will perhaps surprise even those who are fond of Japanese art, and be challenged by the unfamiliar. But the best qualities of the old art in Europe are scarcely heeded now, because our senses as a people have degenerated from their former sensitiveness. With Japan we are called to experience altogether new sensations which astonish and oppress races long accustomed to thin, pale tints, meaningless, motionless forms, vapid imitation, and confectionary compositions; the puerile affectations of a soulless, mercenary, uncreative, and fashion-serving period. As we revive our æsthetic intuitions, and cultivate our knowledge of universal art, so shall we learn to rejoice in much, of which the strangeness at first sight almost repels curiosity or provokes hostility.

New sensations.

There is no country whose condition has been more favorable to the development of marked characteristics distinct from all others than Japan. Its population is directly descended, without intermixture, from the Asiatic race which long before the Christian era occupied its soil and reduced the Aïnos, or aboriginal tribes, to an abject vassalage, or left them to subsist as they best might in precarious savagery, in the remotest wilds of their own archipelago. This latter people appear to be one of the very primitive races of mankind, and although now amiable and tractable, must have been, in their original state, extremely barbarous; for they are invariably represented in Japanese

Favorable conditions of Japan.

The Aïnos

art, in their outward appearance and habits, as little above the level of the brute creation, very often far beneath it, in uncouth and ferocious aspects.

Bear worship. Indeed, they had instituted a sort of worship of the bear, regarding the animal as a superior intelligence, whilst their young women were required sometimes to suckle the cubs, as a sort of expiatory rite for hunting the grown ones. At all events, the Japanese art is remarkably homogeneous as to blood in either stock, and there has been no perceptible mixture of the later comers with these wild men whose origin is lost in an untransmitted past.

Although separated from nearest Asia by scarcely one hundred miles of sea, the new inhabitants always maintained their independence. And this, too, during a long period which saw the rise and fall of all other conspicuous nationalities, sometimes their utter extinction, but oftener their conquest and remodeling at the hands of foreign dynasties and hostile creeds.

Japanese isolation and independence. Doubtless their insular position has helped this national longevity, besides strengthening that complacent pride which imparts for a while a vigorous individuality to those who fancy themselves superior to other races simply because they are compelled to live apart from them. In the end, however, as with individual families, it weakens their powers and leaves them stranded on the shoals of time far in the rear of those peoples exposed to the active competition of equals. But in the policy of the Japanese there was a shrewd common sense, which, whilst foreseeing the risks of unrestricted intercourse with unscrupulous neighbors, also perceived the solid advantages to be gained by the free admission of their arts and ideas. When the proselyting pressure of Roman-

ism began to threaten the autonomy of their institutions, the government cutting off at once all intercourse with foreign nations, was quite as pitiless and far more effective in stamping out of existence an obnoxious faith than was Philip II. in Spain in cauterizing the rising Protestantism of his dominions, although backed by a "Holy Inquisition" and the rampant bigotry of his subjects.

There was, however, a valid reason for the success of Japan besides that of violence, in conserving both her institutions and internal prosperity, as contrasted with the results of a congenial policy but narrower polity on the part of Spain, by which, while preserving her faith, she sacrificed her power and ruined her people. The object of Japan was to secure a unity, not of faith, but of obedience to the government; subjecting all creeds to civil guidance and equality before the law, whilst repressing none which accepted these conditions. At first, Romanism was received as hospitably as Buddhism had been fifteen hundred years before, and might have thriven as well in the new soil, had it not put forth pretensions which jeopardized the very existence of the imperial dynasty, the principles on which the supreme power was founded and the entire basis of the civil government. Romanism, as guided by papal infallibility, leaves to dissentients no choice between its entire acceptance and the consequent overturn of all previous ideas, or its own extermination, as the sole means of self-preservation either to a rival faith or rule. Wisely or not, the Japanese chose the latter alternative the moment it was clear no way was open to reconcile Romanism with their views of religious equality before the supreme law of the land.

Object of Japanese polity.

True, this was somewhat peculiar, and conflicted radically with the fundamental principles of the Papacy. Nevertheless, the Mikados and their subjects had as substantial a right to their peculiar claims and opinions as the Popes and Romanists had to theirs. The question was, how to make two claimants to exclusive divine authority and power over men's souls and bodies live side by side in harmony, differing as they did so antagonistically in the fundamental inferences drawn from their supposed monopolies of truth and authority. But the Japanese being in complete possession of their own ground, after short debate and hesitation, unable to unravel the metaphysical knot satisfactorily to both, cut it by the sword in their own favor.

Polemically viewed, the Mikados, or Shôgoons, acting in their name, were in the right. Not only their dynasty antedated the Papacy more than eight hundred years, but they and their people believed that they were directly descended from the gods of Japan. Indeed, the genealogies of the deities and emperors were one and inseparable. Consequently, in the eyes of the Japanese, the right of the Mikados to supreme rule was unqualified by any attribute of delegated powers, as was the case with the Popes, who were only the temporal agents of the Romanist's gods. In giving the reasons of the Japanese policy, we must look at it from their point of view as well as that of their opponents. So far therefore as a divine right could be cited by either, the Mikados were clearly ahead of the Popes ; and what was surer for their power and influence, the loyalty of their subjects to them as civil rulers was inextricably involved with their devotion to their gods

Genealogies of the Mikados and deities.

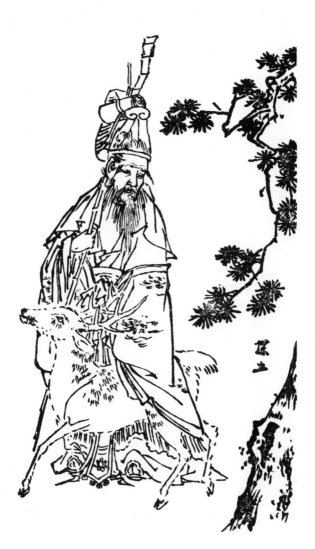

and belief in divinities of any sort. The persons of their rulers thus became so sacred as to be regarded and worshipped as symbols of divine omniscience. Now as this stringent infallibility of power and opinion was conceded on both sides without any attempt, as with the Popes, to prescribe fixed rituals, articles of religious belief, or any of the paraphernalia of creeds and material assumptions by which bigotries strive to enchain mind, the Japanese could and did freely believe and practice as they chose as to whatever directly concerned religion and its forms, whilst the Mikados jealously watched that no church should control the civil interests of their subjects under pretense of taking care of their eternal welfare. Religious Unlike Rome, all dogmas were essentially toleration. free. The Mikado was above all dogma. With what liberty the various sects in Japan exercised their privileges and functions in mutual harmony will be seen as we advance. As for the state, it maintained an impartial polity. If the Shôgoons personally favored the doctrines of Buddhism, the Mikados clung as tenaciously to the rites of Shintôism, their original form of worship. Thus the government itself sailed in peaceful waters so far as doctrines were concerned, and the people were equally charitable and contented.

The Japanese clergy could not, as did the Romanist, make an unassailable monopoly of baptisms, No ritual marriages, burials, or kindred rites, by which, monopolism. through fear of sacrilege and future damnation, the people either were or could be, enslaved body and soul to their priests, and the civil authorities put in peril at their bidding. To retain any influence with their· flocks the ecclesiastical powers must conform to the protective statutes and observances of the state;

for was not the head of the state the personal god
himself? Viewed either as a subtle device to obtain
unlimited power, or as a beneficent instrument to per-
mit freedom of worship under a supreme authority
above all dogma or rites, this Japanese constitution is
grandly efficacious and simple, and compares most
favorably with the elaborated mysticisms of Roman-
ism ending in the futile attempt of this nineteenth
century to attain an equally omnipotent authority
under the specious plea of " infallibility," not to pro-
tect liberty of conscience, but to restrict it to the ty-
rannical interpretations of the age of a Hildebrand
and to abase the civil power to the lowest depths of
servitude.

Knowing, both from the experience of other people
and the pretensions of the converts at home,
the aggressive character of Romanism, be- The barriers
guiled by no sophistries of profit or pleas- of exclusion
ure, Japan held to her isolation until in the thrown
down, and
why.
progress of European ideas her rulers were convinced
they might venture to throw down their artificial bar-
riers and admit Aryan creeds and civilizations to
compete with and modify their own. For several
centuries Japan had been consistent to her system of
self-protection ; nor did she swerve one hair's breadth
from it before persuaded that the baneful spirit of
European adventure, whether under the guise of com-
merce or religion, had come under the wholesome
restraints of enlightened public law and sounder
opinions as to international duties and rights. Be-
lieving that the time has arrived when she can with
safety fall into the line of outside civilizations, she does
so with almost precipitate haste. Electing to live or
die by her experiment of novel habits and ideas, she

has begun to cultivate those radical changes at which she was formerly so alarmed. With what final result who may foresee? Spain, on the contrary, during her probationary period, by persistingly opposing force to ideas with self-destructive bigotry, finished by ruin and disgrace, and now presents a pitiful spectacle of misplaced logic, paying dearly for her credal infatuation. A nation like Japan, which is sagacious at fending off evils while it can, and wise in accepting the inevitable when it must, turning each opposite policy to present advantage, displays a solidarity of character piloted by an efficacious policy that tempts to a closer investigation of the constituents of its peculiar civilization.

My topic, however, confines me to its artistic elements. But to obtain a clear view of art we must look at everything that enters into its composition. To a certain extent, it is quite as much the outgrowths of political and religious sentiments as of the more material interests of a people or the physical conditions of their country. The civilization of Japan, as a whole, engendered a general well-being and happiness which left little to be envied elsewhere, even if the inhabitants had possessed means of comparing their lot with other nations. Indeed, as regards art within their confined scope, they were in advance of all others at the date of opening the country to foreign intercourse. There had been a slow decadence, it is true ; but thanks to their forcible isolation, neither so radical nor general as that of Europe since the sixteenth century, which was also with Japan the best period of its development. Amongst other evidences of its superior condition, Japan early secured to itself the significant

designation of " Land of Great Peace." Rarely tor-
Land of mented by a lust of conquest, or racked by
Great Peace. civil strife, its peaceful decades were highly
favorable to the complete growth of its special art,
whilst contemporary Europe was in a chronic state
of internecine combat, and its spasmodic progress one
broad trail of human blood. On its side, Japanese
paganism presents a spectacle of an almost serene
contentment. The civil and religious institutions har-
moniously interblended and nearly two-score mil-
lions of our fellow beings, living in fortunate igno-
rance of our superior advantages, became wonderfully
advanced in certain phases of the arts and capacity
of taking care of themselves, respectably proficient
in literature, ethics, and philosophy ; and grew to be
highly polished in manners, peaceful, industrious,
asking nothing better of the outer world than to be
let alone, satisfied to subsist on their own resources
and in their own fashion, whilst one hundred mil-
lions of men in Europe, who worshipped the Prince
of Peace, in his abused name were cutting each
other's throats, destroying each other's property, tor-
turing and proselyting by rack and flames, and all
this out of a tender regard for each other's eternal
welfare, if we accept their common explanations of
the singular scene.

However heathenish their ways and ideas, the
Japanese Japanese managed to conserve as regards
morals and civil intercourse and general order, a prac-
habits.
tical morality to which Europe was a
stranger. As a rule, the people were singularly hos-
pitable and amiable, as well as ceremoniously polite.
Each degree in the social state had its conservative
barriers sacred to all. The matrons, if somewhat

untutored according to Anglo-Saxon notions of modesty in some matters of toilette, were otherwise above reproach ; whilst their daughters were as chaste and decorous as those of Christian lineage anywhere, if we may credit those writers who know them best. It is as unfair to judge of female character in Japan from its harlotry, high or low, as to do the same of English or French womanhood by the examples Paris and London display, either of fashionable or vulgar prostitution, or prurient extremes in manners of any origin. Yet some travellers do this in Japan, heedless of their ignorance of its true life, and reckless of the exposure of their own proclivities. If we can rely on the official statistics of 1872, Japan is far more fortunate than Europe as regards criminals. Out of 6,564 persons confined in the prisons, averaging only one in 5,500 of the entire population, there were only 565 women. This paucity of criminals in their sex cannot be owing to social restrictions which shield them from the usual temptations of men ; for they not only figure numerously in the ranks of the Buddhist and Shintô sects in various sacred offices, there being nearly 300,000 of them thus employed, but out of the millions engaged in farming, almost one half are women, and in trade 489,409 are enrolled as against 819,782 men ; all which show that women can compete with men in various avocations. Evidently Japan has advanced habits, if without abstract theories of women's rights, whilst managing to live with fewer male criminals than we do, and almost no female convicts.

Need we marvel that Japan for a time tabooed itself to pugnacious saints, and traders of the European breed, and only allowed them to enter when they had

learned to behave like good pagans, or at least showed a respect for others' rights and opinions! As regards the disposition to learn from foreigners whatever they could without the risk of political suicide, the Japanese displayed a singularly unchristian trait, as well as in not trying to convert strangers by force or persecution to their own beliefs. They not merely permitted rival religions with their numerous subdivisions freely to exist, but with an eclectic liberality and sagacious free thought seldom if ever practiced elsewhere, founded the rationalistic sect of Shingakei, which sought to combine what was most edifying in the doctrines of Confucius, Buddha, and the aboriginal Shintô teachings, with a more practical and simple form of religion. Shintôism, be it remembered, besides the worship of the spiritual gods, the creators and protectors of Japan from time immemorial, those grand mythological figures dimly seen in the first daybreak of history, included the earliest benefactors of humanity, whose good deeds, as with the saints of the Roman calendar, caused their semi-deification by a grateful posterity.

Kamism, which is the same as Shintôism,[1] even
Kamism, or Shintôism. antedates the historical annals which go back to 660 years before Christ, and still maintains its position as the national religion most favored by the Mikados, just as Buddhism was encouraged by the usurping Shôgoons. As it appears to have emanated from the aspirations of an almost guileless period of a remote antiquity, it is perhaps one of the most primitive of religions, and not materially changed in its chief external characteristics, al-

[1] Shintô is a Chinese term, signifying "The way of Spirits," the original Japanese word being unknown: but its successor implies also "Worship of ancestors."

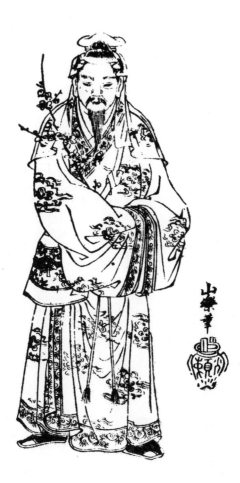

though its earliest doctrines are either much transformed in spirit, or quite forgotten by the masses. Scholars alone know what these are, while nowhere are all the rites preserved in precisely their original purity and meaning, or the dogmas preached precisely as first established. So simple were they, administered, too, without the intervention of a paid priesthood, or a privileged proselyting hierarchy, by the lay-worshippers themselves after the manner of our Quakers, that we may easily conceive Shintôism to have been the spontaneous devotion of a simple-hearted, spiritual-minded race, towards their supposed creators, or benefactors, in the spring-time of their sensations and sentiments, moved by a desire to find out the cause of their being, and to develop and strengthen their conceptions of an ideal standard of purity and goodness. Certainly, as we are informed of its rites, they indicate quite the reverse of the hardness of heart and tendency to idolatry which our catechisms have taught us to be the universal traits of heathenism. Indeed, taking this worship as described by Koemffer, even of the tutelary spirits known as Kamis, it reads like a beautiful idyl, or a symbolization of the spiritual elements of faith and being under the purest and most appropriate forms.

Where may we find a more apt emblem of the divine scrutiny into the hearts of men, than their highly polished mirrors of steel, sym- Its rites. bols of the all-seeing Eye, placed on plain altars decorated with flowers in the centre of the small rustic chapels devoted to this worship? These were supposed to reflect whatever emotions were uppermost in those who looked into them, and to detect and expose unworthy thoughts and passions. How

might rites be more free of incitements to superstition and idolatry than those within shrines, whose chief adornment consisted of white-paper hangings to denote their purity, and to remind their visitors they were to present themselves before the tell-tale mirror with spotless hearts and clean bodies? Among what other sects do we find an equally refined sympathy with nature at large and as full an appreciation of the mystic relations of the landscape with man as imaging a divine, creative, controlling power, than is exhibited in the selection of the umbrageous sites for the Shintô temples, with their commanding views, approached by clean, paved stairs, through wide entrances, at which were placed stone basins holding the waters of ablution?

As this religion had nothing to conceal, no mystic terrors in reserve, nothing to threaten or to make afraid, the interiors of its shrines were freely exposed to view. There were neither images nor complicated rites to distract the worshipper from prayer and self-examination. No priestly caste officiated in them with prescribed ceremonials; but they were invitingly open to all comers to worship as their consciences dictated, without the suggestion even of any of the usual ecclesiastical barriers of bigotry or distinction of persons. Each might leave an offering in the gift-box or not, as inclined. Literally, these were veritable houses of God, hospitably welcoming saint and sinner without price.

The moral significance and spiritual suggestion of this seemingly spontaneous worship — for I believe it was born thus of intuition despite the snags of Darwinism — were as intelligible to the common mind as its symbolism was clear

Moral significance of Kamism.

and direct. By its simple imagery, every one could adore or supplicate the divine ideal of his own consciousness without offense to his neighbor, or inciting controversy, the more especially that there were no entanglements of priestcraft of any species, or foregone dogmas, to mystify his mind and put impossible gulfs between him and his kind. The supreme Lord sees the heart and none but He can be its judge ; adore ; the entire earth is his tabernacle, nothing is hidden from Him and nothing should be from his creature ; welcome without fear ; all are equal before Him. Such appears to be the essence of this soul-worship in its pristine integrity, at all times dedicated to good-will and a sound conscience among men. A more felicitous solution of the vexed problem of a free church and state with voluntary worship based on complete individual liberty and the relations of Man to his Maker, as of child to parent, it would be difficult to originate.

Independent of their spiritual efficacy, such simple rites amidst picturesque surroundings must have fostered the close sympathy with the natural world, both in its realistic and mystical aspects, which is so conspicuous in Japanese art, and which is without parallel in any other people. There must be also something essentially sound in the religious constitution of Kamism, which has enabled it to survive to our times, still swaying the minds of many millions. Undoubtedly, as with the Semitic or Tauranian races, it is due to its central abstract idea of a Supreme Being, impersonal and omnipresent in Himself, even when represented by legions of incarnations, under various forms and qualities, beneficent or otherwise. The main princi-

Fostered sympathy with nature.

ple underlying all, is the absolute impersonal unity of
the divine creative power. This distinguishes Shintô-
ism from Buddhism and Brahmanism, in the same
way that it draws the theological lines between Ju-
daism, or its near relation Islamism, and Romanism
with its outgrowths of Protestantism. In none of
their forms is there any intentional idolatry, whilst
all have a common aim in promoting the spiritual
welfare of mankind. The fact of adhering to any
one of the multifarious aspects of these diverse re-
ligious ideals, is with almost all men an accident
of birth, temperament, or interest, rather than of
downright conviction. Perhaps nothing determines
the choice of a faith oftener than the æsthetic tem-
perament of an individual. If he be inclined to the
abstract, indifferent to sensuous appeals to his relig-
ious faculties, naturally he prefers those rites which
put his soul in most direct communion with the Su-
preme, however much he may like to pamper his
body with sensual indulgence or materialize art to
his pleasure. On the other hand, if he can
feel truth, or reach his ideal only or chiefly
by the medium of the plastic arts, he
cleaves to those sects which most completely admin-
ister to the wants of his soul through an æsthetic
medium. The extremes of all religions of necessity
point to an abstract unity of idea, but the roads lead-
ing to it are many and variable.

*How art af-
fects the re-
ligious tem-
perament.*

Although we can divide all believers into these two
grand divisions as to forms, yet every mind contains
the germs of both inclinations, each of which need
equal and complete development to make the perfect
man ; but they seldom secure this through the ordi-
nary channels of cultivation. Consequently, religions

and men are invariably one-sided in their training, and liable to fluctuations of feeling and convictions. Shintôism was perhaps too severely abstract for the average Japanese mind, and too meagre externally to satisfy the sensuous side of his organization, developed as it was by a passionate enthusiasm for art-language in all other forms of life. Hence, about the beginning of our era, when Buddhism was introduced into Japan it spread rapidly among all classes, because it brought with it a redundant æsthetic element which appeased the longings of their senses for the outward symbols of ecclesiastical magnificence, parade, beliefs, and the material images of the beings venerated, feared, or worshipped, as well as the pictorial scenes of whatever facts or issues there were connected with the worship. Buddhism closely resembles Romanism in its æsthetic devices and latitude of material imagery, not to call it idolatry, which both disavow, however idolatrous the excess in this direction causes the common mind to become in practice. Indeed, Buddhism in Japan is less daring than Romanism, for it limits its highest efforts in image-adoration to the effigy of the founder of the faith, whilst Romanism soars to depicting the Almighty under the form of an aged man. But Buddhism did finally impose a part of its paraphernalia on Shintôism, peacefully, so it would seem, in the form of altar decorations, a litany, miraculous images, processions, a special class of noble laymen whose business was to officiate in and take care of the sacred places, assuming particular vestments while on service, and of an order of monks charged to direct and provide for pilgrims who visited the shrines. Shintôism in return lent to its rival its

Introduction of Buddhism and effect on Kamism.

sacred mirror to be placed on the altars, and some of
Kirin and its later-introduced effigies, such as Kirin,
Koma-Inow. the fantastic unicorn, symbol of good au-
gury, and the equally strangely constructed dog-lion,
Koma-Inow, a sort of chimera symbolizing the purify-
ing elements of fire and water, to be also guardians
to the temples of Buddha. Since the recent official
suppression of monasteries in Japan, the government
has attempted to remove from the Shintô temples all
the Buddhist innovations countenanced by the late
Shôgoons and restore them somewhat to their origi-
nal condition. As the ruling and cultured clases are
mainly skeptical as to all religions, philosophically
indifferent, or else outright materialists, these changes
of forms are only on the surface and for political ef-
fect, whilst the confiscations and destruction of time-
honored sanctuaries and the conversion of Buddhist
nuns and monks into serviceable Japanese men and
women, are very sincere and complete. In evidence
of the present absolute religious toleration of the Jap-
anese, I cite the recent instance of the Rev. Nee Sima,
a native scholar educated in the United States, and
converted to Protestant Christianity. On his return
to Japan he was not only permitted to preach and
Destruction proselytize in Buddhist temples, but these
of idols. were thronged with 'hearers among whom
were some of the officiating priests. He made a
number of converts who, with the usual fanatacism of
their class, began at once to destroy their so-called
idols, as if they were still afraid of them.

Our business, however, is with the past. The mu-
tual helpfulness of Shintôism and Buddhism, and
ability to live together in peace, opposed as they were
in so many outward observances and ideas, are a re-

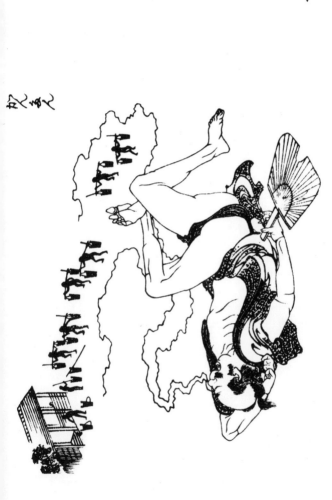

proach to the religious history of Europe during the
same long period. And the lesson becomes the more
marked as we find that neither was affrighted at the
appearance beside them in intellectual rivalry of the
rationalistic doctrines of Confucius and of
Mencius, which, based on human reason and
materialistic thought, were a virtual nega-
tion of their fundamental beliefs and tra-
ditions. As early as A. D. 285, Ozin, the reigning
Mikado, himself the *alter-ego* of the Supreme Lord
of Creation, with a liberality of judgment which
makes the broadest church of Christendom seem nar-
row and doctrinal, requested the sovereign of Corea
to send to Japan the philosopher Wang Iin, to inform
his subjects as to the prevailing religion of China.
His practical ethics were so much appreciated that
the Shintô religionists enrolled him among their Ka-
mis — a species of canonization,'— as a public bene-
factor, instead of crucifying him, testing the sound-
ness of his tenets by roasting him on a gridiron, or
consigning him to an " auto-dà-fé," as was long time
the orthodox method in Europe of welcoming new
doctrines. A politic race this, humanely wise ; one
that could conciliate credal antagonisms, and put
them to account as instructors of society instead of
using them as ferocious instruments for quenching
thought, rending nations into mutilated fragments,
and turning an entire continent into a sanguinary
cock-pit, or a wilting despotism. What wonder, I
repeat, that these sagacious children of the Orient,
this " Land of Great Peace," although at first giving
a welcome to Roman missionaries, as willing to learn
from them as they had been from their Indian and
Chinese predecessors, when they perceived the quality

Introduction of doctrines of Confucius from China.

of their new teachers and tasted the first fruits of their proselytism, what wonder that they imitated the examples shown in the history of Europe by the fellow-religionists of these very missionaries, taught and upheld by their church whenever it encountered difference of opinion, and applying their own rules and practice to them and their neophytes, utterly stamped out of existence both tenets and converts, and hermetically sealed their country thenceforward against any similar experiment!

The long tranquil isolation of Japan excluding all foreign influences likely to harass it, was favorable to the growth of its own indigenous tendencies of art and forms of civilization having their germs deep in ancestral blood. How these primitive currents of mind and feeling originate is a problem as profound as the existence of man himself. He exists, and with him fundamental differences of mental and physical organism that diversely affect the nations that are born of him, and these differences seem to intensify as we trace them to their present sources. Each seed-race asserts that its primeval ideas and inventions are the direct gift of the gods. The wisdom that created man seemingly endowed his mind with definite intuitions which pushed it in certain directions, permitting its action to be modified by the pressure of external conditions, but not forced from its first impulses. At least, as I search history, this seems much more probable than that he was entirely abandoned like a stray atom to the material chances of his arduous existence, with no inspirations or controlling influences except such as sheer physical necessity developed. Further, I infer from the story of his

Isolation of Japan favored its special artistic and intellectual development.

moral and intellectual progress, that from time to
time his intuitions have been strengthened or modi-
fied by fresher currents of the divine creative thought
which originates all things, and is its own supreme
law. In face of the popular theories of science, this
confession of a belief as old as the world, but now
condemned by the self-styled advanced thought of the
age, must appear foolish. Be this as it may, striking
varieties of a common human type do yet exist, each
after its own fashion obedient to an original special
mental impetus, and contributing to the universal
treasury of knowledge of humanity. Out of this
common wealth may there not be constructed, finally,
a complete human type, perfected by the painful ges-
tations of all the tentative civilizations of our globe ?

In the outset of our scrutiny into one of the æs-
thetic periods of human progress of a race Intuition
differing as widely as possible from our own, and Realism
I declare thus emphatically my persuasion art.
that something besides the direct mundane causes are
necessary to account for all man's progress, chiefly be-
cause the specious philosophy of art taught by Taine
and his school seeks to reduce it to a mere formula of
climate, food, and the material and sensual belongings
of a people ; thus giving all the reason of the in-
tellectual phenomena to the physical agencies of life,
while wholly ignoring intuitive principles of develop-
ment. However much the external world may tem-
per or control the æsthetic faculty, it cannot wholly
account for its existence or explain its highest works.
Something more than visible matter is needed to
show us why certain peoples as one mind run in one
psychological groove, however diversified their ma-
terial conditions ; also why one race, under equal and

common conditions, often exhibit such varying and contradictory æsthetic aspects. In every instance in which art has become an eminent characteristic of a people, it is found to be deeply rooted in those sentiments which connect it most closely with intuitions or beliefs of another life, or else its methods of interpreting nature as the symbolical correspondence or tangible manifestation of its ideal of an existence apart from and above its own. The visible evidences of this intuitive aspiration or faith follow the scale of mental elevation, descending in æsthetic motives from the celestial-supernatural toward the human-natural, borrowing its ideals from either world just as the mind gravitates from spiritual apprehensions to material perceptions, and is lofty or low in artistic speech, but ever proclaiming an informing spirit, whether of the heavens, earths, or hells, and borrowing its illustrations from those conceptions of things which make up the heaven or hell of its intuitive desires. It is plausible to account for the superficial phenomena of art by referring them all to the external world about it; but we must go behind mere form and color to detect the potent intangible springs of existence which animate these puppets of the eye. Where are we to look for them except in those intuitions with which the soul is freighted when it first comes to earth; whose force is ever manifested by a longing for an ideal not of the earth and whose presence can only be explained by accepting it at its word as an augury of a superior life to be, or else the dim reminiscence of one gone — in either case another existence?

The real touchstone of art is its recognition of this
Recognition of the ideal. ideal, or belief in something better than
what the senses perceive, and its endeavor

so to use dumb materials as to suggest the spiritual constitution of things rather than the grosser properties of matter. Whatever work falls short of this, however clever of manual stroke and close imitation, or pleasing to the lower plane of æsthetic consciousness, fails in the supreme satisfaction which comes from meeting face to face with the soul's conception of an ideal perfection in life past, present, or to come. Discernible by the clairvoyant eye of an artistic imagination, even inanimate objects become informed with the spiritual essence of life in virtue of their own being; doubly so all animal and vegetable life, and in infinite degree man is seen to be surcharged with the creative free-will. Hands which stop short in their work at the outward shell, give us only the dumb envelope and blank machinery of being, for these form an impenetrable barrier to their higher vision. The hidden sources of life do not reveal themselves to unsensitive organs whose sympathies belong only to the crust of things.

How differently two artists paint the same landscape! One executes a picture with topographical fidelity and details of stony exactness, and cold rigidity of form and color, passionless, emotionless, mutely repellant; giving no higher evidence of life than a clever counterfeit of the substances in view, " a painted ship on a painted ocean," but unlike the Ancient Mariner, telling no tale. But, vivified by the informing stroke of the artist who recognizes the undying spirit of nature so preëminently shown in man, guiding his destiny by material means to divine conclusions, combining all created things into a choral unity of final purpose, the little leading straightway to the great, finite to infinite;

Material and ideal art.

quickened by this silent speech, art becomes at once a revelation and the solution of immortality. Art need not always be pitched on the supernatural or superfine to reveal the presence of conscious spirit, for we can find happiness and edification in its manifestations of the humblest forms as well as the noblest.

Nothing unclean except by man's own will. Nothing made by divine power, or created out of the riches of our own imaginings, is unworthy or unclean unless by the prostitution of our own wills to evil or weak purposes. Science rightly calls this kind of language vague speculation as viewed from its own basis of matter-of-fact analysis and deduction. But art, too, has its own rules and forms of language consistent with its proper being and purpose. Neither can be rightly appreciated when viewed only through the mental atmosphere of the other. The true word of life of art comes from a spiritual insight into its motives rather than from a scientific perception of their material machinery, which at best can only be a technical help towards a thorough rendering of the informing sentiment. To paint a mouth in sole reference to its adaptation to eating is quite another thing from painting it to express the emotions which intensify its movements with pleasure or pain ; so with the nose, eyes, or entire figure. However perfect in modeling and life-like in tint, it is only a dumb effigy until the artist endows it with the human soul and sets it in motion.

European art scientific, Japanese idealistic in basis. European art of our time has a marked tendency towards the scientific extreme, contenting itself over-much with the dumb show of material objects, and finding its supreme satisfaction in their outward likeness. Japanese art tips the æsthetic scale towards the other extreme, paying less

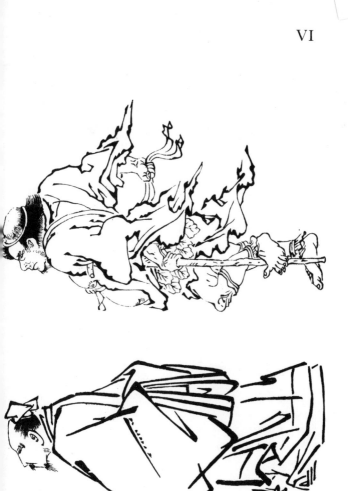

heed to the grammar of art, and bestowing its greatest attention on the vivid rendering of the specific motive in its highest scale of idealization. In other words, it conceives art to be a supreme spiritual function of man, appealing to his faculties of mind more than to those of his body, and best fulfilling its office when it affects the imagination by limitless capacity of suggestion in preference to pleasing the senses by superior skill of a downright realistic imitation. Its abstract superiority, therefore, rests on its profound recognition of the higher to the lower law of art. As this is precisely the reverse with the average practice of modern European art, both reader and artist, in examining the objects we shall briefly review, may be profitably reminded of the past times in Europe when its art, acting on a similar impulse, produced works which we now vainly attempt to rival, or even imitate, simply from too closely following an opposite principle.

The two chief branches of the human family, both originating in Central Asia, and which have developed the highest civilizations, are the Aryan and Turanian. Guided by its nomadic instincts in the outset of its historical career, the latter became widely diffused and separated, whilst the former remained in more centralized and compact masses. Each distinguished itself by characteristics that have slowly crystallized into national idiosyncracies, more or less antagonistic and one-sided as regards one another, and ending in fixed expressions of civil and religious life. Owing to the expansion of commerce these last have been brought into direct competition, to stand or fall on their own merits ; possibly to intermingle, and out of the truths of all civilizations to erect a new platform of progress for the whole human race.

Aryan and Turanian branches of the human family.

The Aryan branch, whose latest family achievement is the unæsthetic restless American people, has been remarkable for irrepressible action and experiment, intense individualism, rivalry, versatility, conceit, discontent, invention and enterprise, love of excitement and extreme sensations, contempt of peril and death, frequent rebound of ideas and psychological revolutions, with terrible penalties inflicted on their much coveted material acquisitions, and protests of soul against the tyranny of matter ; probing, proving, testing all questions in the crucibles of reason or profitableness, the while steadily consolidating its gains into a compact, humane, international life. Among the Turanian races we find much of a directly opposite character. They have shown themselves reserved, exclusive, conservative, custom-abiding, stubborn in their policy, identifying their ideas closely with the past, their ancestors and religions rather than self-seeking, skeptical or inquisitive as to the future, deeply imbued with the consciousness of another life, mystical more than speculative, strenuous to conserve their isolations and their antique institutions, whilst their fickle and emotional Aryan brothers were often overturning and remaking theirs. A noteworthy æsthetic trait of the Turanian is his passion for color, whilst the Aryan shows a preference for pure form, though in each the temperament takes readily to the other art expression. Nevertheless, the predominance of brilliant traits in their art, and absolute delight therein, used with intuitive sagacity and appreciation of harmonious contrasts, gradations, and interblendings, as it were forming refined symphonies or spiritual chords of colors, are a special heritage or instinct of the Turanian family ; just as those of

Aryan descent are more distinguished by sculpture and architecture in general than by a universal appreciation and skill in using color, especially in the minor decorative forms of art.

Whilst eulogizing as they deserve Japanese art or character, I do not mean to assert for either any absolute superiority in the whole over European, but simply to show that paganism is as far from being unmixed error as Christianity is unmixed truth; and that any form of civilization, whether of either origin, is not so perfect as to give it the right to dictate to its neighbor or assert for itself an unqualified supremacy. Humanity is a complex riddle. One thing certain is man's uncertain knowledge and conflicting ideas. Each race perhaps, as every individual, has a special problem to master. None alone may solve the great enigma of life, but all may contribute to make it more enjoyable or harder to bear, according as they use the faculties of their souls, thrown so waif-like on to the inhospitable shores of Time. Truth for its own sake, and used solely for human good, is the principle of action which should underlie all ambitions. Any scope less universal and thorough, or motives less pure and sincere, vitiate results in the degree that they strike their roots downward into selfish aims, false pride, and the rancors of intolerance, lay or religious. We call ourselves Christians more I fancy by the gracelessness of our self-conceit than by the quality of our virtues. The sooner therefore we admit that the heathen have something to teach as well as to learn from us, the faster will be our own intellectual growth, and the broader and keener our pleasurable emotions.

[Marginal notes: Supremacy relative, not positive. / The one thing certain.]

THE RELIGIOUS ART OF JAPAN. — ITS DIVINITIES, MYTHS, AND HEROES.

THE religious motive is the alpha and omega of

The religious motive the chief inspiration of art. inspiration of all art of all races as regards its influence and power. It antedates and outlasts all others. To it the soul instinctively turns as by an irrepressible impulse, to find its deepest solace in present life and to express its passionate longings for another. No matter whether it assumes the forms which we loosely classify under the generic divisions of paganism and Christianity, or the specific shapes engendered of their numerous sects; the vital, human emotion at the root of all is one and the same: viz., the desire to realize to the outward senses in appropriate, material language, the abstract ideas which underlie the soul's consciousness of a creative force superior to itself, and which sways its destiny for good or evil by occult or visible means. There is in principle no more idolatry in one form of its expression than another. Idolatry consists in the ignorant or superstitious use to which the art-forms born of this desire are put. Paganism, as exhibited under the rites of the primitive Shintô worship, is as free from idolatry as any monotheistic religion, as even the strictest Judaism, whilst Buddhism is not more coarsely materialistic in its sacred mythology as rendered by art than Romanism. In dealing with the sacred art of any people whatever,

despite the fetichism of the absolutely ignorant,
whether the object of a blind devotion be a holy book,
an image, or any abstract dogma put in the place of
the creative will itself, which is past all finding out,
in fine, despite sheer idolatry in individual or race, we
should place all art consecrated to religious uses on
an equal footing as regards its fundamental motive,
view the feeling which originates it with respect, and,
in judging it exclusively on the side of art, esteem it
according as it successfully incarnates its fundamental
motives into pure artistic forms.

Idealism in art is a complex phenomenon. It does
not absolutely demand beauty in the mean- *Idealism a*
ing of the Grecian mind. Neither does it *complex phenom-*
confine itself to the spiritual or ascetic stan- *enon.*
dard of the mediævalists any more than it refuses to
lend itself to the strange symbolisms of Egypt, India,
and Etruria, and the grotesque diabolisms of the far
Orient. We cannot compass its spirit, even in the
wide range of the homely, the real, the picturesque,
the sentimental, the natural, the heroic or the sub-
lime, which constitutes at once the variety and mo-
notony of modern art. Looking back a brief bit of
history, we see the Hollanders shaping their *National*
ideals after their own homely, materialistic *ideals.*
fashions; Englishmen, holding domestic life and solid
comfort in highest favor, pursuing theirs in a scarcely
less realistic mode; the Germans, too, having their
specific notions; the Latin races theirs; Orientals
other visions of an ideal; each and all idiosyncratic
in feature, and varying largely, whilst we may now
add to the æsthetic list the American pattern, a
business-like, impetuous, uncultured ideal, vigorous,
impatient, and tinged with charlatanism in some

measure, but promising; no one attempt being con-
clusive and final. For the perfect type, I repeat, still
awaits its maker. Indeed, it must continue to await
until mankind, agreeing on a higher standard of truth
and beauty than has yet been made, shall incarnate
their fresher living word into a new form of BEING,
which, having absorbed all of good there has ever
been on earth, shall move onward to greater and more
complete ends. Meantime, from sheer gravitations of
imperfectness, the human ideal will manifest its exist-
ence as a fluctuating, fickle, antagonistic quantity in
civilizations; often perversely claiming to be absolute
truth and beauty when it is positive falsehood and
ugliness, but ever groping about in such light as it
can evoke from nature, if haply it may find what it
ever seeks. For a brief moment the mind seizes on
some phantom form that pleases its desire, but speed-
ily wearying of an idol which before long mocks its
hopes, it starts anew in search of another divinity,
ever prompted by a divine discontent to win failure
on failure. Each trial, however, gains something for
humanity in proportion as it is governed by the love
of things not altogether transitory and perishable.
But the much coveted everlasting truth never visits
earth except as glimpses of radiant light far away,
and seen through fleeting clouds, reflecting and soft-
ening its brightness to meet the feebleness of human
sight.

No race being wholly without these glimpses, the
highest office of its art is to catch them as
they come, and place them palpably before
our senses. Thus many comparative ideals
are formed which satisfy for a little while the un-
limited aspirations of the soul for sensuous images of

No race
without its
divine intu-
itions.

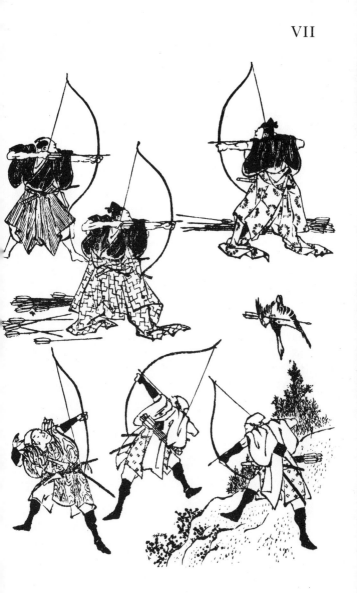

its multifarious thoughts, hopes, pleasures, or fears. Hence, also, the ideal of one man or people differs widely from another. That which may be repulsive, unintelligible, or even idolatry to one person, is edifying and delightsome to his neighbor. Ideas of association, or suggestion, determine in large measure the viciousness or virtue of art. Consequently, as I have before hinted, in judging any art we should not hastily condemn it merely because it differs from our own familiar standards, but search out how far it embodies its originating motives, how it affects the indigenous mind, and lastly, what element it incorporates instructive and enjoyable to the common mind. If we approach art at all, let it be with both this largeness of heart and understanding. Art, abstractly interpreted, is of necessity no more a plastic or pictorial apotheosis of beauty than of ugliness, of truth than of error, and in average practice, we find it as ready to serve the devil as God ; to perpetrate folly and falsehood, as to help the right and make the best appear

Art an apotheosis of ugliness as well as beauty.

the most delectable. Strictly as art, no standards of abstract morality or thought are to be brought to its test. We have only to consider its technical power and beauty of presenting the facts, and spirit of its specific motive, good or bad, in its uttermost idealization. We may devoutly wish that art exclusively served goodness, but it does not any more than do speech and printing. The theories of its transcendental nobility are pleasant reading , but its practice is quite often the reverse, just as with professors of religion. We have too abundant evidence that art is an assiduous propagator of mischievous taste, as well as its cunning, in befooling the mind and de-

bauching the heart. Art, beauty, the ideal, as pop-
ularly comprehended, are all uncertain factors in
civilization, depending for their evil or good on the
good and evil in man himself, and the direction of
The general his intellectual culture. Indeed, art in
desire of art. general, as so far evinced, is a very subtle
phase of human growth, largely governed by a ca-
pricious code of taste and budget of motives, and
with singular fidelity improvising the extremes of
character of the individual or age, with slight respect
for more serious considerations than to do its best
technically for its own sake, get the largest price for
the least æsthetic value, or else to most please its
immediate patron and the ruling fashion. There
have been artists, perhaps epochs, of a nobler ap-
preciation of its fundamental qualities and capacity ;
but they have had no permanent, wide-spread, pro-
found influence on the general character and scope of
its diversified developments. Such is the inconstancy
of feeling, and the constancy of ignorance of the
average human nature, that the best of our period
is most often soon forgotten or despised, in view of
the meretricious charms, or half-fledged novelties of
its successor.

Mind takes two forms of consciousness in appre-
Mind takes hending art; one primary, recognizing its
two forms material semblance to its objects, the other
of con-
sciousness. its capacity of an inward suggestiveness, or
manifestation of the fundamental spirit, or ruling
thought of its motives. In this latter form, crea-
tive force is preferred to the mere technics of art.
A sound critic or artist is he who best combines the
two into consummate judgment or execution, keeping
in view that the aim of all art is, primarily, Truth,

and secondarily, Beauty, so far as any line can be drawn between them.

There are only two ways of producing art. Either we copy or invent. The sort of truths necessitated by copying what is outwardly seen, is palpable and demonstrable to our material senses, and the success of the artist depends on his strict adherence to his copy or model, and in invoking those vital qualities which most animate and control them he bestows on his effigies their most characteristic phenomena. But the truths which determine invention, *i. e.*, those qualities or phenomena *seen by the mind*, although no less substantial as regards art, are more evasive as regards the senses, and difficult to master. Their test is, that which is thus invented, even if unlike any known product of the natural world, shall be as conscientiously true to its own apparent organism, and as readily account for and explain the laws of its being and their sequential phenomena, as if its entire organization was the actual growth of nature itself. All art which does not come within one or other of these living categories, is mere paint or plastic gabble.

Two ways of producing art.

What fragrance is to the flower, rhythm to poetry, melody to music, a smile to the countenance, grace to form, elegance to manners, beauty is to art; not art itself, but the imponderable, undefinable something which superadded to the elemental fact or idea, bestows on them their supreme refinement and delight. Alone it appeals directly to sense or spirit, and serves both as a temptation and a reward, to attract towards the search of the absolute truth, whence it emanates and which it adorns.

The relation of beauty to art.

As the controlling force of art, truth assumes at
will either of the two guises it momenta-
rily needs, Idea or Fact. The former is the
more important, as it is the soul-germ which
is destined to animate the organic fact which art
counterfeits. This counterfeiting may be done with
much technical accuracy, and yet be comparatively
valueless, because the artist fails to put an idea or
living purpose and vital spirit, whether of realism or
of sentiment, into his work. Further, Idea and Fact
may be harmoniously united, and yet no positive
æsthetic quality as a whole given. The result would
no less be tangible art, but art without its most
charming attribute, Beauty. I do not affirm there
can be art without some trait or mark of beauty, for
there is no created or imaginable thing in its normal
or healthy condition, utterly destitute of the divine
gift in some sort, however masked by general ugli-
ness or viciousness. It never wholly abandons man
or nature. We sometimes say such a person is so
ugly as to be fascinating, which is also true of some
things. But there must be a reason for this subtle
influence, which is a sign of some latent æsthetic
possibility, or veiled quality of soul, not altogether
devil-gone. I do maintain, as before intimated, that
art being, like nature, many-sided, is as legitimate
an exponent of whatever is ugly and false, as of the
reverse, despite classical experience. Whether she
should often put it in practice, is quite another con-
sideration. Modern thought, even if no deeper, has
a vastly wider scope than ancient. When an artist
The ideals of constructs a devil, he must put into his
ugliness. ideal effigy the totality of evil his imag-
ination can evoke and hands fashion. In the Siva

Truth of Idea, and Fact. (margin note)

The ideals of ugliness. (margin note)

worship of India, Kàli, the goddess of destruction, is as much a work of art as the Athena of Phidias, but how differently conceived! This idealization of an evil force is thus described. "She is a colossal, naked effigy, with the skin hanging to her bones, and her veins and muscles frightfully distended. Her hair is brushed back under a fillet of snakes, with a death's head on her forehead, and the distended hood of a cobra as a canopy above. Serpent tresses twist and squirm over her cheeks, ending amid strings of skulls worn as necklaces, and running all over her foul body. In one of her hands she holds a brimming cup of blood, and a battle-axe in another, whilst she dances with fury on the prostrate body of her husband." The mother of the god of death, is a similar figure of scarcely less concentrated evil import, joined to the decrepit figure of an aged shrew. These conceptions are far from lovely, yet art has labored as zealously to create them, as ever she did the beautiful Aphroditè rising from the ocean-wave, or the spiritualized form of the Madonna, queen of heaven.

Kàli, the goddess of destruction.

In view of the successive failures of the mediæval-ists, I advise the modern artist not to try to fashion the Christian "God"; but if he will, he must incarnate divine attributes into a personality which best befits infinite power, wisdom, and love. How can art personify Omnipresence and Omniscience? The mere presence of the human type, however elevated, suggests the limitations of time, space, thought, and force, if not goodness. Whenever art soars into supernal spheres, although its motive may lift it far above all human standard, still its capacity of material representation is confined to its

The Christian God.

own mundane basis of matter and knowledge. Hence the divinities of all races are so many measures of the intellectual and moral powers of those who depict them and express the limitations of their minds as well as hands. In

The divinities of all races are the measures of their moral and æsthetic limitations.

their best estate they are humanly created effigies of the highest types of men and women which their makers can conceive as embodying their supreme notions of truth, beauty, durability and strength, and which they hold in profoundest esteem or dread. As humanity advances its ideal of divine goodness and perfection, so its standard of extremest evil or devil-dom recedes from its primitive hideous apprehension of the same, and the monstrous forms which express its hopes or fears become less repulsive and disgusting, until at last they terminate in the gentleman demon of our time, with hoofs and horns, very pleasantly disguised by the immaculate cut of his tailor

The Christian devil.

and the consummate suavity of his manners, borrowed from the life of the modern fashionable world. The Greeks were too æsthetically sensitive ever to let their art invent a devil. Devout pantheists are perhaps the most rational as well as poetical of worshippers. Seeing a divine idea and image in every phenomenon, they are inclined to give the benefit of their doubts and their ignorance of the machinery by which nature works, to a beneficent rather than a harmful design, or at most to limit the powers of evil almost to the par of man's own forces, each individual constructing his devil as well as his god according to his own idiosyncracies of mind and matter. Even in the grossest idolatries there is a flickering light for the darkened soul to guide it toward something better. More progress could have been

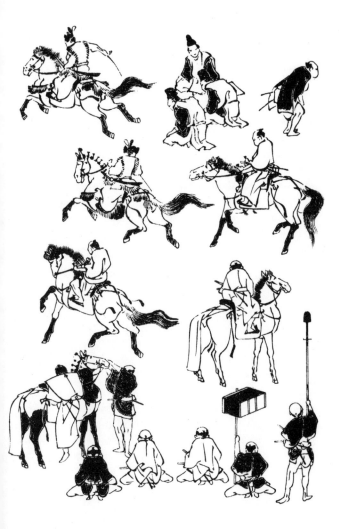

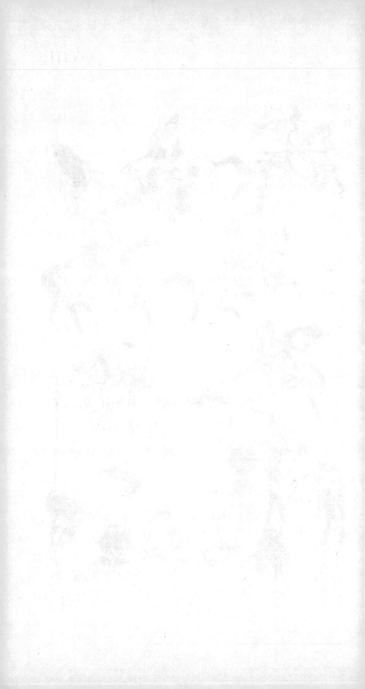

made by mankind as a whole, had the Christian sects, instead of putting the knife at each other's throats and those of paganism, sought out what was really sound in aim or principle in their neighbor's creeds, and thus made religion a universal, conservative, yet progressive force in civilization, instead of a jealous, destructive, doctrinal fiend. The Jewish idea of a Jehovah, out of which has sprung the common Christian notion of a supreme divine personality, has little beside his abstract unity of being and infinite power to recommend him to an enlightened religious sentiment. Too many, by far, of his acts and attributes partake of human weakness and passion, and these have left their taint on the image of his successor as popularly conceived, although in the aggregate there is a loftier idea of justice, benevolence, and might, and possibly fatherhood. When opinions clash, those which embody the least truth will of their own accord go to the wall if not persecuted. There is more modesty in error than would seem. We are too apt first to make it rampant before trying polite persuasion, or leaving it to its own ways of conversion. The Hawaiians destroyed all their idols and publicly renounced their own faith before a single missionary came nigh them, and this because of a few years' peaceful intercourse with a score of unproselyting traders. Let us be sure that we have something superior to new fetiches to exchange for old ones, before cauterizing any issue of belief, however fetid it may be to our nostrils. Christianity, as it has been organized, is as much on trial as regards its beneficial influence on humanity, as paganism in any form. All religions will have to live or die by their own merits as men grow sufficiently

[marginal note:] Jewish Jehovah.

enlightened to leave them in peace to their own vital resources.

Scientists are not wholly without a fetichism and bigotry of their own breeding. Denouncing

*The fetich-
ism of
science.* all religious faith and symbolism as untenable in the light of human reason and scientific fact, they yet claim for elusive matter a position in the psychological development of our species equal in importance to what the religionists do for their intuitions or revelations. Even could they actually seize and bottle up the original, conscious, evolving atom of creation and crown it " Lord of All," should we be any nearer a solution of the soul's birth and destiny than we find ourselves in the visions of the ecstatic saint or the babblings of the vaguest "medium"? The logical thinker puts all experiment and faith on an equal basis of toleration, be its guise art, science, or religion. Every creed, rite, philosophy, or art, is to him a way of confessing and searching for the Infinite, each having its appropriate use, phase, and term of being, and all are means to one end. Why, then, quarrel and provoke hostility instead of seeking to get at in each its legitimate kernel of right and truth? Even the numerous posers in science and religion, living solely in the outward fact or thought, are but awaiting their turn to receive the spiritual idea which will free them from their slavery to abstract Form or absolute Substance. Possibly Fact and Idea, whether as art or religion may yet become the unit of Truth. It is a favorable symptom of our

*Occult prob-
lems of life.* century, that there is increase of mental activity and toleration as regards all the occult problems of life. We are drawing nearer a better era, I trust. For my own part, I have no sincerer desire

than to promote such appreciation, both of Christian
and pagan art, as shall hasten the coming of the long-
promised but much deferred, — but let us keep in
mind, — solely by our own acts, " peace and good will
to all men."

The highest use to which the art of the Orient has
ever put the human figure is very happily
exemplified in the statue of Daïboudhs at
Kama Koura, in Japan, more than six cen-
turies old ; a bronze effigy of Buddha sixty

*The highest
use oriental
art makes of
the human
figure.*

feet in height, sitting with his knees doubled beneath
him on the customary lotus flower, forming a colossal
statuesque whole of severe grandeur, and even maj-
esty, combined with extreme simplicity of appearance
and treatment. The great Hindoo reformer is enjoy-
ing his nirvana or the ecstatic disregard of outward
things which he held out to his disciples as their final
compensation for various probatory reincarnations on
the earth and having extirpated every feeling which
unites the heart to the world and its fleeting pleasures
and illusive hopes. Absorbed in the Eternal Soul,
and forming an integral part of it, yet according to
some believers conserving a complete individuality,
whilst others hold to its entire loss, in either case
the soul no longer suffers changes or modifications of
its everlasting beatitude. Christian art presents no
motives equally abstract and destructive to all the
common forms of human self-consciousness. In every
example we find absolute individuality, active or
passive, but positive of some degree. But in Daï-
boudhs there was to portray a human face reflecting
a sentient soul absorbed in its own impassive bliss,
having attained to all knowledge, yet disclosing none
of it, baffling all inquiry into the unknown, and

promising as consolation for all personal ills a like
impersonal happiness, or else an absolute annihilation,
just according to the interpretation each believer gave
to this spiritual riddle. The artist has met with no
common success in dealing with so mystical an idea.
Retaining the general characteristics of the human
model, largely and majestically conceived, he has con-
structed this gigantic statue, which, while suggesting
man, inspires less awe from its massive severity of
form than its inscrutable calm and measureless dis-
tance from mundane interests and cares. Whether
as an immense idol for the unlettered, or an eloquent
symbol for the cultivated, it is wonderfully impres-
sive. Long wave-like ripples of drapery flow over its
shore-like limbs ; a head-dress of shells forms an effect-
ive ornament, whilst the broad contours and masses,
and the unspeakable repose and benediction which
illumines its every feature, each and all harmoniously
unite into a stupendous image of intensified enigma.
A people who could thus embody the most elusive of
metaphysical mysteries must have had an exceedingly
lofty conception of the capacities of art.

Various expressions are given to the Buddhas, but
all reflecting this supreme repose and joy in
nirvana as the finality of many wearisome
incarnations in flesh, undergone to attain thorough
purity of soul by personally overcoming every earthly
passion and weakness. It is at once seen that the
oriental sculptor, in obedience to his abstract motive,
was obliged virtually to reverse the practice of his
Grecian brother. He tried to make men god-like on
the physical and intellectual plane of the well-under-
stood human constitution. The former proposed to
himself the more arduous task of sinking both into

The various
Buddhas

an abstract spiritualization, negativing all merely human faculties and ambitions and creating an ideal form which should suggest a consummate, perfected bliss, destitute of every earthly taint or reminder. The ascetic, Christian doctrine hinged its chief art-motive on the vicarious sacrifice of one man, or god-man, for all, and consequently he was ever to be represented as a suffering mortal under-going a death of slow torture, not for himself, but for others. But Christian art always confined itself to the narrower scope of making the crucifixion either a conventional symbol of faith or a painful piece of realism. Its central idea of a divine atonement could not be positively represented by art, because it was an abstract formula of creed the moral effect of which was made largely and mainly to depend on skillfully depicted human agony, whilst the reason for so unparalleled a self-sacrifice had to be laboriously taught as a profound religious mystery. The office of art regarding this doctrine was therefore a simple and direct realistic spectacle, and as such was nar-rower and less æsthetic than that which art had to do to interpret even the classical mythology, and was still further removed from the almost impossible mys-ticism of the nirvana. Here the sculptor, although compelled to make use of the human form to symbol-ize the motive of personal sacrifices and tribulations through various incarnations in order to arrive at per-fect individual bliss, or final absorption into the un-speakable joy of the source of all good, must subordi-nate all those artistic human details which, perfectly given, made the chief merit of Christian and classical art, to the broad, mystical, central idea, purely spirit-ual in conception and imagery. Consequently, he had

Christ as an art-motive.

to stop just short of their respective successes and make his abstract motive triumph over his visible matter. Whether he did this by force of æsthetic logic, or sheer instinct begotten of his contemplative faith, his sagacity has piloted him to a rare success, and he has developed a species of serene mystical beauty in sculpture on a sufficient human foundation of figure as to command our æsthetic sympathies and admiration, while suggesting to our souls the supernal attributes of an immortal being to spring from the perishable elements of the present life.

There is no direct school of the nude in Japan, or apparent love of it in their art. In common life their customs afforded them every facility for its study, were they inclined, either in vigorous action or complete repose. Indeed, so far as it ever became necessary to use the more or less naked figure, they did so with entire accuracy of movement or position, and as extraordinary a realistic vigor of pencil or outline modeling as disregard of the lesser anatomical details, showing that their observation was masterly just so far as they permitted it to go, and if they stopped at certain points we consider essential to complete design, it was in obedience to their own æsthetic rules and not their inability to acquire or practice ours. Shintôism, undoubtedly, as primitively taught, was unfavorable to sculpture, and perhaps painting, for it had few or no images, and limited its sacred colors to red and white. Buddhism, on the contrary, like Romanism, was a nursery of art. Its army of saints, list of myths, traditions, symbols and love of decoration and appeal to the sensuous side of human nature, were quite on a par with those of its eastern rival.

The school of the nude in Japan.

Shintôism unfavorable, Buddhism favorable to art.

But deeper rooted than even their religions in their minds, there seems to be an instinct which inclines the race to indifference as regards the nude and physically beautiful, and a profound disposition for the representations of strong emotions, active or passive; an ecstacy of the sentiments, sweet or caustic, melancholy, the passions, such as fright, anger, hatred, surprise, jealousy, above all boisterous gayety, extravagant humors, and practical jokes, and rarely the tender, sentimental, pathetic, or what we should call the strictly heroic. Theirs is a free pencil, seizing on its topic without other regard than to make the ruling point. Nakedness in the laboring classes suggests no immodesty any more than the limbs of animals. Oriental costumes of the richer classes are more chaste in style than similar fashions in Europe. Indeed, in all the sensual seductions of dress and calculated exposures of person, the European lady is far more an adept than her Japanese sister. From time immemorial the fashions have remained unchanged. There were rigidly prescribed costumes for virgins, matrons, and courtesans. The garments of the women differed not very much from those of the men. Both were made of narrow pieces of stuff, sewed at the edges, and falling straight from the shoulders without any attempt to closely adjust them to the figure. During the cold season several were worn, one over the other. Hence there could be no elegant flow of drapery and sensuous display of charms. When in full dress the great ladies of Japan, unlike those of Europe, are over much rather than under-clad. They bury their beautiful contours in heavy, angular, sharply adhering and long trailing, rich stuffs, forming cumbrous

Costumes of both sexes and various ranks of people.

masses of decorously elegant but awkward clothing,
necessitating a clumsy gait and restrained move-
ments. Imperial etiquette required the gentlemen
who came to court to trail beneath their feet long
robes, or trousers, which made them appear as if ap-
proaching the Mikado's presence on their knees.

Both sexes of rank being so over-costumed, it is
easy to perceive why the artists, in rendering the life
of their country, are so skillful in representing its
gorgeous, heavy habiliments, and the general action
the wearers, without any taste for the libertinage of
dress so common in Europe. At the same time their
native standard of modesty, free of any corrupt desire,
admits in their pictorial literature a liberal exhibition
of family life and scenes at the toilette which we re-
pudiate in ours. During the hot season when the

Japanese
ideas of
modesty.

mat or paper screens of the houses are put
aside, a passer often sees respectable women
at their avocations or ablutions naked to the
waist, whilst the men of the household, lolling on the
floors, are bare to their loin-cloth, just as was the
universal fashion in Polynesia a score or two of years
since. A Japanese gentleman, so says Mr. Mitford,
author of the delightful " Tales of Old Japan," on be-
ing told that Europeans considered it indecent for
men and women to wash together, observed, " but
these Westerns have such prurient minds." He
might have added, also, that after they were washed,
men and women were allowed in our balls to mingle
freely together, scarcely more clad as regards the
latter sex, than when at their toilettes, and certainly
with greater libidinous provocation. A Japanese does
not associate sensuality with nudity as we do. In the
earlier stage of European intercourse this compliment,

I am told, has been paid by a high Japanese functionary to the wife of a foreign official at a festival: "How handsome you are; I should like to see you naked;" as if speaking of a statue.

The hidden or obtruded, but studied sensualisms of our schools of art, perhaps I should confine this remark to the French, as a whole, have no counterpart in the Japanese. Obscenity and libidinousness proper having no fictitious disguises are relegated to their own vile haunts, instead of being paraded in conspicuous places. Nevertheless, there is a freedom of dramatic representation arising from the positive realistic standard of common life, which would not be permitted anywhere in Europe. Deities, heroes, and ladies are, however, always overwhelmed with clothing, not from ideas of propriety, but to give them dignity. The design, coloring and arrangement of drapery, therefore, becomes a very important study, and doubtless to the detriment in general of the figure proper. We find in the best wooden or bronze statues, however, uncommon ability in posing and modeling, a profound respect for idealization of the particular motive after its kind, wonderful technical skill, and a truthful appreciation of nature, both as to action and sentiment, mingled with a strong disposition for the laughable, grotesque, bizarre, and even for contortion and exaggerated muscular efforts, but always uniting opposites, as for instance the laughable and terrible, in the most natural and artistic manner, and with a perfect simplicity of free and apparently easy execution. The chief effort is to make the motive tell its tale in the most direct, emphatic manner, with the smallest display of technical labor

The dignity of clothing, etc.

Character and skill as shown in sculpture.

and means. The key-note to most of their composi-

tions is found in an occult imagination more prone to jest than fear, largely tempered too by unbelief, or perhaps such a thorough be-lief as to make the unnatural and frightful seem like the familiar things of the household, and beings that we should look at as uncanny and unclean appear as very good fellows with better hearts than shapes. At all events, their art has given birth to a prolific imagery, either of horrible or ludicrous aspects, seldom rising above the burlesque to the comely in looks. I fancy its singular personifications of natural phe-nomena must have grown out of the slow corruptions of the original Shintôism, as they seem to be, however individualistic in character and form, representations of ideas and facts of nature rather than of absolute divinities or even demons. Let us look at some of them, especially the best favored and most liked in the people's households. For in Japan now, as in

Europe, skepticism in all religious matters is the rule among the higher and erudite classes, who incline to view all religion, in general, either as a sentiment created by man merely to min-ister to false hopes, or as a means to placate and keep the lower classes in serviceable subjection to the state and their superiors.

The favorite of the seven chief household deities

is named Ben-zai-ten-njo, and she is both beautiful and virtuous ; not like our Venus, simply a lovely, physical type of female charms, but an accomplished, decorously clad matron, somewhat pensive and sentimental, and usually represented as sitting or standing by the sea-shore playing an accompaniment to the music of

the waves on a quaint instrument of her own invention. Quamon, queen of heaven, similarly appareled and of great dignity of deportment, is too much absorbed in her own beatitude to be much alive to the cares of mortality. Indeed, both these celestial ladies in their highest functions appear to be types of certain conditions of mind produced by their states of nirvana rather than active agents in promoting human welfare. They serve to indicate the " rewards of merit " of a contemplative, religious mind, such as oriental mysticism engenders.

Ordinarily a sect takes its creeds and rites as they are made for it by the priestly authority, and confines its belief or discussions within the ecclesiastical boundaries fixed for and not by its members. Independent thought almost invariably leads to direct persecution and its extinction in those countries where Romanism is supreme. But in Japan, as we have seen, there seems to have been room from the first for the growth of different religious ideas and forms without coming to loggerheads. Indeed, before Romanism intruded itself, the various sects got on together as one " happy family " in this " land of Great Peace." The admission to the people of the right of creating at their own sovereign will fresh types of divinities as the older lost significance, shows great ecclesiastical shrewdness and liberality in the dominating sects unexampled elsewhere, except perhaps in philosophical China, and a steadfast desire in all to seek out and adore under forms the most significant to their minds the unknown God of all men. Those tangible effigies into which the popular mind incarnated the deities elected by its own free suffrage most interest me, for they represent its notions of well-being and hopes as apart from the

dogmas and laws of church and state. The popu-
lace voluntarily placed themselves in charge
of a family of ex-officio divinities, who de-
voted themselves to the people's immediate
welfare without any threats or promises as
regards the future life, or the costly and dubious inter-
vention of a priestly caste. Especially the attention
given to things terrestrial, and particularly the press-
ing needs of the hour, must have made them im-
mensely popular, and contributed greatly to the gen-
eral contentment and happiness of the poorest classes,
whose benefactors they chiefly were. For their prac-
tical teachings and the faith reposed in their good
works, even if emanating wholly from the imagina-
tion, were very comforting and quite foreign to the
spirit of Christian asceticism which seeks to console
humanity for present suffering by the promise of re-
ward in an unknown life to come, and indeed to make
its degree of joy depend on the amount of sorrow or
deprivation voluntarily undergone in the flesh. If
the Japanese sentiment be too exclusively based on
the materiality of life, at least it shows a wholesome
disposition to try to make the best of the present and
to be cheery and trustful under all circumstances.

What more wholesome fruit can any faith grow out
of the soil of every-day practical life? " Give us this
day our daily bread," epitomizes its idea. The super-
stition it stimulated was certainly not more harmful
than its kin of other religions, whilst it had the par-
ticular merit of being conducive to good will all
round, and calling for no tithes, proselytism, persecu-
tion, or a potent priesthood. Born of the people's
religious instincts, each family could set up its own
altar and cultivate its own rites without external in-

*The people's
deities as
elected or
revealed of
themselves.*

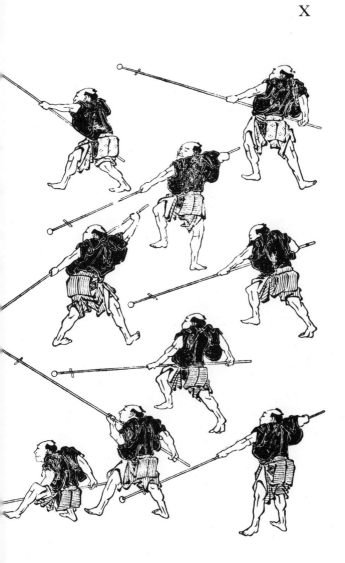

terference. There were always open to it besides, the established temples and their wider ranges of beliefs and ceremonies. But judging from the evidence of art, the untutored devotion of individual hearts was more abundantly bestowed on the seven household guardians of the inhabitants at large. Believing firmly in them, it was facile for minds mystically inclined to lapse into notions of witchcraft, and even sorcery. They fancied all animate and inanimate things, as well as men, were liable to be obsessed by spirits which were capable also of assuming unnatural shapes to accomplish their spells. But these spirits were not always mischievous. Indeed, they most commonly boded good to those who wished them no harm. This idea alone was equivalent to a well-organized society for the protection of the lower creation. It was further fortified by the impression that there exists a spiritual relationship between men and all other organized forms of life, not to mention manufactured articles used by spirits as temporary abodes by permission of higher powers, to tempt, reward, or punish individuals as each case demanded. Thus all nature, art, and humanity, were united in one great moral tie, beneficent to the good, retributory to the evil. Indeed these Gentiles possessed a disciplinary law unto themselves as efficacious on its own lower ethical standard as any " Thirty-nine Articles," or Vatican Infallibilities, to ourselves. The same minds that believed weapons might be infested by evil spirits, also believed that the chief duty of a sword was to protect the good, punish the wicked, and to establish tranquillity, — a lofty principle which, once adopted by all governments, would speedily end wars.

Spirits, good and bad, in art.

Let us see how tender a heathen conscience some-

Yoshiaki, the famous sword-maker. times becomes. Mitford tells us that a certain Kusano Yoshiaki, who lived opposite him at Osaka, was a swordsman, and most intelligent and amiable gentleman. His idea was, that having been bred up to a calling which trades in life and death, he was bound, so far as in him lay, to atone for this by seeking to alleviate the suffering which is in the world; and he carried out this principle to the extent of impoverishing himself. No neighbor ever appealed to him in vain for help in tending the sick or in burying the dead. No beggar or leper was ever turned from his door without receiving some mark of his bounty. Nor was his scrupulous honesty less remarkable than his charity. Whilst other smiths were in the habit of receiving large sums by counterfeiting the marks of famous makers of antiquity, he never turned out a weapon which bore any other mark than his own. Without knowing it, Yoshiaki was a sound Christian. There are also many Christians who are very bad pagans and never once suspect it.

The chief business of the domestic divinities is to

Business of the domestic deities. procure for men, — shall we add unregenerate — the gifts they most prize, such as length of days, food, riches, talents, fame, love, and contentment; though possessing the others the last would seem superfluous; but the household gods, evidently from much experience of humanity, knew better. However much the first six smack of earthly ambitions, the Japanese do yearn for them with a sincerity and openness calculated to mollify the strictest minded of their family deities, who, it would appear, are never tormented with our whip-the-devil-

round-the-stump modes of supplication for the same good things of life. A Japanese sees no impropriety in asking his divinity to give him a lucky number in a lottery, or to help him in his business or amours, without any of the specious bribery or persuasion which characterizes European prayers of a similar strain to saints and madonnas. Too naïve a child of nature for any subterfuge, he goes directly to his aim with greatest plainness of speech ; but is not very greedy as regards his spirit benefactors. An amount of good fortune sufficient to satisfy one Anglo-Saxon's wishes would suffice a whole village of Orientals.

My pet deity is the amphibious Yèbis, provider of daily food, a jovial marine demon, com- *Yèbis, the provider of daily food, etc.* monly seen with a gigantic craw-fish as his head-gear, sea-weed for waist drapery, and spindle legs of agile tenuity, ending in crispy claws. As he slips along on the back of a fiend-like dolphin, performing a nautical fandango whilst holding out his gifts, there is a droll mixture of benevolence and jocoseness in his lumpy countenance, and his bright eyes sparkle with vulgar fun and robust life. Before me an antique bronze Yèbis is caracoling on the back of a monster fish, the ocean scud flying over both of them, with the rollicking waves keeping time to their movements, and all done with such flexibility and fineness of modeling and vitality of spirit as to make it not only a masterpiece of art in every respect, but a most fitting type of the good fisherman's genial caterer and protector.

The Japanese are very shrewd in the ethical distinctions of their deities. Hoteï is the pat- *Hoteï, the deity of contentment in poverty.* ron god of contentment, not in riches, which they know cannot be, but in poverty ; so

they leave the wealthy and famous to their own moral
and material resources, and reserve the pure senti-
ment for those who have nothing else to rely on for
their daily happiness. A dreamy, yawning, obese
vagabond is Hoteï, of the Diogenes pattern, minus his
sham philosophy and shameless egoism, but equally
liking to bask in sunshine ; just the tramp to invite
the attentions of a village constable in New England
as having no ostensible means of livelihood. He is
a prodigious favorite with country-folk, particularly
children, to whom, as he lazes away his time in some
picturesque spot, he tells pleasant tales, brings little
gifts, allows them to play him tricks and scramble
over his fat body as he takes his noon-tide naps, or
edifies them with stories of the magnificence of the
heavens, the stars, and whatever in nature or life will
most amuse or excite their youthful imaginations.

Daïkokou's person, the god of riches, is squat and
burly. He is as amply costumed as a daimio
of the old pattern, half sunk in immense
boots, and covered by a huge sack contain-
ing his treasures. Generally he is seen sitting on
bales of merchandise tied with strings of pearls,
always carrying a miner's hammer, and with a char-
acteristic touch of humor, has for attribute the special
enemy of property, the rat. In the make-up of nearly
all the gods there is an element of satiric humor which
puzzles one to understand precisely how seriously their
functions are regarded. The wit is sure to be intelli-
gible if the moral be puzzling.

Daïkokou,
god of
riches.

Longevity, as embodied in the person of the vener-
able and much venerated Shiou-Rô, appar-
ently is considered too desirable a gift ever
to be made the subject of a religious pun or

Shiou-Rô,
the god of
longevity.

joke. He is taken altogether very seriously, as he deserves to be if his favors are to be won. His benign, handsome countenance, with a snow-white beard falling below his waist, is topped by a cranium that rises enormously above his eyebrows, giving immense scope to his moral and intellectual organs, and withal so well managed as to seem quite natural and comely. This abnormal expanse of brain is caused by his continually reflecting how he can best promote human happiness. We find him frequently in pictures, in bronze, terra-cotta, and other substances, always delineated with scrupulous respect, and looking like a very lovable old patriarch of antediluvian length of years. Indeed, he is fabled to have remained in the womb of his mother sixty years or more whilst maturing for his human destiny. The most artistic effigy I have seen of him is made out of a solid bit of ivory, slightly tinted in the draperies and exquisitely carved. His sympathetic figure is sumptuously robed, and his face beams with benevolence and self-satisfaction in his honors and years, as he leans on his inseparable crook, attended by a snow-white, aged stork, likewise the image and symbol of the serenest old age, and which nestles affectionately at his side. The tortoise is another of his attributes.

Tossi-Tokû, god of talents, is no youth either. He dresses like a learned doctor, is of most grave aspect, with an extravagantly elevated skull, enlarged by perpetual meditation. Like Shiou-Rô, he is also a perpetual wanderer, distributing knowledge as he travels, likewise carrying a crook on which he suspends his palm-leaf fans and manuscripts. As a companion, he takes along a pet fawn.

Tossi-Tokû, patron of talents.

The god of glory rejoices in the significant name of
Bis-ja-mon. He is a stalwart figure in golden

Bis-ja-mon,
the god of
glory. armor; but, be it told to the credit of the
good sense of the populace, counts for least
among their most sacred and beloved seven. Pos-
sessing the substantial goods of life, although admit-
ting an effigy of martial fame into their list of de-
sirable things, the people do not seem inclined to
overmuch esteem this divinity or exaggerate his func-
tions. Probably, as elsewhere, their share in his
worship was more in hard knocks than in substantial
loot of any sort, or even flattering words; and they
were shrewd enough to find it out and accept martial
fame at its true worth.

There would seem to be two sides of character to
several of the deities, as well as at times an admix-
ture of functions, doubtless originating in the funda-
mental differences between the two chief religions
and their mutual reactions and intermixings. I have
already spoken of Ben-zai-ten-njo in her more abstract

Ben-zai-ten-
njo, as Ben-
ten, the peo-
ple's type of
highest
womanhood. and lofty significance, perhaps as adopted
and interpreted by the orthodox Buddhists.
In the popular fancy, however, she assumes a
still more winning, though homelier appear-
ance, under the familiar appellation of Benten. This
appears to be her more practical domestic aspect as
untinged by the mysticisms of nirvana, or made too
transcendental for the common mind. Without a
knowledge of Japanese literature one must be chiefly
governed in his interpretations of these objects by the
indications given by art, which, if indefinite as to dates
and dogmas, is not the less a tolerably clear exponent
of the current ideas and sentiments of the people at
large. It has been seen that Ben-zai-ten-njo is not a

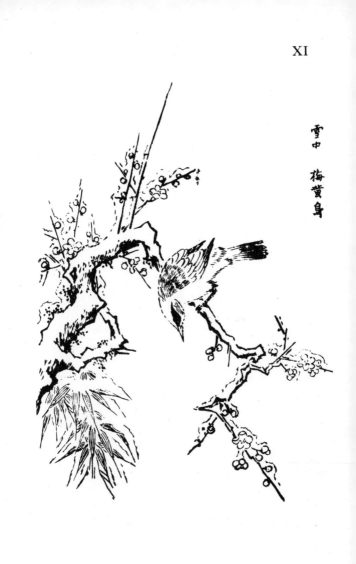

雪中 梅黄鳥

prototype of the amorous Aryan Venus, inciting men and women to physical love, and breeding scandal and mischief in Olympian society. On the contrary, she is ingenious and accomplished ; for it was she who invented the lute, and she ever delights in poetical reveries on moonlit shores with the silver-tipped waves caressing her tiny feet. Mature are her charms and wisdom ; a ripe, full-bloomed, sapient dame, respectable and sympathetic in every sense ; at least such is one of her many roles. As Benten, we see her equally good and handsome, but performing a more motherly and housewifely part to the edification of all good matrons and housekeepers ; a model parent, and perfect example of domestic and civil virtues. Hear this, all ye teachers of women's rights, and set up Benten for your typical female and patron ! Where will you find a more complete one, necessarily beloved by all true men and adored of fathers and sons. Surely not in the Roman virgin-madonna, chastely-lovely though she be as she sits in her spiritual panoply with her divine child in mystic repose on her knees. She is far too impassive and inefficient to stand as a practical type of her sex in these days of scientific pessimism and positive philosophy. No ! Benten is our ideal woman. Listen to her full credentials. Handsome, virtuous, learned, accomplished, benevolent, witty, poetical, yet thoroughly practiced in motherly and wifely duties ; and what more is needful to an Anglo-American madonna, unless it be wealth and social position, of which in Benten's case I find no definite record. The Roman madonna, indeed, comes of the royal line of David, and has the indispensable inoculation of blue blood. But with Benten I fear there is no first family lineage to fall back upon. So she will have to accept

such consideration as her own beauty and virtue may win, while for riches she has only to show a splendid set of " Cornelia's jewels," of which, maybe, some of my female readers will declare she has an excess.

Benten is prolific, I confess. She has fifteen sons, Benten's all of whom, save one, are well educated and sons. trained to follow either a useful occupation or a learned profession. The first is an author, another is an office-holder; still another a metal-founder, a banker, a farmer, a merchant, a tailor, a silk-grower, a brewer, a clergyman, a doctor, an expressman, a breeder of animals, and lastly, a baker; only the fifteenth son has no profession. Possibly he is the " spoilt child," or the " black sheep," which, like mistakes, will creep into the best of families to their utter vexation. But, shade of mother Eve, what a family this of Benten! Only one fifteenth part dubious, or a domestic failure! Perhaps he was simply a curb-stone or club idler; a sort of foil to the industrious and thrifty ones, just to prove there was nothing really supernatural in the paternal blood; his brothers' industry and thrift paying for his fine feathers and fine manners, while he, disdaining toil and toilers alike, and all utilities whatsoever, feels compelled by his own ideas of nobility to draw the lines fixedly somewhere between all plebeian virtues whatsoever and his own sovereign patent of an aristocratic uselessness.

Be this as it may, fourteen serviceable citizens given the state, and an ornamental one thrown in as loose change, are as good credentials of sound womanhood and as strong arguments for its rights as we can conceive. The Japanese are right in honoring Ben-

ten as the best type of her sex. They do more. She is worshipped on a far higher plane as the fecund principle of virtue and benefaction, personifying the nourishing ocean that protects, feeds, and enriches, and also glorifies *Benten, as the fecund mother and provider, Queen of Heaven.* the great empire of the far Eastern Seas. In this shape the Japanese encircle her beautiful brow with a divine aureola, crown her head with an imperial diadem, and clothe her in magnificent robes. Under any of her forms, however, there is none of the mystical, illogical, and undesirable virginity attributed to the Roman ideal woman. Benten is always the *mother*, the fecund generator, provider, educator ; a substantial benefactor and producer of mankind, and completest embodiment of the virtues and deeds most useful and pleasurable to men. As attributes of the extreme range of her functions and accomplishments, she holds a *latch-key* in one hand and a matchless pearl in the other. In her loftiest mythological aspects she becomes the dual incarnation of the supreme powers of nature and humanity ; the veritable god-mother of Japan, on whose head burn three celestial flames ; the queen of all the delights and refinements of human existence, having eight hands all busy in good works. Does not this energetic, cultivated, large-hearted Benten, make a better figure in mythology than the impossible, uninstructed Jewish maid, Mary, however amiable and pure ? With all respect for the limited Roman conception, to my mind it is inferior as a practical example in life, or as an invented queen of heaven to the larger Japanese thought. Under both aspects, Benten is a charming and poetical offspring of the religious sentiment of these islanders, as original as she is

simple and natural, and yet endowed with sufficient
mystery of symbolism to take a deep spiritual hold
of the understanding. Her profoundest attributes
are so tempered by earthly wisdom and experience,
whilst her affections and emotions are so swayed by
kindred causes, that her all-comprehending being be-
comes intelligible and edifying to all classes, and theo-
logically offensive to none.

Notwithstanding their highest celestial attributes,
Household
deities in
their lowli-
est aspects. our Japanese friends will crack broad jokes
even with the supreme divinities, caricature
them, or perhaps we should say travesty
their functions. Oftentimes they represent them as
strolling actors meeting with ridiculous adventures,
or performing unseemly feats. Tossi-Tôku is worth
a dozen of Saint Nicholas for amusing children on
these occasions. Benten does not disdain to sing to
chance audiences like any roving troubador. When
benevolently inclined she sews for the poor as actively
as a Dorcas society. All of them get up picnics to-
gether, play games, make fun, and do whatever else
a decorous-minded Japanese permits himself to do
within his social limits, either for his own amuse-
ment or to please his neighbors. If there be less of
the grand style in the deportment of this circle of
jovial divinities than is current among the denizens
of Olympus, there is a higher standard of morals,
and greater real usefulness, than is found among most
ascetic saints of any calendar, if spiced with less per-
sonal sacrifice. These household gods of Japan may
well put to blush the classical deities of Greece as
salutary examples of daily life. How can a poor
man murmur at his lot in face of the merry, tutelary
Yêbis, no richer than himself, yet ever ready to do a

kind act and help him keep up a cheery heart. Does not the philosophical Hoteï live like the meanest peasant, his sole property a big wallet, a fan, and a knife, with but scant raiment! Each one has some pertinent counsel or gift for the toilers of the earth. None incite to envy, malice, sensuality, or theft, but all strive to lighten burdens and strew flowers in their paths. Doubtless very pagan and material, all this; but where do we find in other religions impersonifications of less reprehensible qualities, or more directly useful and encouraging? In a certain measure they are a homely, artistic expression of the spirit of the "Sermon on the Mount;" the bread of life put into the vernacular symbolism of a people yet in the infancy of their intellectual development. A race which invented so guileless a mythology and conceived a religion so abstractly spiritual as the Shintô, must have had an innate consciousness of the Supreme, such as no art could effectively portray, and which as effectively barred any attempt to image the divine essence itself, as any law of Moses or Mohammed. At the same time their familiar associations with its attributes, as delegated to inferior agencies not wholly dissimilar to man himself, were a lively incentive to art.

The Chinese have possessed from time immemorial a numerous family of divinities of similar import, some of whom appear to be identical with the Japanese, and are treated in their art in very much the same style. Among those most commonly represented in pottery, particularly, we find *Cheou-lao*, our friend of longevity, who fills the role of supreme arbiter of earthly affairs, and regulates the seasons, carrying in his hand a leaf of the

Chinese family divinities.

fabulous *Fan-too* tree, which blossoms once in three thousand years and takes as long a time to ripen its fruit.

Konan-in is a gracious goddess of Buddhist derivation, veiled, and represents the generative and creative power ; evidently the prototype of Ben-zai-ten-njo, in her highest symbolical aspects.

Pou-tai stands for *Hoteï*, as the personification of Chinese materialistic ideas of contentment. He is grossly stout and vulgar, of a thoroughly sensualistic figure and features, with a swollen belly, twinkling, leering eyes, and a plethoric sack of the good things most coveted by his devotees to make them contented with their lives.

This list of coincidences might be indefinitely extended. Probably in the outset the Japanese got many of their notions of their household deities, as they did their art and literature, from their older, civilized neighbors, and adapted them to their own specific wants and temperaments, sometimes with a decided advantage to their general features and functions.

Besides their pantheon of general, irreproachable

The root axiom of Japanese art.

deities, the Japanese have invented scores of minor ones, demons after their kind, charged with special functions, and often very impish and of uncertain tempers. Hoffksai, the founder of the latest school of design, said to have been originated in the last century, — a school, as we shall see, of wonderful realistic force and humoristic character, — taught it was easier to invent new forms than to copy exactly what one sees in nature ; an axiom which seems to lie at the bottom of all the most original art of Japan.

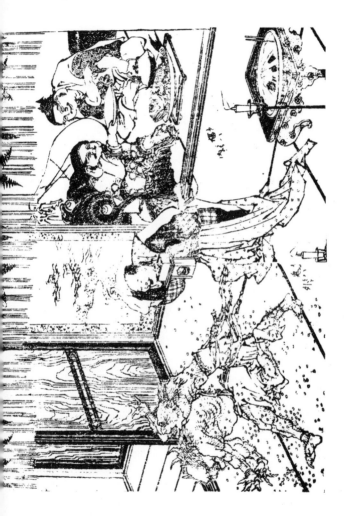

Another cause of its varied demonology and the passion for the fantastic and terrible can be traced to the peculiar features of a land- _{Demonology of Japan.} scape which abounds, not only in the picturesquely beautiful and grand, but in weird shapes and prolific suggestions of uncanny beings, grotesque and frightful, basking in their lairs of sea-girt, basaltic rocks, black and gloomy, pierced with caverns and tortuous channels into which the ocean surges with ominous shriek and roar, and glistens in the hot sunlight, or pales and trembles before the moon's cold rays; or else as peering from out of dense forest shades and entangled masses of vegetation at the imaginative traveller, and as actually taking possession of natural objects, and by their foul spells endowing them with fiendish life. Thus it has been brought about that Japan early became a land of romance and mystery to its own inhabitants, — all the stronger because of their isolation from other peoples; which romance and mystery begot a prolific legendary literature that fed their native, psychological bias by what itself grew upon. This state of mind was in no ways weakened by the prevailing religious ideas. Indeed, they confirmed and strengthened it, and caused it at times to degenerate into exorcisms, magic, and extravagant superstitions. Their most skillful jugglery, in all departments of which they excel, is deeply rooted in the love of the pantheistic marvelous, particularly on its ludicrous or horrible sides, and takes its quaintest forms in forcible contrasts and subtle antagonisms of emotions. Spiritism, or the evocation of the dead by professional mediums or diviners, is also common.

The fiercest of the submarine monsters, lying in

the still depths of fathomless waters, is *Tats-maki*,
Tats-maki, the dragon of the typhoon, the most terri-
dragon of ble of demons. Its frightful jaws snap to-
the
typhoon. gether with a crash like thunder whenever
his horrid head, fury-lit eyes, and snake-like anten-
næ, floating amid surging masses of coarsest hair,
rise to the surface during the loudest howling of the
tornado, while its enormous green and ruby body and
long tail, crested with a gold-like flame, with claws
unclutched and threatening, mingles in the convulsive
heave of the wind-lashed ocean, and revels in the up-
roar of the elements: a fearfully magnificent image
of the destructive force of the most terrible of storms,
alike to the landsman and to the sailor.

Japanese fancy indulges in *bizarre* humor, with a
touch of caustic criticism on an occasion offering. It
transforms the sacred utensils of Buddhist temples —
vases, candlesticks, incense-burners, and images —
into diabolical flying imps, holding high festival un-
der the direction of rollicking devils. Again, in a
more sober spirit, we find it depicting the separation
of the soul from the body after death, heralded, as
the mediums declare, by a slight crackling noise.
Assuming its phantom life, it hovers awhile over its
own corpse, taking its general appearance and reflect-
ing its principal traits while living. A touch of the
ludicrous — which the Japanese artist never refrains
from when any opportunity is given — is often thrown
Ghosts. in, generally in the person of an affrighted
witness. Ghosts are not greater favorites in
Japan than elsewhere, even if more believed in. Some-
times a moral lesson is hinted, as in the shade of a
mother who has committed suicide, leaving an infant
destitute. She is made to haunt the spot of her crime,

bowed down with remorse, until she can find some one
to assume the charge which she wickedly abandoned.
Criminals are forced to hover in prolonged misery
about the scene of their execution, until relieved by
personal contrition and benevolent intervention.

We must not fail to discriminate the differences
which exist between all the forms of the in- Differences
digenous art and the motives and style of between the
indigenous
those imported from China and India. The and bor-
rowed art of
genuine Japanese are invariably character- Japan.
ized by vigorous and marked national traits, whether
of idea or execution. By turns it is strongly individ-
ualistic, idealistic, or naturalistic; intensely sincere
and local, varied and lively in fancy as in movement
and tint, borrowing less from its neighbors than it is
able to give back with large interest, but owing to its
insulated position exercising little influence outside of
its own border, at least until a few years ago, when it
attracted the attention of European artists and excited
the enthusiasm of foreign amateurs.

The great statue of Daïboudhs, and all sculpture
akin to it, borrow their motives and types from India.
There still exist in Ceylon and Java similar works of
an earlier date. Whatever there is of this style, it
owes its inspiration directly to Buddhism and is sim-
ply Chinese and Hindoo ideas put into the æsthetic
vernacular of Japan, more or less modified by the
translation, in general on the side of realistic strength
and masculine vigor. Even in its mystic and contem-
plative aspects there is a decided gain in intensity of
expression and feeling.

There is before me a striking picture which I take
to be the "Trial of a Soul" in Hades, the The "Trial
group consisting of six figures admirably of the Soul"
in Hades.

distributed and delineated. The judge of hell, seated
at a draped table on which is spread out the book
of law, is regarding with compassion the execution of
the sentence he has just pronounced on a wretched
mortal in the grasp of one fiend, while another is ad-
ministering the prescribed blows with swinging force.
His Good Genius, neglected in life, stands sorrowing
in the background, while the Evil One, having con-
summated his work, gloats over the frenzied agony
of his victim in close proximity to his prey. There
are no elements of supernal horror, such as are de-
picted in ordinary Christian pictures of this class. In
feeling and composition it recalls the Etruscan man-
ner of telling like tales of retribution in death, whilst
in design it is certainly above the average of that
art. Each figure is appropriately costumed, group-
ing and action are simple and serious, and the mean-
ing plain and suggestive. As a spectacle, it fittingly
represents the usual rapid forms of oriental justice,
except that the solemn gravity of the chief actors
announces that more than ordinary interests are at
stake. A noteworthy point is the contrast between
the grim satisfaction of the evil genius, who, with
uplifted hands, beats time to the avenging strokes
of the impish executioner, as if they were delicious
music to him, and the pitiful gaze of the stately
judge as he leans almost protectively toward the
writhing sufferer and clasps his hands in convulsive
sympathy.

There is another painting which haunts my imagi-
nation like an apocalyptic vision. It is done
in finest silk, mounted on ivory rollers, and is
about five feet long by two wide. The com-
position, combining as it does profoundest mysticism

A remark-
able paint-
ing.

with extreme simplicity of treatment and extraordinary grandeur of invention, fills the mind with a consciousness of the primeval spheres, when the world was formless and void. One hears, as it were, an elemental voice out of the night of ages; deep calling to deep, as the Divine Will bids light, and water, and land appear. There is an art that baffles description and defies analysis, its kingdom being over the soul, into which it enters as a spiritual tonic, electrifying our entire being with fresh currents of immortality. Unscientific and heathen although the conception of this composition may be, its mystic awe penetrates the soul, and suggests the symbolical presence of the Supreme.

I will briefly recount its features, even at the risk of making this confession of its power over me seem pure hyperbole. Let those who have eyes and ears only for sheer human uproar, or the whiffs of human vanity, deride and pass on. What will they see in the deep-drawn breaths of this illimitable ocean, whose vast storm-waves sweep onward before the cosmic hurricane in foaming hemispheres, until lost in the driving heaps of dark clouds that repeat their cosmic forms and mingle air and water in one vapory mass on the distant horizon? But look nearer! In the surging foreground there is seen abruptly arising out of the hell of waters a sharp, volcanic rock, edged with green, and over it the salt spray dashing its claw-like spurts. The sacred turtle of Japanese mythology, trailing behind its fabulous feathery appendage which forms a fan-like tail, has climbed out of the sea to its surface, and is looking upwards, into the sky, watching a spiral vapor or breath of so translucent a substance as to let the murky background of sullen

atmosphere, relieved above by a broad belt of gray, ominous light, be seen through its more ethereal matter. This mystical air-spout descends in a constantly diminishing column with a gyratory, spirit-like movement, to the mouth of the sacred turtle, from the beak of Tsouri-Sama, the holy lord, a gigantic crane, emblem of longevity and peace of soul. Its immense milk-white body sweeping downwards with majestic stroke of wing; its jet-black neck and head, topped by a crimson crest and curling gracefully toward the turtle on which its piercing eyes are fixed, with its equally black tail and legs thrown upwards in a magnificently conceived movement, balancing the similarly bold action of the enormous wings; these all make up a mysteriously grand figure in strong relief against a huge, blood-red orb, whose lower edge is buried in driving mists. A lurid glare, like that of the sun half shrouded in fog, gleams from the upper portion of the disk, while far above and extending into space on either side is seen the infinite empyrean. Does Milton's verse, —

> " Those who with mighty wings outspread
> Dove-like sat brooding o'er the dark abyss
> And made it pregnant, etc., " —

surpass this work of the artist's pencil? Were ever the stupendous creative forces of the universe more potently and beautifully symbolized? The purity, force, and subtle gradation of coloring throughout are quite on a par with the breadth and vigor of the drawing and originality of the entire thought.

Despite the pure theism and simple worship of their aboriginal faith, — perhaps owing to them and to their cosmopolitan facility of receiving new ideas, — the Japanese, with the imported Buddhism, accepted

many of its popular notions of a material hell and demonology, which, originating in Central Asia, finally leavened the current Christianity of Europe with their doctrinal horrors whilst infusing themselves more or less into all creeds with a frightful train of predicted woes to the unconverted and wicked of every race. Amongst them all hell became The worship of evil.
an appalling material fact. Sacred art was stimulated to invent the most direful imagery to bring the retributive dogma home to believers' hearts with an irresistible conviction of fear. This dread apotheosis of evil caused a more or less direct worship of the destructive forces of nature and the retributive action of offended moral law, symbolized in such hideous ways as only the affrighted imaginations and perverted understandings of untutored peoples could conceive. The Hindoos were the most conspicuous inventors of avenging deities, culminating in the worship Siva and of Siva. Our Satan is a mild and pleasant Satan.
gentleman in comparison with this being. But the Japanese mind, although scarcely less prone to occult symbolisms and mythology, was at bottom of a more healthy psychological temperament. In the breadth of its hospitality, if it did not really welcome the foreign effigies of a belief in the powers of evil, of whatever origin, it put no restrictions on them as beliefs, and left them to make their doctrinal conquests as they best could, provided they respected the state. It might have given unlimited license of proselytism to the subsequent Roman missionaries if no political propagandism had lain coiled within their creed. Heretofore, whenever the foreign religious element had come into contact with the native, the former had been largely shorn of its more objectional features as

regards the Japanese polity, and tempered anew by the
native pantheistic tendencies, which had nothing in
them hostile to the government. As we have seen,
the common people, in the general guileless, simple,
good-humored, fond of jesting, and equally fond of the
romantic and marvelous, had invented for themselves
not a family of great, aristocratic deities, lordly and
beautiful like the Grecian, or sternly and grandly
metaphysical and symbolical like the Egyptian, but
cosy, familiar ones, bone of their bone, flesh of their
flesh, embodying their own ideas of what well-inten-
tioned, good mannered, social, democratic gods should
be, especially those whose functions are to protect and
befriend poor men ; patrons with whom they can chat
and joke, even snub and be blandly forgiven, and who,
to their unlettered believers, served as an outlet for
their intuitive confidence in a supervising Providence
which they could define in no better manner. Hence,
too, their more realistic and grotesque than grand and
beautiful personifications of the natural phenomena of
their varied climate, which appealed to their minds as
outbursts of good or bad temper on the part of some-
what eccentric deities rather than as orderly effects of
physical laws. Forces which they neither could under-
stand nor control and which were prodigiously harmful
or terrible, like lightning or the typhoon, took quaint
and grim shapes in their fancies, similar to the imp of
the former and the dragon of the latter, or other su-
pernatural forms and hues that most vividly person-
ified their interpretations of the irresistible power of
the elements, or the mystic functions of purely imag-
inary beings.

The " Guardians of Heaven " are extremely cu-
rious creatures. They are of Michael Angelesque

size and muscle and action, with ferocious looks, —
gesticulate wildly, have circlets of tongue-
shaped flames issuing from their heads, and *The "Guardians of Heaven."*
bear a general resemblance to Etruscan fu-
ries, or door-keepers of hell. Japanese devils do not
seem to be the incarnate enemies of men, bent on de-
stroying their souls, like the orthodox Christian de-
mon. On the contrary, they have a marked prefer-
ence for playing tricks with their bodies, and getting
out of them while in the flesh all sorts of impish en-
tertainment. I refer to the aboriginal devils, not the
imported Buddhist varieties. The former roast their
victims by coarse jokes and pointed jeers, which is
better fun for them than to broil sinners on real coals
of fire in an eternal place of torment. Sometimes
the living men, by the aid of superior spirits, get the
better of these devils, and turn the laugh on their
teazers and frighteners. Psychologically, it is a sin-
gular recognition and treatment of evil in life, ac-
cepting it thus half seriously and half jocosely ; but
the spirit seems characteristic of the Japanese in
almost everything in their art. And yet in matters
of etiquette they are unsurpassed in gravity, suavity,
and elaborated, complicated ceremony.

I will cite a few examples of their materialized
imagery of the atmospherical phenomena, to illustrate
its character. We instinctively associate thunder
with the sublimity of resistless, elemental force, or,
the anger of an omnipotent creator, when the imagi-
nation alone deals with it. The Japanese see in it
a fantastic, hairy, distorted imp, of knotted joints
and twisted limbs, called Raïden, leaping *Raïden, imp of thunder.*
madly about, or turning somersaults in the
centre of a dark cloud, banging away with heavy

sticks at a wheel-like circle of thin drums, which he swings around his head, not altogether unsuggestive of the prolonged rattle and reverberation of the eléctrical fluid, but so pitifully a droll symbol of the real thing as to seem like the work of a reckless wag, rather than a sincere artistic conception; an impression which strengthens when Raïden is depicted frantically struggling on the earth, thrown out of his cloud-home by the recoil of his own lightning.

Even that stupendous symbol of physical force, Tats-maki, the dragon of the hurricane, is quite as conspicuous in subjecting mankind to ludicrous catastrophes as in destroying them. The very instant art seems on the point of reaching the beautiful or sublime, most often a malicious common sense or an uncontrollable drollery pounces upon it and sends all its finer idealisms flying for dear life. Instead of awe we get a roar of laughter; in place of beauty a burlesque. But the Japanese impulse is subtle and amusing, even when low and irreverent. It is not like Doré's, a mockery of man and nature, marred by a weird extravagance of design and diabolism that either disguises or defies all truth, so that there is no wholesomeness in his art. On the contrary, the Japanese designer, in making merry over his conceit, does not disgust and repel by implied or rendered meanings which burrow only in the recesses of perverted imaginations. We may not get an exalted notion of his personages and their functions, but we are spared despising them, and any cynical or disheartening reveries as to the upshot of humanity or the malevolence of nature.

Füten, the wind-god, is an equally ugly, but more

serious conception, half enveloped in an immense bag swollen with imprisoned tempests, which he carries on his back, holding the two ends in his hands ready to unloose their destructive forces whenever the caprice seizes him.

Füten, the wind-god.

As patron of arms, the Mars of Japan, there is a hybrid monster, partly man above, and animal beneath, or neither, just as the imagination can take hold of the strange medley of functions. The face of the bestial portion resembles one of those hideous *rococo* knockers common to most palace doors when the devil was all-rampant in social life, while the mere human part has enough heads, arms, and weapons attached to its nondescript form to furnish an entire army. As an image of the anarchy, cruelty, and wholesale slaughter which make up the old oriental idea of warfare, it is even more pertinent than the patron saint of horsemanship, who careers through the clouds on a coal-black steed with fiery eyes, brandishing two swords over his head like an *aureola* of flames, scowling the while fiercely to make the world aghast as his supernumerary limbs are actively engaged in what seems more like acrobatic tricks than a rider's well-trained skill.

The Japanese Mars.

But the quaintest specimens of abnormal design, done with an artistic keenness which makes their queer attitudes and performances seem natural, are those impossible beings, so common in their sketch-books, with legs or arms extending five or more times the length of their bodies, and yet who preserve the dignity and almost the grace of normal humanity, while doing things as unaccountable as their laughable proportions. Sometimes their heads, connected with their trunks only by a sort of

Grotesque inventions.

umbilical string, fly off in the opposite way to which
their bodies are running, gyrating a moment in the
air, and finally, upside down, find themselves staring
with a sardonic grin into the faces of frightened folks,
who lose their wits on seeing these trunkless inverted
heads, with bodies blundering about in another direc-
tion. Perhaps the most wonderful of these inventions
is that double-bodied and headed individual, who, al-
though so copiously provided with brains and *viscera*,
has but one pair of arms and legs to wait on them ; a
no less strange freak of art than is of nature the living
negro girl of America with her four arms and legs,
two heads and only one body.

As a drawing it is extremely well done. The
countenances are not ignoble, with somewhat of a
dandyish cut of hair and whiskers. Each head, as
with the negro girl, maintains a will and character
of its own ; but the hands and feet are used in com-
mon, apparently gesticulating and marching in unison
to one impulse. They or it, as you please, without
a rag of clothing, are promenading on the sea-shore,
in the society of other extraordinary creatures, in-
cluding some of the long-armed or long-legged gen-
The bird- try, which attributes, however, never are
people. found together on the same individual. All
have ugly features, and crouch on the sands. One
projects his ungainly arm a rod before him to grasp
a scroll which has just been brought from the " south-
east kingdom " by one of its " feathered people,"
who descends with rapid sweep of wing head down-
most. The legend states that this people " have
cheeks lengthened out like those of birds ; their
beaks are red ; their eyes white. Wings grow upon
them, and they can fly a short distance ; they resem-

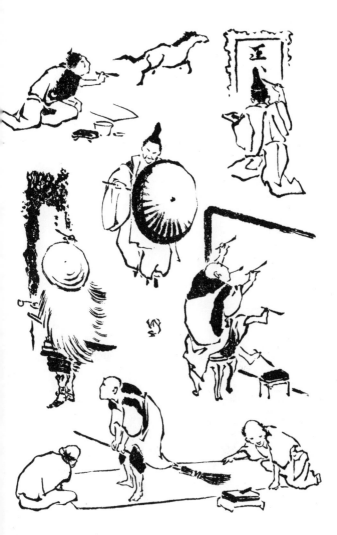

ble birds, but are not hatched from eggs!" All which features are strictly observed by the artist. He has constructed something which is neither all man nor all bird, but has the qualities of each accurately blended, as are those of man and animal in the centaur. Feathers and wings run almost imperceptibly into clothing. On one view the face seems to be entirely a bird's beak and skull; on another, it looks like a human *cranium* with a low forehead and sharp nose.

In another plate two of these beings are represented fighting as cocks fight, their feathers torn and flying about, whilst their faces are animated by human intensity of passion and capacity of stratagem. The bloated demon of gambling, with cuttle-fish eyes, and ensnaring, flexible feelers, quivering over them, delightedly watches the struggle. Often in lieu of a beak they display a slim nose several feet long, which they turn to practical use by placing the end on a comrade's shoulder and hanging bundles to it, partly supported in one hand to ease the weight and prevent oscillation. These long-noses are great jugglers. They write, paint, toss and catch rings, and do all sorts of tricks, with this well-trained member. Indeed, impossible acts and growth of limbs are so cleverly managed as to appear feasible and natural. We come to look on them as no more outside of nature than a fresh turn to the wheel of fashion, bringing up the monstrosity of yesterday as the beauty of to-day. In this naturalness of the unnatural lies one of the specific triumphs of this species of Japanese work. We may forgive ourselves for believing in the existence of the mermaid, because the strangest vagaries really look like studies after life. Specimens of

monsters in whom each member and function is antagonistic to its neighbor, so plausibly constructed as to make the whole appear vitally sound and well adapted to its own ends in life, could be generated only in imaginations steeped in a belief in their possible existence.

The rococo grotesques of Europe are wanting in this principle. Besides being stupidly ugly and imbecile in motive, they are far less original in thought, and have no organic life, truth of instinct, or reason of being. Not even a Raffaelle, or Razzi, could impart to their bizarre fancies the constitutional verity of existence which animates the Japanese designs; still less bestow on them a corresponding dignity and purpose of characterization. Theirs are out and out artistic lies, unworthy of their powers of invention, and with the latter painter frequently indecent. The common run of artists dwarfed, distorted, or befouled nature with no adequate result in way of decorative design, not even of pleasurable surprises or grim humor. For proof, examine the frescoed ceilings of the corridors of the Florence gallery, which embody the best and worst of this species of ornamentation. But the Japanese artists amuse by the quaintness and freshness of their ideas; edify by the profound comprehension of their motives and materials; and excite our senses by forcible suggestions of the unseen things in the universe. Spiritual in the Christian sense, never; but always entertaining. Nevertheless, in some of their compositions there is to be seen a physical grasp and grandeur that borders on the sublimely terrible. Witness the spectre evoked by a magician out of his inkstand, issuing as a vapor, and slowly taking the

The ink-spectre.

shape of a huge dragon, with claws that can clutch
mountains, and a spine whose crackle, as it uncoils,
reverberates like the roll of thunder, and makes the
whole firmament shudder, whilst its noxious breath
darkens the air, and condenses it into a mass of
gloom, in the midst of which glisten two round fiery
eyes, like phosphoric balls. Does not this spectre
woefully signify the poisonous effects of a vitiating
literature on any land ?

In my estimate of the seven household deities of Japan in the preceding
Section, I have shown them either as popularly viewed, or as a stranger
may regard them in their artistic aspects. But to some it may be interest-
ing to know more as to their origin and acceptance by the majority of the
human race.

Thanks to the erudite Professor Anselmo Severini of the "*Istituto Supe-
riore*" of Florence, and a translation in Italian made by Signor Carlo
Puini under his supervision, of *Ye-ma-no-te-hon*, an illustrated work in six
parts, on some of the most famous pictures in the oldest temples of Japan, I
am able to give a little more light on the subject. At the best, it is diffi-
cult, because of the easy eclecticism of the Japanese in the choice of their
divinities, drawing freely as they do upon the overflowing calendar of the
Buddhists, which is in itself largely infiltrated with Brahminical ideas and
images, and even more primitive worships. Their own aboriginal religion,
Shintôism, being in practice a deification of ancestry and the adoration of
the hosts of spirits known as *Kamis*, whether of terrestrial or celestial origin,
it follows that there is not only a vast number of so-called deities or genii
of mixed nationalities in the Japanese mythology, but considerable confu-
sion of names and attributes, all which makes its investigation, coupled
with the difficulties of the several languages, no light task. The book in
question, although old, is not a special treatise on the subject-matter of the
sacred pictures, but a series of notices cited from older works, giving also,
in several instances, the names and families of the artists, of which *Kaihô*
appears to be the chief, but frequently saying that the artist is unknown.

The Japanese theory of the creation of the universe ought to delight
modern evolutionists. Briefly, it reads thus : There was a time when
there was neither heaven nor earth, nor principle male and female. All was
sexless, and inclosed pell-mell in an unformed mass the same as a chicken
in its shapeless germ. The finest atoms, in rolling about at hazard, formed
the heavens ; the grosser, mutually adhering, the earth. The former, in
knocking against each other in their movements, being quicker, formed the
heavens first ; whilst the larger and heavier moving slower, were longer in
producing the earth.

So far, it would appear, either chance or an unknowable organic force

created and guided matter. At all events, cosmos is launched into space and time. We now are told, "*Because* the terrestrial matter balanced itself in the ether like a fish sporting on the surface of the water the gods were born " — to look after it. Evidently, the necessity of an intelligent will to take charge of all this stupendous erratic matter early forced itself on the primitive human mind, and thus was engendered the idea of a god, and subsequently a prolific mythology. For it would not do to leave all to blind chance where man was concerned, nor could he altogether accept the notion of there being law without a law-maker. Be this as it might be, the naked Japanese statement of the appearance of a material before a moral and intellectual creative force, agrees with the positive skepticism of the present hour that makes all faith and religion begin and end with the physical individual ; his temporary want giving rise to the idea, and the idea shaping itself into the effigy of a divine being capable of creating and administering the universe and conferring his own immortality on man, but having no other foundation in philosophy or fact than the ignorant fears or interested wishes of perishable humanity. As a sort of compromise with the perpetually recurring question, "What first gave rise to chance, law, matter, or whatever the mind recognized as the beginning of life ? " and the impossibility of solving it, the Japanese imagination fell back on a starting point within the compass of human fancy by asserting that three male gods, born solely of "*celestial reason*,"—not a bad supposition this, considering the dilemma, — first took charge of the universe. After them came other gods, male and female, generated by the union of the vital principle or "reason " of the earth with the "celestial reason " of the heaven, — seven successive generations of these mixed beings being thus produced. This is analogous to the statement in Genesis that "the sons of God saw the daughters of men that they were fair, and they took them wives of all which they chose." Izanaghi and Izanami were the last of these superhuman couples, and at their disappearance, we get onto solid historical ground in the person of the founder of the empire of Japan twenty-five hundred years ago, — Zin-mon, a sort of Alfred the Great, or Charlemagne, only more successful, for his political institutions and dynasty still endure.

I have abridged this relation from the Abbé Rousseille's translation in the " Revue de l'Orient " of the genealogy of the sovereign-gods of Japan ; a curious mixture of fable, fact, speculation, the real and supernatural in an insoluble literary compound.

Carlo Puini's translation puts us on somewhat less apocryphal and transcendental ground ; indeed, on a very materialistic, earthy basis of ideas in regard to the fundamental uses and goods of life. We soon perceive there is nothing celestial or spiritual in the origin and constitution of the " seven genii of felicity," commissioned to look after the welfare of the sons and daughters of men ; for they are simply the substantial effigies or symbols of those desires which most heartily affirm the material happiness of the average Japanese mind without any reference to a future existence. Their worship, therefore, is quite distinct from the adoration of those celestial and terrestrial *Kamis* or spirits who have an absolute individuality.

The former confines itself exclusively to mundane well-being, and must on that account recommend itself to the philosophers of the purely rationalistic schools, who, denying God and all personality after death, propose to substitute for immortal hopes and felicity the positive but transient welfare of time in the guise of whatever satisfaction art, science, and culture may yield. Forgive the suggestion, but it really seems to me that these seven Oriental genii would form an admirable pantheon for philosophers of this pattern, and appease the instincts of their followers for worshipping something outside of analysis and dissection, by providing them with artistic symbols of what they most covet on earth, already recognized by scores of millions of their fellow-men. What could be more appropriate, for instance, than a beautiful temple erected to Ben-zai-ten-njo in Berlin, the inventor of music and art, and teacher of the refinements and virtues of daily life, with a disciple of Strauss as high-priest? Quite as edifying would be one to Bis-ja-mon and Tossi-Tokû, administered by a Schopenhauer or a Hartmann. Any or all of the seven are in solidarity with the current materialism of Europe and America. By adroitly using them it would agreeably vary its arid monotony and cheerlessness, do homage to the artistic faculty, and repair in some sense its one-sidedness as regards the whole being of man, without abating one jot of its logical or scientific assumption. By all means, ye disinterested speculators in the human mind, build us elegant temples and dedicate them to the substantial seven as the artistic embodiments of the philosophy of material evolution and the beginning and end of all things, our souls included.

The Chinese reduce the seven to five, as follows: longevity, riches, health, love of virtue, and desire of death by old-age, which they call *go-fuku*, the five happinesses. Our Japanese friends vary their wishes some, adding two, and sometimes three, to the list, — glory or fame, talents, and the daily-bread supplier and comforter, the inimitable Yebis.

Yebisu, as it is also written, is aboriginal Japanese, fabled to have been born of the last pair of gods, Izanaghi and Izanami. In his grand functions he is the chief dispenser of worldly prosperity, the privy-councilor, bestower of rich harvests, and patron of commerce. In this role he is better known in literature as Firuko. One legend represents him as the progenitor or the civilizer of the Yebisu, — the wild, hairy, ugly savages who first peopled Japan, fathers of the present despised Ainos. Hence the mixed appellations and functions of this deity and his universal popularity, being recognized by all classes.

Tai-koku (Dai-koku), Bi-suja-mon (Bisjamon), and Ben-zaiten (Benten), are of Indian origin modified by Buddhist transmutation. Fotëi (Hoteï), Ziyon-ran-zu (Shiou-Rô), and Fuku-roku-ziyu (Tossi-Toku), are said to be of Chinese creation. But all are now so thoroughly naturalized in Japan that scholars find it difficult to trace them clearly back to their independent sources. They supply a common want in one form or other of the populations of India, China, and Japan, adapted to each, and varied according to the culture of the individual, their diverse functions at times being interchangeable or intermixed.

The hammer of Dai-koku is used to strike his sack every time he wills it to be filled with money, food, rice, or whatever else is needed.

Bisjamon is one of the four kings of heaven that guard the world at the four cardinal points of Meru, the central mountain according to Buddhist cosmology. Since writing the description of the two famous statues in bronze in Section V., I have been able, I think, to identify them with two of these celebrated Guardians of Heaven.

In the Buddhist mythology Ben-zai-ten is an extremely mystical personage. Her fifteen sons are as many beneficent functions or gifts, the beating away the cruel genii of hunger and thirst being among them, and to shower the earth with gems and precious things. She is also called Koutoku-ben-njo, goddess of merits and of the marvelous voice; yet the Japanese stoutly claim her as their own invention. Possibly she is confused with a Buddhist goddess somewhat similar. Uga-no-kami is the name of one very popular as the protectress of food and divinity of the five grains. Tradition ascribes to her the discovery and cultivation of rice, the staple grain of the East. The fox is sacred to her and held in great estimation, and also feared because of its powers of witchcraft.

Fotei (Hotei) is neither more nor less than an obese, dirty mendicant Buddhist friar, of great sanctity, self-taught, affable, jovial, generous, sleeping on the ground outdoors in all weathers, and always carrying with him his sack of begged victuals. Japanese fancy sees in him a lovable old vagabond, auspicious of good luck and cheer.

Longevity, or Ziyn-ran-zin, by our Chinese account, was not altogether a pattern of good morals; for he loved to go into market-places, gamble, buy lottery-tickets, tell fortunes and spend his gains in drink, striking his head on the ground, as he cried aloud, "I am the holy man who lengthens human life." He told the Emperor of China, who was curious to see this strange dwarf, — he was only three feet high, half of which height was in his forehead, — "he loved wine and when he was drunk he could speak well." Being put to the proof he prophesied prosperity for China and the emperor whenever the Yellow River ran clear, and then he disappeared; that is, went back to heaven.

Kiti-ziyau-ten is an eighth deity who is not infrequently in company with the preceding, and seems to be a sort of compendium of all their good. He removes evil and pain, bestows favors, gives exuberant fortune, tranquillity and contentment, if addressed in perfect faith with utmost power of will in certain formula of prayer. Indeed, he has the power to give to satiety money, clothes, gems, food, coral, amber, in fine everything the asker covets, and must be spoken to as the universal giver, dispenser of favors and sovereign beneficence. Repeated disappointments have probably put his worshippers out of countenance, for his image is not described, or else his functions have been incarnated into a more possible shape in the person of the god of talents, the aged, wise, and respectable doctor, Tossi-Toku. I had wished to give a fac-simile in photolithography of a Japanese wood-cut in one of their old Encyclopedias, exhibiting the seven deities of felicity on a picnic; but besides being a little injured, it is too delicately drawn to be fairly reproduced. It represents the party assembled on a

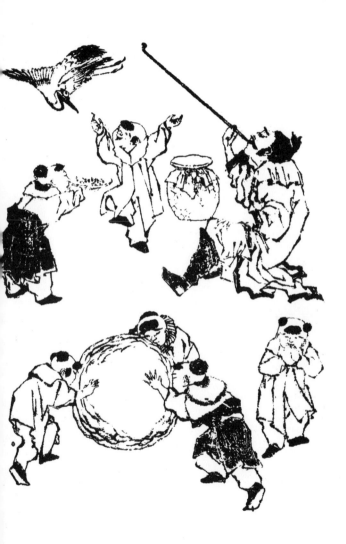

paved terrace overlooking distant mountains, with all the materials of good cheer about them. Yebis is the central figure, holding a fishing-rod over his shoulder and dancing in the maddest fashion a fandango to the music of Benten's harp, which she holds in her lap. Tossi-Toku stands a little back, with a grave look, and opposite him, Bisjamon leaning on his three-headed spear, contemptuously regarding the antics of Yebis. Daikoku, supporting his fat cheeks with his elbows resting on his plethoric sack, lying on his stomach, is bursting with laughter, whilst Hoteï, his legs doubled beneath his pot-belly, head thrown back on his huge skin wallet, and hands uplifted, is absolutely convulsed with merriment. Shiou-Rô's tall head comes into the back ground with a very rollicking expression of countenance. The sacred turtle is intensely watching Yebis, and the stately stork is pirouetting in the sky above, keeping the jolly fisherman company. Is this skepticism, impiety, caricature, mere fun, or serious belief in the artist? Whichever it is, its spirit is characteristic of the way the Japanese view these divinities and their faith in them, which seems none the less for their entertaining themselves after the fashion of mere mortals. I have another picture in which Kiti-ziyau-ten is pounding Shiou-Rô, who is face-down on the ground, with a big bag, whilst Bisjamon, pipe in hand, lying on his back, is flirting with Benten, and Tossi-Toku and Dai-koku are pleading to save the tipsy old man from being too severely punished. This latter scene is the one represented in the frontispiece, taken from the work " Ye-ma-no-te-hen," or " Models of Paintings," etc., in old temples.

SECTION III.

THE LITERATURE AND POETRY OF JAPAN.

THE immediate effect of cheap books in Europe is
to deprive art of its old intellectual suprem-
acy by giving the lead to the reasoning fac-
ulties. Ungracious as is this temporary ob-
scuration of the æsthetic disposition in its immediate
general effects, it is no less an onward step in civili-
zation. Both the emotions and imagination, as with
children, take the precedence with nations in the
development of their mental powers, giving rise to
distinctive religious and artistic phases of national
life, constantly fluctuating and changing, because of
their undue predominance of sensuous and sentimen-
tal elements and deficiency in the exact sciences and
positive philosophy. We have yet to ascertain if the
æsthetic and scientific faculties, in their most profound
meanings, can be perfectly balanced in one harmoni-
ous, complete homogeneity, whether of race or indi-
vidual. In looking back on Japan, we get a general
likeness to what must have been the dominant passion
of Europe during the Middle Ages for ornamental
art; for until yesterday, there obtained in this coun-
try a kindred feudalism and division of society into
castes, ranks, and guilds, and an average instruction of
the people, almost identical in direction and quality
with what prevailed in Europe before the Renaissance.

Japan had cheap books, I believe, long before Eu-

Effect of cheap books on art.

rope, but no system of common education to develop the logical powers and diffuse useful knowledge. On the contrary, there were distinct alphabets or methods of writing, regulated by the social condition or sex of the scholar. Women and the inferior orders were taught the Hirakana alphabet, which was the vulgar one, and used for the more ordinary purposes. A man of quality mastering this could read his wife's, daughters', or servants' letters, but they could not decipher his, unless they had surreptitiously learned the Katakana alphabet, which was reserved for the higher male classes and scholarly literature.

The alphabets of Japan.

But the literature most in vogue, common and intelligible to all, and constituting the real mental diet of the people, was incorporated into a system of cheap pictorial books, often executed by the very best artists. The chief of this series or class of books, the most artistic and clever in every sense, was done by a school of associated artists of whom one Hoffksai, who is said to have flourished in the last century, is the most famous. These books are printed from blocks, either plain or in colors, at a single impression on one side of a delicately tinted and very thin paper, which is doubled and left uncut to form a leaf that very frequently divides the pictures by cutting it in halves, leaving part on one page and part on the other, a disfigurement to which both artists and readers seem quite indifferent. But whatever loss this may involve, it is far more than compensated by the softness and delicacy of the impressions and their uniform excellence, proving how skillful the Japanese are in engraving on wood, and their intimate knowl-

The pictorial literature and Hoffksai school of designers.

edge of the material substances used. They contrive
to get their very best qualities out of them by a
species of manual freemasonry. We have no pro-
cesses by which the vital points and characteristics of
things are rendered with a corresponding cheapness,
facility, precision, and sensibility.

These sketch-books or albums embody the history,
poetry, myths, arts, trades, legends, mythol-
ogy, magic, jugglery, riddles, jokes, science,
natural history, in fine, the entire life of the
people in a compact, handy form, and are equiv-
alent to as many popular lectures or cheap travels in
keeping alive and perpetuating their artistic instincts.
As they are taught by the pictorial representations
or symbols of things rather than by the text, which
forms but an extremely small portion of the books,
often consisting of only a few characters interprinted
with the sketch itself in a corner, or at random in the
page, the style of the design is with them the chief
point, and of the same relative importance that the
style of the composition is in our books. Theirs
graphically focus into a small compass all that is best
and worst in their taste, true or false in their charac-
ters and deportment, without the least disguise or af-
fectation. It is plain to see these designs are the un-
tutored language of a race, or at least of a class, very
fond of holding up their mirrors to nature, indifferent
as to the moment it reflects their ideas or image and
what it discloses. There is an unmistakable generic
similarity of expression and method in all, indicating a
common fountain-head or school of art, but exhibiting
various degrees of merit and distinctions of touch and
style, showing different hands, from the most mas-
terly to the more timid or conventional of a pupil or
imitator.

Sketch-
books and
albums.

In speaking of this pictorial literature we must not overlook the radical changes which are now affecting it, as well as other objects, frequently rendering what was true of to-day obsolete or transformed on the morrow. The old art, of which alone I treat, as a distinctive national feature, is rapidly being revolutionized. It may linger awhile longer in a few localities in the shape of a tradition of the past, but nothing new is invented in the spirit of former times. With the complete overturn of those ideas and habits which gave it birth, there can be but one end to the genuine indigenous art — its extinction. And this comes the faster because the restored Mikados, the patrons of Shintôism, from principle are more or less hostile to Buddhism, which was the adopted faith of the usurping Shôgoons, their late rivals. These last rulers, although somewhat inclined to baroquism in taste, were prodigal in the artistic adornments of their tombs, temples, and palaces. Hubner, writing of the sanctuaries of "Shinba" says : "One is overwhelmed at each step by the richness of the materials, the prodigality of the decoration, the fineness of details and the solemn magnificence of the entire spectacle ! "

The over-turn of old art ; its chief cause and probable result.

The best period of the Shôgoon art embraces the fourteenth, fifteenth, and sixteenth centuries of our era. After the reign of the distinguished Taïko-Sama, known also under the name of Hide-yoshi, A. D. 1586–1591, as in Europe, there was a steady but more gradual decadence. Now that the Mikados have begun to destroy or dismantle the temples and monasteries, confiscate their revenues, and sell their sacred paraphernalia, all of

Best period of the Shô-goon art.

Japanese art based on the religious motives of Buddhism seems destined to a speedy destruction, and threatens to leave Japan, at least for awhile, in the same barren condition, as regards its better art, as was England after the spoliation of the Roman Church by Henry VIII. Indeed, the parallel seems likely to be all the more striking, inasmuch as strict Shintôism implies as direct iconoclasm as the Puritanism of England in Cromwell's time, if not the utter negation of all ritualistic forms of worship, thus cutting off all art's opportunities in a religious direction, and relegating it for its precarious support to the material interests, tastes, and current skepticism of the population at large.

Fortunately, as we perceive at each step of our inspection, the people still have a deep-seated love of familiar nature and its corresponding art, whilst their daily habits confirm their devotion to both, and their appreciation of their interchangeable aspects and functions. Both in Europe and in America this desire has to be created and fostered by direct instructions. To young and old, nature, as an æsthetic object, is a good deal of a bore, necessary to be done occasionally as are museums in a foreign tour, either for health, fashion, or recreation ; but with no real sympathy or understanding of it. Society, high and low, hinges itself mainly on material interests and enjoyments, and likes best that art which pays the most flattering tribute to individual egoisms. In Japan, irrespective of religious ideas, even the peasant has an almost exaggerated love of the picturesque, both in the objective and the mystical sides of nature. A poetical and spiritual, and perhaps a superstitious, pantheistic appre-

Love of
nature of
the people.

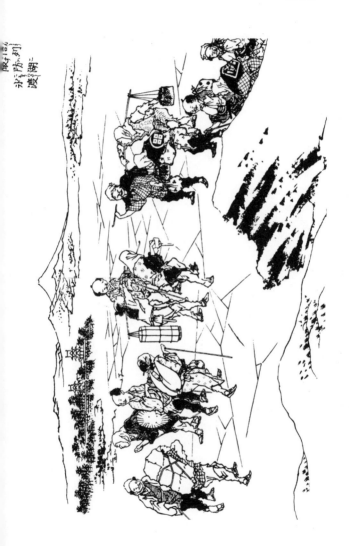

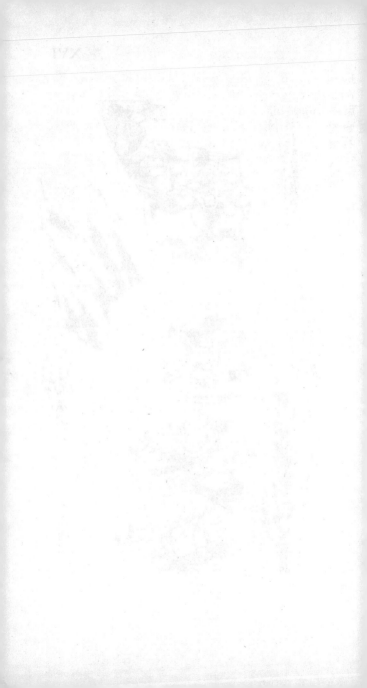

hension of the natural world, besides a thoroughly realistic enjoyment of it, comes forcibly to him as a blood inheritance from remote ancestors, unmixed as yet with other people's inherited idiosyncracies. Whatever makes up a sensuous, imaginative temperament, is lively felt by him. He rejoices sincerely, or appears to in his art, in the facts of his daily being; is still a naïve child of nature. Heretofore his wants have been few and easily met. When trees blossom and flowers bloom, the farmer's family go into ecstasy, not because of a prospective crop, but at the beauty of the spectacle. Old Japan has never been greedy of riches or lustful of conquests. It was content to be left alone to its own resources of happiness. Extremes of wealth and penury were rare. The nobles were open-handed, the people obedient and loyal. All ranks liked pretexts for amusing themselves and taking life " *a la* picnic " as much as possible. Hence the prevailing *insouciance*, numerous pageants, fêtes, and pilgrimages, both laical and clerical. The abstract teachings and practical philosophy of the disciples of Confucius made no conspicuous impression on the old-time habits of the Japanese. Their axioms might serve as texts to sermons, or moral points to the romancers, but their influence on the multitude ceased here. Even the politicians came at last, so says Hubner, to confound them with the original dogmas of the aboriginal Shintôism, and both in the end were in great measure forgotten by the populace. Their most familiar art, unlike European, was bone of their bone, flesh of their flesh, born of their own feelings and sentiments; truly their æsthetic vernacular, giving vent to their beliefs, emotions, passions,

[marginal note: Habits of all classes as regards amusements and love of nature.]

and actions, and not a special distinction and production of the culture, rank, and wealth of their country, as in Italy, France, and Spain. It is even surmised that some of its technical short-comings were due not so much to the ignorance of the artist as to his conservative desire to keep on the level of the common people's standard of viewing its objects, which antiquity and their own long personal experience had made a second nature to them. In fact, it is no easy matter to change for the better the way of looking at or enjoying art of cultivated people who have once unconsciously, or without questioning the grounds of their taste, settled down into specific likes or dislikes. Much more those who have always accepted their impressions and associations as first received and implicitly believed in them.

Nevertheless, I have seen Japanese books of drawing in which linear perspective was clearly shown and taught. Baron de Hubner, an experienced observer, fresh from the best schools of design in Europe, observes that he saw in an ancient temple at Kiŷoto " a picture of three women at the entrance of a palace, worthy of our great masters and faultless in perspective." Still we must not overmuch emphasize the exceptional features of Japanese art, but accept it as generally understood and practiced.

Perspective known to Japanese artists.

The motives of the figure-art already examined, appertain chiefly to their religious ideas. Our enjoyment of it cannot be so hearty and complete as of that based on the social life, the natural history, and the landscape of Japan, because in this there are fewer drawbacks from imperfect comprehension or lack of sympathy with the theme.

Motives of figure-art.

Indeed, we are let into an artistic paradise of an original character, which Europe does not rival. This is specially true of the strictly Decorative Art. No other race understands better the vital exigencies of ornamentation, or is more skillful in manual practice. Here the Japanese have obtained as decisive a mastery as the Greeks in treating the human form. Outside of plastic art, within their own limits, the Japanese even succeed in this. There are two principal schools of the figure, that of Kiŷoto, the spiritual capital of the Mikados, being the oldest. It is imbued, as was the early Italian, with Byzantine feeling, and is impregnated with the Chinese love of repose and richness of decoration, tending to laborious minute conventionalism rather than to strictly artistic invention. Nevertheless, it displays superlative delicacy and brilliancy of illumination, picturesque skill in composition, and a felicitous balancing and tempering of masses of color and gold. It devotes itself chiefly to sacred and historical topics, or those favored by the aristocratic susceptibilities of the imperial family. Like the art of the miniaturists of mediæval Europe, with which it was contemporary in origin, it formed a religious historical and romantic school partial to gold backgrounds and magnificence of decoration, chiefly under the direction of Buddhist monks. These had acquired the art of clouding the page on which they wrote with gold powder and leaf of varied tints and brilliancy, intermixing figures and text with golden masses and suggestions of forms, so as to illumine the page and give the effect of dissolving views, not unlike the softened splendor of the sun's rays in the landscape as they pass through mists. The quiet,

<div style="text-align: right">Two chief schools and their characteristics.</div>

though somewhat monotonous, refinement of design, and the harmonious elegance of coloring, without obscuring the story, seduce the senses into a languid forgetfulness of it, as the ear often drinks in the music of an opera while the eye is unmindful of the stage-scenery. This fascination belongs to the best Decorative Art of the Orient everywhere. But the Japanese miniatures are wanting in the intense realistic characterization and vivid action which constitute the prominent traits of the more decidedly indigenous school as represented by the pencil of Hoffksai and his numerous followers.

The antithesis of Grecian design is the rule of the more secular Japanese art. Mobility and flexibility of body and features ; moments of liveliest action and surprise, real, homely, often grossly exaggerated, but as the Greeks intensify repose ; and, above all, absolute distinct individualism in every figure, each one a *character*, as we specially define the term, and doing something with all his might, sometimes rather more, putting into pictorial action the quality of American drollery which verbally delights in comically contrasting and intermixing ideas and sentiments and turning facts inside out to their utter confusion, with a realistic vigor and ludicrous unconsciousness of impossibilities which make up a frantically ridiculous joke, or opposition of emotions. This is a very popular sort of wit. In the genuine Japanese school of art there is no nirvana. Its mobility and restlessness overcome or largely temper all the contemplative tendencies of the imported faith. Besides its muscular and gymnastic bias, it is fond of subtle irony, objective humor, and an intensity of naturalistic action which, when not extended into absolute caricature,

gives to the art a pungent flavor, like repartee to conversation. Sometimes the comic and sad are brought together with an amazing psychological dexterity, causing conflicting emotions, vividly stirring curiosity, and leading the imagination captive into strange regions. Even if the nerves are somewhat excited by surprising " *tours de force*," or the position borders on the equivocal, an irresistible comicality is ever uppermost, and leaves nothing serious in its train to disturb either conscience or taste, provided we accept the situation as the artist really means it.

Hoffksai's designs are extremely varied, thoroughly original in style, and give the idea of a rare spontaneity of execution. They either seem Character of Hoffksai's style. caught from nature as it were, on the wing, or else are veracious fruit of his own daring and eccentric imagination. It must be admitted, in a cosmopolitan sense they form a limited art ; but it is one which encompasses the entire sphere of Japanese civilization, and is second to none in forcible characterization and vigor of pencil. Guided solely by its own keen instincts and pertinent aims, owing nothing to any other school or influence, it is supreme in its own ways and wholly free from inane types, wearisome conventionalities, and pettiness or shams of any sort ; it goes directly to its point, scorning all subterfuge ; sturdy, versatile, never repeating itself, every stroke and thought a distinct note in art, realistic or idealistic, as the motive demands, exhaustive of common and aristocratic life, spicing everything it touches with racy individuality, few, if any artists of any country surpass Hoffksai in the faculty of making common things and little things tell more pleasurably to the fancy as artistic surprises and fresh interpretations of the ordinary phenomena of nature and society.

Somewhat of the Japanese facility of pencil is un-
doubtedly caught in its elementary phase in
learning to write the two alphabets most
in vogue. A delicate brush and dextrous
handling are needed to make their bold incisive
strokes, which are just such as come most aptly into
their system of drawing. Indeed, the *Katakana*, or
aristocratic letters, are to be seen combined into the
guise of a learned doctor, with a perfect rendering of
his dignified pose and scholastic costume, while the
plebeian *Hirakana* is allegorized into a beggar, equally
graphically done. Learning to write becomes in Japan
the first step in learning to draw ; for it gives the
same flexibility of stroke to the fingers that fingering
the piano by the Stuttgard method does to the mu-
sician's touch. A glance at any one of Hoffksai's
albums shows the analogy between Japanese writing
and drawing at once. The arbitrary signs of the
alphabets can readily be expanded into vigorous sug-
gestions of human forms and drapery, and as facilely
decomposed into their abstract elements again. But
the informing spirit which gives such intense life to
their personages can be got only by a most sedulous
observation of nature, objectively and introspectively.

A Japanese draughtsman is not less successful in
delineating natural than in constructing unnatural
forms. None are more happy in hitting the exact
limit in the ridiculous where the action stops short
of inane caricature. He makes the position droll be-
cause of its adroit combination of probabilities, rather
than possibilities, under conditions which he himself
creates. We are all familiar with French plates of
the effects of a high wind on pedestrians of both
sexes, who make a prurient display of limbs and per-

One cause of the Japanese facility of design.

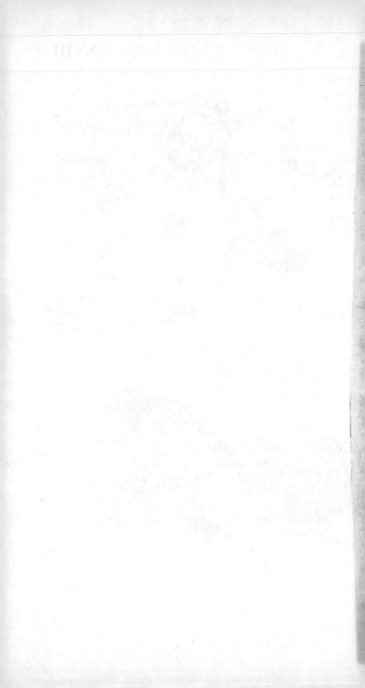

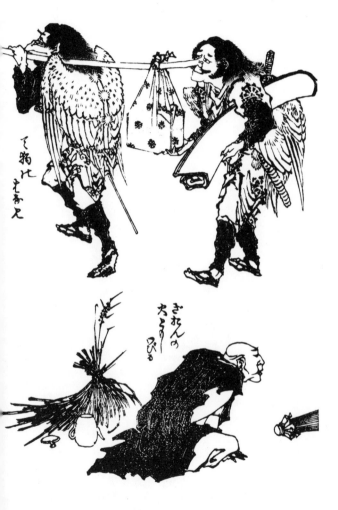

sonal encounters, forming a picture unseemly alike to
eye and fancy. Hoffksai, taking a similar event,
sends drapery wildly flying, entangling arms and legs,
blinding eyes, and getting its owners into a furious
turmoil, without indecency of drawing or exciting
other emotion than honest laughter.

What a nice sense of humor, too, there is in his
plate of a tired porter asleep on the ground, with
his brawny legs across one another, only to see him-
self in his dreams working harder than ever ! Again
we see the facile production of art burlesqued by an
artist represented as seated before an immense screen,
or canvas, painting in a most vehement manner
with a brush in each hand and between the toes of
each foot with a supplemental fifth tied to his nose.
Where do we find his superior in depicting gymnasts,
fencers, wrestlers, and scenes that call for the utmost
muscular exertion and dexterity ? He is as felicitous
in limning steady industry of all sorts, perpetrating
on occasion the inevitable joke — each person doing
his heartiest, and making the spectator *feel* that he is,
without any consciousness of self-exhibition and of
the impotent model which is so obtruded on the sight
in European art nowadays. If it be a woman scrub-
bing herself, or a resisting urchin in a tub of water, a
fine lady at her toilette, a family quarrel, a pleasure
party, a physician examining the tongue of a patient,
half choked in forcing it out of his mouth, a musical
critic tortured by an unwelcome serenade, an unmen-
tionable punishment of a faulty servant, blind men
leading one another astray in crossing a river, — in
fine, whatever the topic, and however complicated the
scrape, it is executed with a realistic swing of pencil
and *naïveté* of expression that commends it to the

sight as actual life itself. So simply, too, with so few
strokes and touches, so much reserved power and so
little artifice, is the occult mechanism of humanity
revealed to us that we seem to have a clairvoyant in-
sight into the consciousness of the actors. This inner
being of the object shown constitutes its chiefest iden-
tity, and is evoked by such slight technical means
that at first we overlook its wonderful artistic sim-
plicity in admiration of the spirit of the composition
in the whole.

The skillful manner — hiding, if I may so term it,
the manual means — with which Japanese
artists bring vividly in view the animating
idea of their work is also wonderful. It
may be done by a few lines, dots, blotches
of light, shade, or color: always simply and sparsely
with no unnecessary labor, and certain to stop at the
precise point the idea is reached, without elaborating
any detail not absolutely required to complete the
unity and emphasize the meaning of the composition ;
doing too little, rather than too much, technically ;
concentrating the attention on the artistic aim and
with slight perceptible effort hinting a whole biogra-
phy of an individual, or the complete habits and in-
stincts of an animal, the nature of a plant, the state
of atmosphere and the sentiment of a season. Ex-
plicit force of design for the eye and unlimited sug-
gestion for the mind ; economy of labor, luxury of
idea, æsthetic seriousness, solidarity, conciseness, and
drollery, devoid of Gallic levity, license, and little-
ness of purpose, or American impatience, pretense, and
superficiality, such are some of the elements I recog-
nize in this unique school, rendering it an example to
those academies which do so much and express so

Simplicity and direct- ness of Japanese designers

little, and, blinded by their systems, lose sight of the real intent and substance of art.

Although the predilection for action is most conspicuous, the Japanese understand equally well how to render contemplative repose, as in the figures of gentlemen on their balconies, overlooking a wide landscape, in passive enjoyment of moonlight or rapt in thought. These are simply perfect in pose and feeling. Thus also, poets meditating by the sea ; harsh-featured men on the brink of precipices, so absorbed in gloomy reverie as to be seen to form a part of the wild, speechless world around them ; with passion-lit faces, indicative of inward strife ; a momentary lull in a stormy life, to gather fresh momentum of action.

Repose as well understood as action.

Opposed in sentiment and attitude, with relaxed tension of limb and nerveless looks, are numerous images of ecstatic saints and holy men enjoying incipient beatitude. Not even Fra Angelico endows his holy personages with a more rapturous bliss and impassive serenity. But these transcendental motives are opposed to the general bias of Japanese art, and only serve to show with what facility it can lend itself to extremes of thought and action. Their artistic sway over animal and vegetable life is as complete as over men. Moreover, they are eminently successful in giving to animals a human character and physiognomy, and the psychological reverse, as well as impregnating dumb nature with other meaning than its own. Indeed, there is a predilection for the dark and mysterious in life, almost as strong as for the poetically sweet and true.

Ecstatic art.

Treatment of animal and vegetable life.

Japanese of all classes being trained from infancy

to familiar relations with nature, it is a national cus-

Fondness
for out-door
life and
objects.
tom during spring-time to make family ex-
cursions into the distant country in order
to enjoy the *sakura* or mountain cherry
trees when the wild blossoms are fullest and color
the deepest. They fill their pictures specially with
this beautiful flower, and seem to revel in its vigor-
ous tints. One of their old poets thus alludes to
them : —

> "The dark-massed shadows flecked,
> By the mountain cherry's bloom."

Again,

> "Should the mountain cherry cease
> In the spring-time of the year,
> With its mass of new-born bloom,
> Mortal men to cheer; alas,
> Would the heart of spring be gone,
> And its brightness fade away."

This habit helps engender a passionate fondness for
out-door existence, and a hearty appreciation of what-
ever is beautiful in landscape. Their houses are con-
structed so as to admit ample views of the country,
while, as compared with European homes, there is
much less to attach them very fixedly to the interiors.

Construc-
tion and
furnishing
of houses.
Built of the flimsiest materials in the light-
est but neatest manner, held together only
by wooden pins, containing the most com-
bustible articles, they burn like lucifer matches in the
frequent conflagrations which devastate the towns,
but are quickly and cheaply re-made. This alone is
sufficient to hinder the growth of those profound as-
sociations with a family hearth-stone, dear to the
Anglo-Saxon heart and so conducive to an indoor art
and luxury, and to throw our Japanese brother more
upon his out-door resources for social happiness. His
requirements of housekeeping are extremely few and

simple. Clean mats for beds and seats, a few wooden
pillows, prodigiously uncomfortable, a portable stove,
a score or more of lacquer and porcelain dishes, per-
haps a pretty cabinet to hold writing and drawing
materials and their few small objects of art, a musi-
cal instrument or two, and as many screen-paintings ;
these quite suffice a young couple's wants, and as for
this matter, an old one's too.

Instead of costly framed landscapes hung on their
walls, the nobles make their rooms scrupulously clean,
airy and spacious, with movable divisions Divisions
or screens, which can be so arranged as to and screens;
how ar-
leave open, as if inclosed in frames, attrac- ranged.
tive vistas of out-door scenery. Often the screens
themselves are made of the finest materials and either
elaborately worked in gold and silk, or richly painted
with landscapes, and scenes from national myths and
history, or curious and capricious devices, so æstheti-
cally ingenious as to afford an endless entertainment
to the eye, and which are as readily shifted as the
scenes of a theatre.

Regarding nature, the Japanese manifest a very
sensitive æsthetic conscience. Believing it The æsthetic
to be the most satisfactory source of enjoy- conscience
of the Jap-
ment, whether by itself or transfigured by anese.
art, they study to secure her best in multiform ways,
with no end of variations and inventions. It is this
wholesome habit of mind which has prevented them
from stagnating like the Chinese, despite kindred
faiths and equally changeless codes and customs.
Their love of nature being at the bottom of their love
of art, the two are so mingled as to save them from
the grosser materialisms of their neighbors, and to
preserve in them a perpetual juvenescence of feeling,

elasticity of temperament, quickness of intellect, almost Arcadian simplicity of life, and general goodness of disposition.

The charm of the towns chiefly lies in their beauti-

Charms of
their cities.

ful positions, lovely gardens, stately groves, and rural interminglings. Picturesque solitudes abound in the centres of the densest populations. These waifs of far-off wildernesses are devoted to offices of religion and rustic pleasures, which have much in common. They further serve as bountiful reservoirs of health, distributing to each city threshold the pure air of the dearly beloved country. This appreciation of nature extends to her gifts both small and great. A European can hardly take in the passionate joy of a Yedoite in his darling Fusi-yáma, the " peerless " mountain, whose volcanic cone, clothed in eternal snow, lifting itself high into the intensely blue azure of his native skies, in magnificent silence, is his climax of sublimity in the material world, symbol of imperishable patriotism, and of his celestial paradise. Neither can he share his intimacy with the animal world and the secrets of its varied instincts. The wondrous ethereality of the atmosphere, defining distant places as sharply as the lines of an engraving, alternately with semi-transparent mists, which suggest new forms and veil the old, gives an additional charm to the landscape. When weird in aspect, as we have seen, his fancy peoples it with spirits thin as air, strange in form and hue, wishing him weal or woe, according to their disposition. With a more materialistic sense he delights in his wild camelias in full blossom, fifty feet tall, the songless birds of bright plumage that add to the deep hush of the forests, and favorite picnic grounds, with their musical waters and

enamel of wild flowers. These are but a few of the
beloved agencies of his outer world that serve to keep
him in a more cheerful mood and his æsthetic percep-
tions keener than those of most other civilized peoples.

Unlike Greek poetry, that of Japan is full of de-
scriptions of the landscape. The popular
feeling finds vent almost as much in song
as in painting and design. In general it is
plaintive, and sung to the accompaniment of a *sam-
mishen,* a sort of banjo or guitar: or a *koto,* a kind of
clavecin, and any other wind-instrument. Some of
the impromptu stanzas of their poets, expressive of
their intense sympathy with nature, are very sweet
and touching, while their similes are beautifully apt.
I extract brief examples and some similes from the
collection of ancient and modern poems, known as the
" Kokinshin," first quoted by the Portuguese Père
Rodriguez, A. D. 1604, in his treatise on the Jap-
anese language, and cited in the " Westminster Re-
view " for October, 1870.

Poetry of Japan. Its sentiment.

> " Icy flakes are falling fast
> Through the chilly air, and now
> Yonder trees with snow-bloom laden,
> Do assume the wild plum's guise,
> With their mass of snowy flowers,
> Gladd'ning winter's dreary time."

> "Darkening the wintry air,
> Clouds are gathering in the sky,
> Rain-drops sparsely patter down,
> And the frozen tears melting
> Drip from yonder willow tree,
> Through the chilly vapours seen,
> Sadly bending o'er the stream."

> " There the dizzy water-fall,
> Flashes mid the hill-side bowers,
>

> " Never shall the sacred child,
> Weary of the pleasing murmur."

> "Nor of gentler beaming moon
> Hail the shadow-fringing shimmer."

> "Vaguely erring smoke."

> "Bright i' th' sun gleams Suka's peak,
> Cloud-veiled Sudska's summit bleak,
> Tseuchi's top between doth lie,
> Rain-dimmed, hid from traveller's eye."

There is no false, sickly sentiment in these effusions, but the same sincerity of feeling, delicacy of touch, felicity of comparison and truth of observation that are to be observed in the sister arts. As a specimen of kindred metrical realism of a corresponding vigor, the following stanza, from a dramatic romance, is noteworthy. It represents a girl hastening to meet her lover by water —

> "Ha! Atsta's shrine descry we yonder? Yes —
> Full seven leagues across the bay.
> Haul taut the sail, bend, mother, to th' oar,
> With measured stroke — away, away —
> Haste, mother, haste, far yet the farther shore —
> O mother, every nerve be strained!"
>
>

> "How fierce the hail drives through the windy air,
> We cover from the storm our heads;
> Now side by side our barques through the waters tear —
> Now one the laggard other leads."

The earliest myths of Japan, antedating the demi-

Earliest myths.

gods, go back to the dawn of human life, if not in our planet at least to its presence here at a period when mind, beginning to try its half-fledged powers, transformed the phenomena of the skies and atmosphere into personalities more or less monstrous and superhuman. They are said to show as fertile, if not as cultivated invention as those of the corresponding pre-historic epoch in Greece, and abound in similar cosmic significance and potential imagery; either the almost spent reminiscences of a once higher state of existence or the mystical intui-

tions of the child-life of man, who, as his powers become matured, is left by his guardian agencies more to his own control, that he may develop himself into a self-sustaining being. The logical end of man would seem to be to acquire a lordship over nature in virtue of self-conquest and growth through much tribulation and unceasing effort ; every mistake piloting him to a surer channel and bringing him nearer the ultimate purpose of humanity.

The sacred literature and traditions of all peoples become more simple in form and elevated in tone as they are traced backwards towards their primary beginnings ; more symbolical and supernal in character and imagery, and grow to be materialized and overlain with merely human fancies and experiences as they approach historical times. Our first ancestors sought to scale heaven by the open ladder by which Jacob's angels came and went. We are trying to grope our way thitherward by the back-stairs of positivism. Once the quickened imagination, like the photographer's plate to rays of light, was keenly sensitive to intuitions born of spiritual knowledge. Now, reason closes this portal of the soul and allows nothing to pass not indorsed by exact science. And reason is in the right. For the imagination had allowed itself to become the tool of superstition and to be perverted to destructive and debasing ambitions. Even though reason might for a brief moment overthrow existing religious dogma of every kind, and cause its complex superstructures to fall to the ground, man would in the end gain in spiritual strength and knowledge, by the rigid separation of the wheat of faith from its chaff. Every event which opens up to research more definitely the properties of

Sacred traditions and literature.

soul or matter, or discloses more profoundly their rel-
ative functions and limitations, contributes towards
the solution of the paramount, unavoidable problem
of man's own existence, — whence came he, how should
he live and whither does he go. Japanese myths and
art at first look may appear to have little in them
helpful to us in this direction. But the more I inves-
tigate them the more I find they are instructive and
enjoyable, and the more earnest I become to impart
my convictions to my readers.

All genuine art is so suggestive in its twofold
nature that it is continually prompting the
mind to reflect on many questions and issues,
and to perceive much which does not always
seem in the outset to belong to it. But the outward
eyes see things in one aspect and the brain in another.
To the latter is opened, as to Peter in his trance, a
vision of all sorts of objects, common or uncommon,
let down from heaven for his use. Occult things do
exist and it is for us to find them out and trace them
to their origins. For this end we must often wander
from the plain beaten track into those psychological
paths which lead to unexpected views, or another as-
pect of the object than that which falls only on the
retina of the eye. Thus a glimpse into the songs of
a people, or, as with the Greeks, their dramas and
epics, and the poems of Dante with the mediævalists,
discloses the spirit of much that animates their objec-
tive art and which would not easily be found without
their literary coöperation. That art which is only
skin-deep is not worth looking at twice. Having no
meaning deeper than the drag of the brush, the im-
pression it leaves on the mind is equally shallow.

There is another side to Japanese art besides that

of its prevalent gayety, contentment, and rollicking pleasure in things material and common. It chiefly expends itself in music or song, but also finds continual expression in design and carving. Japanese children are early taught to chant in chorus the fundamental sounds of their speech grouped in verses of four lines called the Irowa. In some of these songs thus formed, there flows a deep undercurrent of plaintiveness, a mystical apprehension of the unseen forces that brood over nature for woe rather than for weal, at times almost sublime in its spiritual hold on matter, at others dismally materialistic and despairing ; the piteous refrain of resignation to the inevitable, or pious acceptation of the transitoriness of earthly objects and pleasures, being as melancholy in tone as the expressions of absolute forlornness or of utterly extinguished hopes as to there being anything better in store for man than present misery and final extinction. Neither the author of Ecclesiasticus, nor yet the Roman Lucretius, nor the Italian poet Leopardi, present sadder views of life or utter more soul-rending wails of skepticism than do some of the poets of this far-away olden " Land of Great Peace ; " [1] thus demonstrating that humanity under the most diverse forms and conditions is one and the same offspring of a common parent, inheriting similar intuitions, desires, and feelings, and alike groping in universal doubt or common hope in quest of " more light," or else sinking into a finality of despairing disbelief and utter rebellion.

The plaintive, skeptical, and despairing side of Japanese poetry.

But whenever the popular poetry of Japan stops short of absolute moral stupor, a resolute acquiescence in the inevitable, or buries itself in the impassiveness of nirvana, taking a spe-

Epicurean satisfaction in wretchedness and disbelief.

[1] See Appendix II.

cies of epicurean satisfaction in the most disheartening
conclusions, evidently making a sort of pathological
luxury of wretchedness and annihilation, it tries to
extract all possible joy from nature, because of its eva-
nescence, changeability, and hostility. It also shows
its scorn of fleeting wealth as not worth the amassing
for the brief tenure of human existence ; a phenome-
non of mind more peculiar to the Orient than the
Occident, and with us virtually unknown.

The following brief extracts vividly illustrate the
current poetical feeling to which I have
made allusion. They exhibit the same real-
istic sharpness of outlines, tender or sturdy
organism, and lack of balanced light and
shade, which we notice in the other artistic
forms, whilst all are closely related in idea and ex-
pression.

Graphic
realism of
poetry ; a
counterpart
of their de-
sign in feel-
ing and aim.

> " Pensive by the river standing,
> Search I long the clear depths,
> Listening to the shrilly cries
> Echoing through the streamy land,
> Of the snipelets up the river
> Calling down the river sharply,
> Calling on their mates,'' etc.

How distinctly we hear the cries of these wild
birds in their marshy home, so directly and pointedly
in a few incisive words brought before the mind's
sight, just as a few sharp strokes of the artist's pen-
cil present the same scene with equal force to the
outward eye. This is the only true sort of Pre-ra-
phaelite art, and corresponds to the practice of the
best and purest of Italy's " old masters."

The succeeding poetical picture of moonlit reverie
is also a favorite one of Japanese sketch-books.

> " Over wood and over lea
> Sheds the moon her pallid light ;
> High o'er drifting clouds exalted

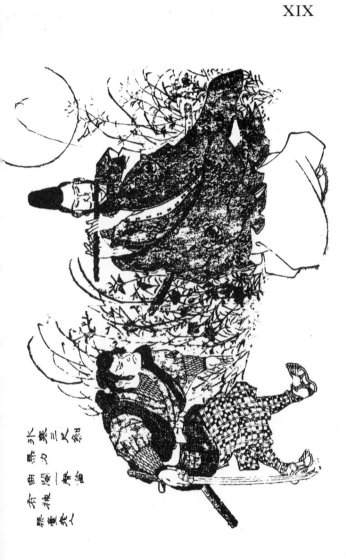

剣　又三郎
繪　一學　僧
假名垣　魯文

> In autumnal radiance,
> As I watch the changing shadows,
> Sadness slowly o'er me steals."

How wild blossoms in spring-time are gladly welcomed, let these lines, with their pathetic refrain delectably witness!

> " Should the mountain cherry cease
> In the spring-time of the year,
> With its mass of new-born bloom,
> Mortal men to cheer; also,
> Would the heart of spring be gone,
> And its brightness fade away."

And again —

> " How slowly roll the mists
> Off Miyoshino's hill-side
> Hiding still from our longing eye
> All the blooming wild-cherry flowers !
>
> . . .
>
> " The dark-massed shadows flecked,
> By the mountain's cherry bloom."

The sincerity and simplicity of these compositions, the yearning for what is most æsthetically poetic in nature, and the paucity of technical means by which they express varied emotions and facts are alike remarkable, and afford a pleasant contrast to the excessive sentimentality and overstrained composition of much of our modern poetry. The Japanese, too, are as appreciatory of " red tints of mountain maples giving a ruddy glow to autumn woods," as the most enthusiastic admirer of America's autumnal tints, and never weary of portraying the brilliant colors of the dying forest leaf, or sighing over the dying year.

The seasons in poetry.

> " Men may at this cheerless time
> Gaze on autumn's ruddy tints
> Through the streams of falling rain."
>
> . . .
>
> " The wild duck's mournful scream
> Piercing the distant sky
> Faintly echoes in his ear," etc.

The depression produced by the departure of what made up their naturalistic joy in the full bloom of nature, turns to gladsome strains in its reawakening and young growth when winter is gone.

> " The hearts of men are glad.
> 'Tis the happy month of Growth —
> And the slopes of all the valleys,
> Hidden as by fleecy clouds,
> Gleam with snowy Sakura bloom," etc.

How the pure taste and absolute naturalness of Japanese poetry are transmitted with a corresponding zest and pertinency into the decorative art of the country, I shall show in subsequent chapters. Meanwhile let us listen to their more melancholy strains Stubborn of verse, illustrative of a stubborn material-materialism. ism which refuses to be comforted even while yearning for immortality, and yet profoundly appreciating the better side of nature, and, as it were, unconsciously admitting a God and a hope from out of the very depths of unhappiness because seeing none.

> " Heaven above from earth below
> Long ago the God hath parted.
> (His) vast abode thus ne'er
> Hath the utter darkness known
> Of Primeval Chaos," etc.

> " Colors and fragance vanish —
> In our world nothing is permanent —
> To-day disappears in the deep abyss of nothing —
> It is the frail image of a dream —
> It causes not the slightest trouble."

A more low-toned resumé of life was never de-Plaintive picted than in this " Uta," a song resembling "Uta." the " Stornello," of Italy. Its plaintiveness is soul-haunting.

> " When the end of things shall come,
> And the troublous world shall cease,
> Shall not men be glad at heart,

> Hail the term of their unrest;
> For 'tis a world of misery,
> Ever evil are the times,
> As to man's benevolence
> As to human sympathy —
> Momentary joys are they,
> In an age of bitter pains;
> Fleeting as the passing water
> Left by yonder skiff impelled
> By some early fisher-boy,
> O'er the bay at break of dawn.
> Is this world a vanishing dream,
> Or a sad reality?
> Vain the question ; never may
> Mortal man the answer say."

The great Hebrew doubter and pessimist is here beaten on his own ground, and " all is vanity and vexation of spirit " reëchoed from the farthest extremity of the inhabited globe, in not less eloquent and touching phrase than his own ear-piercing strains.

Professor A. Severini of the " Istituto Superiore " of Florence, has recently translated into Italian Tane Hico's novelette of " Riu-Tei," or " Men and Screens," first published by its author in Japan, A. D. 1821. I cannot more forcibly finish this chapter than by extracting some characteristic lugubrious verses as sung by an unknown voice in one of its scenes.

"Men and Screens" a Japanese novel.

> " Della vita mortal che mai t'avanza ?
> Tenebra e nulla più.
> Corre l'uomo alla morte : una sembianza
> Vorresti averne tu ?
> Fingi al guardo una via che da un deserto
> In un deserto muor :
> Via buja, angusta, che dal passo incerto
> Ti smunge ogni vigor."

> " Sogno é di sogno, miserabil cosa
> La vita ! e vuoi saper
> Quant' ella sia ? Mentre ad un ciel di rosa
> Del giorno messagger,

> Già si diffuse a suon di squilla o canto,
> L' eco stessa che muor
> Del suon di questa vita appena é quanto
> A udir ti resta ancor."

Literally and imperfectly rendered : " What remains of mortal life but shadows and nothing more. Man runs to his death. Wouldst thou have a likeness of it? Imagine a road which, coming from a desert, in a desert dies. A road dark, painful, that by its uncertain course exhausts all strength.

"Dream of a dream ; wretched thing is Life. Do you wish to know what it is? Even whilst the rosy tint of heaven, messenger of the coming day, diffuses itself to the notes of the little bells or songs, the echo itself of the very sound of this life dies away before you can scarcely hear it."

Fortunately for humanity, few hearts anywhere beat time to this wilting apprehension of life ; but it is a psychological phenomenon that inevitably is born of the first stages of mortal conflict between faith and reason, and although so far in human history there has not been found a satisfactory solution or sufficient counterpoise, we need not despair finally of answering the question, " What is Life ? " in a far more encouraging manner.

SECTION IV.

THE CONDITIONS OF LIFE OF THE JAPANESE ARTISAN AND HIS WORK.

IF the soil and climate of Japan were as favorable to a prolific vegetation, supporting human life under easy conditions as to food, shelter, and clothing, as are some of the picturesque groups of islands in Polynesia, we might be less surprised to find so much attention given and enjoyment received from the æsthetic side of nature and the minor arts whose motives spring directly from it. But Japan is a land of great extremes of temperature, atmospherical vicissitudes, and diversities of soil, not to mention those frightful earthquakes and typhoons which periodically lay waste its fairest sites of industry, and cause a destruction of life and property elsewhere unparalleled unless we except the opposite coasts of China.

Soil and climate of Japan.

Extending over sixteen degrees of latitude, from 30° to 46° north, very mountainous and volcanic, underlain by subterraneous fires and percolated with hot streams, broken up into innumerable fragments of land small and great, sparkling with running waters and crystal lakes embosomed in verdant hills, divided into vast irregular sections and promontories by many inland seas and wholly surrounded by the vast Pacific Ocean, although possessing certain meteorological and climatic conditions very

Its physical features.

favorable to man, Japan demands of him also unre-
mitting labor to subsist and resist the destroying
agencies which go with them. Hence, these islanders
were always under a twofold stimulus to the health-
ful action of all their faculties, although their lives
were based on what the more ambitious Aryan races
might consider a somewhat scanty standard of mate-
rial needs and intellectual development. But so far
as it went it was thorough and good, and as it proved,
competent to make them happy and prosperous, with
sufficient mental and æsthetic activity to give them
a substantial superiority in some of the essentials of
life over Europeans. A manifold nature, alternating
from the sublime to the exquisite, with infinite beauty
of detail and forcible contrasts, ever pleasurably in-
vigorated minds keenly sensitive to its charms, whilst
amply providing abundant harvests for their simple
diet, and supplying them with every requisite motive
and material for the full exercise of their artistic pro-
clivities.

Until the recent political changes the people had
lived contentedly under a mixed feudal
and patriarchal *régime* which although it di-
vided them into sharply-defined classes with
distinct duties, occupations, customs, and privileges,
worked harmoniously on the whole, and maintained a
general well-being that left the masses nothing to envy
elsewhere, if we estimate the value of life by its cer-
tainty of daily food, freedom from harassing servitudes
and over-toil, and a cheerful acquiescence in existing
things; even if its religions held out no very cheer-
ful views of individual consciousness and bliss in a
future life. True, all the land belonged to the Impe-
rial Government and was held in martial fief by the

Feudal sys-
tem and
peasantry.

grand Daimios, or feudal princes, who rented it out to their literary and military retainers, the Samurai, — a class of local aristocracy which filled the provincial offices, did police duty and monopolized the fighting, — and to wealthy contractors. In turn these sublet to the petty farmers who paid their rents in kind, as is still the practice in Tuscany, only the Italian *contadino* is very apt to get the better of his landlord in the division of their joint harvest. If his Japanese brother were more honest or less shrewd, he had his compensation in the obligation of his landlord or feudal chief in times of scarcity to feed him out of the public crib he had helped fill in seasons of plenty; a coöperative principle of practical merit, under whatever paternal system of government.

Little was spent by any class in our so-called necessaries of life, which to all were superflu- Necessaries and superfluities of life. ities not worth the coveting. Indeed, there were few household effects to catalogue in the Japanese domestic circles outside of their sumptuous but not numerous full-dress toilettes, nor anything to give anxious parents a moment's anxiety regarding the dots of their marriageable daughters. Meat, rich and varied furniture, jewels, upholstery, equipages, dear viands and wines, periodical changes of fashions, expensive pews, more expensive schooling and costly political elections, were among those things which were not to them; a deficiency that left whatever surplus of earnings and income to be bestowed on the luxuries, as we miscall them, of a family; in other words, those artistic objects and rural and æsthetic pleasures which figure so extensively in every well-to-do Japanese household.

Food, chiefly rice and fish; clothing, chiefly silk

or paper; the metals, minerals, and woods they used,
the books they read, and whatever else was
required — little enough it was — one and
all were inexpensive and abundant. Even
gold was only four times the value of silver, and
small account made of it, except in ornamentation,
for which it was, as is proper, lavishly used as being
the purest and most precious of substances, the most
enduring, and therefore the most fitting materially
and in significance to be employed in the service of
beauty.

Values of gold and silver.

Although wages were infinitesimally low, they suf-
ficed to supply the wants of the family.
Shop-keeping gains were on a like diminu-
tive scale. Not even the native Plutuses were per-
mitted to be extravagant in garments or living. No
class could go beyond its prescribed sumptuary bound-
aries. Yet all fitted together in brilliant and forcible
contrast, or delicate gradations of designs and color-
ing, like one of their own inimitable straw-mosaics,
or harmonious combinations of multifarious materials
in best lacquer work. I do not assert that this is the
best possible type of a human society. Far from it!
But it had some positive merits of organization and
performance which we need not gainsay.

Wages and gains.

The too tightly drawn lines of castes, especially
the military, as might be expected, engen-
dered some conspicuous evils, as did also
the principle of confining certain trades,
arts, offices, occupations, etc., to distinct
classes by inheritance. This law favored skill and
continued perfection within defined limits, sustained
the thoroughness and nicety of all artisan work,
helped the growth and conservation of a fine taste,

Castes, arts, trades, etc., descend by inheritance in families.

prompted a healthful pride, and fostered a steady habit of keeping customs and things up to their highest standards of excellence; all which was extremely beneficial, as is demonstrable by the material results of their several industries. Nevertheless, it hindered a universal progress, and often prevented the selection of the fittest talent for a special work or office. Society became securely anchored in a well-sheltered roadstead without doubt; but it was at the expense of the accumulation of many barnacles on the bottoms of its vessels, which the rougher waves of an open ocean would have prevented, much to the advantage of their sailing qualities. Individual development was subordinated to the conveniences of a system or transmitted privilege, whether deserving or not. As things are, so must they be, is a seductive maxim to those who rule in virtue of it, and are born to the prizes of life; but rather hard on those capable of winning some for themselves, but are forbidden, lest they disturb those in possession, even if no longer qualified for society's trust. There is somewhat to be said on both sides. As the Japanese after a long trial of the one system have gone over to the other extreme, we have only to wait and see how it will answer in their case. It cannot but be serviceable in extinguishing the swaggering Samurai; which caste, not finding a congenial employment after the downfall of their feudal lords, was wont to vent its surplus combativeness in home-bullying and violence. A change which converts a ferocious or selfish egoist into a useful citizen is a gain to any community.

But brutality and folly were not the rule of the privileged classes in Japan. The current deportment of the various social strata, Deportment of various classes.

among the higher classes, was elaborated into a punctilious courtesy which won for them the reputation of being the most polite of all aristocracies anywhere. Their suavity and stateliness by degrees interpenetrated all the inferior orders, developing a polished decorum, and an elaborate etiquette gracefully carried out, conducive to the general amenity of manners and interchanges of kindliness, often to the absolute devotion, even to death, of the retainer to his lord, that all foreigners who have had free intercourse with the various classes have pleasurably remarked.

Indeed, ceremonial politeness obtains to such a degree, that it acquires at times almost a touch of grim humor. When a noble is to suffer death, the executioners are selected from his own family and retainers, that he may not be soiled by impure hands. The persons chosen are those most friendly to him, and are called his "guardians," or "seconds," as if their appointment concerned his deepest interests and honor. With a polite irony, as we should consider it and beg to have omitted on such an occasion, they address the noble criminal, often their most intimate friend, or nearest relative, in such words as these : "Sir, we have been appointed to act as your seconds ; we pray you set your mind at rest." Then the one who is elected to give the fatal stroke, adds, "As I am to have the honor of being your chief second, I would fain borrow your sword for the occasion. It may be a consolation to you to perish by your own sword, with which you are familiar." As the last moment approaches, perhaps adding with a crowning courtesy, "Sir, your final minute has arrived ; be so good as to turn your cheek, so that your head may be in the

Etiquette at the executions of the nobles.

right position," which words were actually said to a councillor of Prince Katô, on his recent execution.

The punctilious self-control and fine bearing of the victims are worthy of their aristocratic births and breeding. In inflicting on themselves the death-penalty of *hara-kiri*, which they have at times the option of doing before a select circle of witnesses, they show the same formal serenity and, one cannot say contempt of death like the savage at the stake, but calm resignation to their destiny, and a triumph over physical suffering equal to a martyr's, accompanied with exquisite courtesy of speech and gesture to the last breath, solicitous only, like the great Cæsar, to die with decency, as befits their rank or culture. As the *hara-kiri* consists in plunging his own broad-bladed dirk into his bowels and Hara-kiri. twisting it about, making a frightful wound before the friendly second is permitted to cut off his head, the condemned person must require no small amount of nerve as well as good-breeding to perform the operation with the dignity and calmness expected of him. But even in the late instance of Tuki-Zenzaburô, the petty officer executed by order of the Mikado in the presence of the foreign legations for an attack on some of their people, with an unmoved countenance he made those present a profound bow, saying " For my crime, I now disembowel myself, and I beg you all to do me the honor of witnessing the act," as he struck the dagger firmly home and cut himself open.

It is noteworthy that fine manners diversely emphasized according to ranks and conditions, Fine man-graceful and elaborate in highest society, ners, causes and effects. simple and winning in lower, as a general rule characterize peoples who have a genuine feeling

for whatever is artistic and beautiful. This disposition seems to exercise a reflex influence on all the faculties, by putting the entire soul in sympathy with the refinement and æsthetic culture that comes of a devotion to true art. The inhabitants of Japan for ever so many centuries have allowed free rein to this subtle psychological principle under the guidance of an orderly civilization, especially adapted to keep it alive and fully develop its forces. Much, if not all that is comprehended under the term fine manners as personal deportment, seems to coincide with a mature art-culture in any people, and to diminish as they grow indifferent to it. Baron Richthofen, in his travels in China, writing of the people of Syr-chwan, an inland province, says they are " the most gentle and amiable in character, and the most refined in manners " of all the Empire. Speaking of the capital, one of its largest cities, he adds, " nowhere in China is art valued by the present generation as high as in Ching-tu-fu. All tea-houses, inns, shops, private dwellings, have their walls covered with pictures, many of them reminding one of the Japanese ink and water-color drawings in point of artistic touch. No traveller can help being struck with the great artistic perfection of the triumphal arches, worked in red sandstone, which abound in the country. They are covered with sculptures in high and low relief, representing scenes of mythical or every-day life, mostly with a tinge of the humorous. Some of them are masterpieces of Chinese art. In no respect is the refinement more perceptible than in the polished manners and gentle behavior of the people, in regard to which the inhabitants of Ching-tu-fu are ahead of the rest of China."

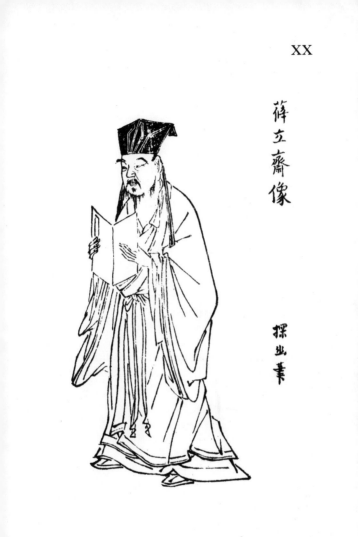

蔣立齋像

探出書

Similar causes tend to like results everywhere. But I do not wish to be understood as saying that *all* art tends to produce fine manners by any means. If art is insincere in itself, low in motive, or partakes of any of the infirmities of base passions and mean egoisms of any sort, its tendency is to the destruction of whatever is genuinely fine in manners and character. It then becomes an instigator and diffuser of evil thoughts and associations, and familiarizes the eye with low types of every species. Consequently the taste becomes perverted, impure, and even impish, delighting in cruelty, extravagance, and things abnormal in crookedness and perversity of mind and manners, and uglinesses in general, personal deportment being no exception. The "rococo" bestialisms, inanities, and distortions, evince this phase of art as Dutch sensualisms do its coarseness and abasement in another, while absolute materialisms of every kind are a moral and intellectual deadweight to art in any refining and spiritual sense. But whenever art is characteristic of an entire people and strikes its roots deep into their better dispositions, taking its motives from the purer aspirations and instincts of humanity, aiming first to establish itself in those heaven-fed truths which are the birth-right of all men and nature, and to clothe them with beauty, if we do not barter them away for a mess of porridge as simple Esau did his birthright, then art cannot fail to express the same beneficent influence over mind and manners that it did in Japan, Italy, and Greece.

Low art tends to low manners and habits.

This too all the more, if noble families, imitating the example of the Dukes of Urbino in perfecting majolica, encourage the progress of the minor arts, less for profit than as insig-

Japanese princes encourage art and practice it.

nia of aristocratic culture and gifts beyond price to
princes, and standards of perfection in their various
branches. Not only did the Japanese nobles thus
sustain art, but they further made it fashionable by
their personal knowledge and practice. The most
exquisite bit of inlaid ivory lacquer-work I have ever
seen, a cabinet with lovely compositions of birds and
insects and scenery on the panels, is said to be the
joint work of several princes, brothers, who lived two
centuries ago, and was kept as an heir-loom until it
fell into profane hands during the recent civil war.

The best epochs of Japanese art correspond appar-
ently with the European. At all events,
there is a generic likeness, varied of course
by the specific tastes and resources of the
former people, to the successive art-waves which have
passed over Europe. Perhaps it would be more exact
to divide the periods of Japan into two great ones,
answering to our religious and naturalistic phases.
The first is contemporary with the ancient dynasty of
the Mikados ; the second corresponds to our Renais-
sance, and is more identified with the Shôgoons on
their accession to the executive authority, but has less
of the *rococo* spirit that grew up with its fortunes in
Europe. The virgin freshness of both schools, per-
petuated through so many centuries, is largely due to
the habits of the artisan and the sovereign instincts of
the people in their devotion to nature.

The workman was a thorough *worker* and master
of his particular art, content with nothing
short of absolute technical perfection, æs-
thetic and material, in every object he un-
dertook, whether it was cheap or valuable. Usually,
he labored by himself, in his own cottage, or else with

Marginal notes:
Best epochs
of Japanese
art.

The work-
man a thor-
ough master
of his art.

sympathetic associates on such branches of art as had been slowly perfected by many generations of his ancestors under the fostering care of their feudal lords. Thus he was born both to pride and skill in his work. There was a marked contrast, involving a fathomless æsthetic gulf between him and the average European artisan, doomed to monotonous uninspiring toil, herded with his fellows in unwholesome factories or the filthy purlieus of crowded cities. The nature too of his task was akin to his tastes and a source of happiness to all concerned. Besides the domestic satisfaction of being always at home in a congenial circle of qualified critics and co-laborers, his own spirit unconsciously imbibed in more or less degree some of the purity, poetry, and refinements of the motives which actuated his art. These in general were derived from the ever bountiful landscape, which was always an unfailing spring of pleasure to his easily contented household, or from the pictorial literature which embodied the myths, romances, traditions, and history of his native land, whose " great peace " in this manner interpenetrated his inmost being. It is no matter of surprise that he left his work with reluctance, returned to it with zest to perfect it, and was always diligent without thinking of how much he was to gain by it, or what the newspapers would say of him. The pay was at the best a mere pittance. Sometimes he was lodged, fed, and received monthly wages equal to from three to six dollars of our money. The same system and lowness of gage once obtained in mediæval Europe, producing the best work, even when artists were put on the same social footing as common mechanics and day-laborers. The *working* architects especially, master-masons we

term them now, built up the best architecture of the
time, step by step as they went on with their work,
qualifying themselves in every part, and thus making
an æsthetic unity of the structure and its uses, as orig-
inal as it was appropriate,—'economically done also.
But we have changed all this, as we are fast obliter-
ating the ancient Japanese artisan and turning him
into a machine-laborer, prompt to begin and end on the
minute, to run on time, caring only for his pay, care-
less of what he does, as well he must be, for there is
no soul in what is required of him.

But our workman was free to work when he felt in
the mood to do justice to his object, and
Perfection
and variety
of his work. equally free to seek repose the instant fatigue
notified him of failing powers. By no other
system could he have attained to such uniform perfec-
tion and infinite variety in his work as he shows in
everything which can be classed under the head of a
fine art. The absolute excellence, rare invention,
pure taste, accurate finish, entire adaptability of each
article to its destined use, besides its superimposed,
harmonious, æsthetic cachet, beauty combined with
the cleanness and neatness that is next to godliness,
infiltrating every fibre of an object, all this make up
a veritable music for the eye, even in those cheap ar-
ticles which are destined for the multitude. Each
is perfect, novel, and idiosyncratic ; no more like its
neighbor than one man of spirit is the tame repeti-
tion of another man.

We must not confound the tawdry, frail, meaning-
less articles made to order for foreign markets with
those begotten of the old *régime*. Until to-day, one
may say, industrial and social science, fettered to a
purely mercenary commerce, had no weight in Japan.

Its art got at its results in its own free, off-hand way. We have seen how the old Japanese lived as a people without being in bondage to any system of superfluous wants. Yet although uncaring for furniture in our sense of it, they required of each article, however common, that it should in some way be so constructed as to strike the senses with its elegance or beauty as the *first*, and always the most obvious sensation. Convenience was a secondary, but *Beauty the chief aim.* not neglected object ; for the Japanese artisan beats us here whenever he chooses or has occasion to come into competition with our useful articles. The mechanical perfection of Japanese carpentry, metal work, papers, leather, in short whatever they manufacture, from a mammoth bell down to a box-hinge or hair pin, is quite as conspicuous to the eye of a mechanic as are the æsthetic features of objects of art to an artist's senses.

Nevertheless, they preferred to amass artistic treasures ; things and ideas to beguile the mind from over-much dwelling on the utilitarian side of life. It is not wonderful, therefore, that in the superior enjoyment these give, they forgot to invent our heaps of homely *Utility a subordinate feature to the æsthetic, but not neglected or slighted.* necessaries of existence. Nor yet in obtaining sensuous loveliness and poetical feeling did they altogether neglect the higher instincts of the soul. Often side by side with, and interblended, we find the most delicate art, subtle skill of handicraft, and quaint or practical lessons of life or morals. There is in the possession of Mr. Sutton, of New York, a tiny, elongated vessel of the red Kagha porcelain, in the interior of which, so small and inaccessible as to be a miracle of art, in minutest Chinese characters of

cobweb delicacy, is the following text explanatory of
the painting on the outside, of two men standing by a
stream conversing and fanning themselves with assid-
uous politeness. As translated in the "New York
Tribune," it reads as follows : —

" Kutzen had already taken his leave, and was wan-
dering by the side of the river, in a sorrow-

A unique
vessel.

ful and dejected manner, when he met a
fisherman, who said, ' Why do you come here ? You
are the chief retainer of King Sâ.' Then Kutzen
replied, ' The men of the world are all alike, and as
impure water, but I am pure ; they are all drunk,
but I am sober ; therefore I came here.' Then the
fisherman said, ' An ancient sage has said that if
we mix and associate with the men of the world, we
shall become as impure as they are ; if they are all
drunk we shall be drunk also, and drink the sediment
of their drink ; if they are dirty, we shall be dirty
also, and stir up the mud.' Then Kutzen replied, ' It
is an ancient saying that when we dress our hair we
necessarily rub the dust off our cap ; when we bathe
in hot water, we necessarily shake the dust off our
clothes ; thus, when our hearts become pure we shake
off all defilement. I would rather throw myself into
the river and become food for the fishes than to be
defiled by thee !' Then the fisherman went away
smiling, and striking the gunwale of his boat, sang :
' So, when the waters of Soro are clean, I will wash
my cap-strings ; when the waters of Soro are dirty,
I will wash my feet.' "

As regards the strictly industrial arts, the principle
of making ornament subordinate to use is a sound one.
The constructive form of the object should be care-
fully adapted to its final purpose. If grace of shape

and attractive color are superadded, these should be
as accessories to commend it to the taste. The Jap-
anese artisans understand this principle perfectly in
its minutest and humblest applications. Even the
common articles of necessity are made so agreeable
to the eye by accurate finish and mechanical ingenu-
ity, that it is a pleasure to use them, if solely on ac-
count of these qualities, as we by force of
wholesome affinity become fond of persons
of an inferior social position; however ig-
norant and homely, if sound at heart and
healthy of body we must esteem them. Common arti-
cles in Japan are very certain to be sound as regards
their strength, neatness, and utility. We can trust
them. But even the meanest is quite sure to have
about it some slight suggestion of ornament, some
dainty touch of an æsthetic finger which gives it an
air of good-breeding, and like the trained politeness
of the Latin peasant, or the Japanese, too, as for that
matter, raises it to the higher level of an intellec-
tual as well as material recognition. This comes of
the perfect knowledge of where utility ends and deco-
ration begins, their reciprocal virtues and duties, and
skill in uniting them.

The constructive soundness of common articles.

But the mischievous confounding of the funda-
mental purposes and limitations of the in-
dustrial, with the fine arts, is but too com-
mon in Europe and almost universal in
America. We produce in consequence a vast num-
ber of things incongruous in constructive principles,
vulgar in ornamentation, garish in colors, and at the
same time of little poetical value; whilst those in-
tended particularly to gratify taste are tortured out
of their legitimate forms by a futile desire to force

Confounding of indus-
trial with fine arts.

them to subserve some domestic need. There are
people who would put nightingales into harness and
make lilies pump water if they could. Our homes
are crammed with inappropriate objects, neither use-
ful nor beautiful. They *furnish*, or are charitably
supposed to, one may guess in conjecturing the cause
of their existence. But the more furniture, the less
real comfort and satisfaction, is the experience of the
æsthetically wise man in America. Money is worse
than thrown away in heaps of uncomfortable trash,
frivolous in idea, inane in look, and every way vex-
ing the artistic eye, without yielding any adequate
return to the physical senses. Paris and Vienna are
the chief centres of this traffic. Not only are many of
their would-be-tasteful productions wrongly conceived
structurally, false as regards the grammar of orna-
ment, but meretriciously ugly. There is displayed in
the greater numbers a pitiable poverty of æsthetic
invention, especially in the attempts to get at some-
thing original by departing from pure classical forms
developed on principles of harmonious curves founded

Radical de-
fects of
European
ornamenta-
tion.

on subtlest gradations of lines. But the
radical defects of European ornamentation
are more vividly shown by placing it beside
the Japanese. Any fair collection of Jap-
anese decorative art makes the average European look
distorted, pretentious, or pitiful. What once in the
latter seemed true and tasteful to us, now sinks to
its rightful level and appears crude and inharmonious,
besides showing more or less defective workmanship.
There may be fineness of material texture, superb
polish, showy coloring, and fair academic design, and
very likely a certain prettiness of composition and
dainty manipulation ; but as an entirety, the articles

will lack a correct style and true method of decoration, a style and method by which the substance itself, its technical and scientific treatment, its modeling, painting, or whatever else is done to anoint it with beauty, are æsthetically combined into a harmonious unity, every detail living for itself in virtue of its own laws of being, and yet nicely adjusted and balanced in reference to the whole thing, and causing the spectator

Epitome of character of best Japanese art-work.

to forget the dextrous handicraft and the delicately trained perceptions of the workman, in the spontaneous pleasure his work evokes, and only to be reminded of his means, when the mind is stimulated to analyze the causes of its satisfaction. Now this is an epitome of the character of the best Japanese decorative art which our short-sighted commerce is ruthlessly destroying, aided by the radical social and political revolutions of the country itself. For from time immemorial, contrary to European practice, but rightful in the intellectual scale, the artisan of Japan had taken social rank above the trader and merchant. The former created, the latter simply sold; one made wealth, the other exchanged it on toll. Here, it seems to me, the Japanese saw deeper into political economy than we. At all events he recognized the higher calls on intelligence, study, observation, imagination, and the emotions, of the artistic over the commercial professions, and how great an intellectual strain was placed on the body and brain of the former, to keep up to the standard of taste of a population long trained to enjoy and comprehend their best work.

European articles, not infrequently, are artistic without being æsthetic. This essential distinction

must not be overlooked. A man may draw, model,
and paint with academic skill, and yet be
without any real appreciation of beauty.
So, too, the reverse holds equally good. He
may also thoroughly enjoy and compre-
hend the nature of fine art, without any technical
knowledge of art. As a people, we Americans have
some slight experience and cleverness in the mechan-
ical direction ; but are destitute of sound æsthetic
taste, and indeed feeling, as a nation. The Euro-
peans are fast becoming more artistic than æsthetic, I
fear. Ancient Greek art was the happiest union of
the two that the world has as yet seen. In the sense
in which I am now defining art-work, the Japanese
are perhaps even more æsthetic than artistic. Evi-
dently they seek in their decorative arts to create
pleasurable sensations primarily, as does music, by
striking those human chords which are most sensitive
to delicate, subtle, mystical, or emotional impressions.
I know intimately a European scholar of fame, whose
time is so occupied that he never can look at a work
of art unless his attention is incidentally called to it,
and whose artistic knowledge is absolutely a cipher.
Yet when he does look at a good work of any kind,
of any race, he quivers with delight and most tersely
and truly interpenetrates its spirit, and explains its
being with a sincerity of feeling rare, even among
great artists. The majority of artists, so-called, I
have known, have shown little or no æsthetic feeling
or discrimination, and were unacquainted with the
history and arcana of their profession. The most that
can be said of such is that they are artistic machines ;
mere human substitutes for that famous invention
which undertakes to make statuary by patent ma-

*The distinc-
tion between
artistic and
æsthetic in
man or ob-
ject.*

chinery. Outside of their dry studio work, they neither cared for nor enjoyed art, and had no sympathy with what the true artists had done or were doing, except as it might be made a means of making money for themselves, and padding their own reputations. No genuine æsthetic objects, unless as stock in trade, adorn their walls ; not an indication of genuine æsthetic feeling ever escapes them. And it is into the cold cunning of this mercenary, egoistical class, largely ignorant of culture of any kind, indeed indifferent to it, whose highest ambition is to get rich and famous by shamming a feeling and knowledge it does not possess, and which is as destitute of any real demonstrative passion for art, as its works are mechanical and soulless, whatever may be their degree of technical excellence honestly acquired, or surreptitiously bought, that the destiny of much of modern art has fallen. What marvel, therefore, that a low grade of realistic excellence now seems to have become the most popular standard of art the world over !

In view of this fact, we may all the more profitably dwell on the best Japanese examples of the happy combination of an unrivaled sensitiveness and minutest delicacy of subtlest manipulation, on their directness, firmness, Japanese art, what it combines, its threatened extinction. and minuteness of touch, stroke, and outline, on their high and low harmonies and contrasts of color, on their inventive daring and variety of designs and composition, their thorough and masterly hand-work, wedded to a vivid truthfulness of artistic and æsthetic characterization, giving this last, albeit it should have the place of honor, for it takes unconscious precedence over all the rest ; and we may weep over their threat-

ened extinction. Ever since Chinese art has followed
the European mercantile track it has lost more and
more of those qualities which made it only second in
interest to that of Japan. As we now get it, the
Chinese modern art, its degeneracy. bizarre, extravagant, exaggerated degenera-
ting into positive ugliness, want of fresh in-
vention and love of nature, and an abundance
of diabolism ; such are the more obvious features of
what is left of the original art of the Celestial Em-
pire, tempered somewhat by lingering traditions of
the once matchless, pure tints of its porcelains, but
really rejoicing most heartily in overcoming mechan-
ical or technical difficulties.

Kiyoto, the sacred city of Japan, is the centre of
the old art, as Tokio, or Yedo, is of the later
Kiyoto and Yedo, the seats of the old and new schools. school. When we consider to what extent
the negation of prosaic utility obtains in
most of their decorative art, their emphatic
throwing overboard of serviceableness whenever
forced to choose between it and the loss of the æs-
thetic principle, we must give the palm of a high-
toned consistency, as regards art, to the Japanese.
We are more hampered by our mechanical and utili-
tarian tendencies and avidity of gain. The common
taste follows the grooves of trade and obeys its dic-
tates, which directs it from the noble, pure, and sim-
ple to the pretty, ingenious, meretricious, or appar-
ently difficult. Beauty is handcuffed to a specious
political economy and false social system. Rich
furniture in excess of any reasonable wants is the
tyrannical necessity of household life. We must
furnish, and in the latest style, whether the objects
are needful, comfortable, beautiful, or the reverse.
Custom requires a vain show of upholstery and

kindred expenses transitorily adjusted into passing grooves of fashions invented to fill covetous trades-folks' pockets with greater rapidity than any perma-nent, well-founded taste would permit; to excite dis-contents and a passion for frequent changes, in which the individual judgment or character of the buyer shall be subservient to the interests of the vendor, and he be frequently deluded into a vain-glorious re-newal of his expensive domestic fittings; such is the tempter, tyrant, and dictator of our æsthetic faculties and purveyor of our taste. All this might be endur-able, and perhaps, useful, if the workmen were free artists as in Japan. But to make art more unspeakably sordid and mechanical, we man-ufacture a multitude of costly, uniform ob-jects, which are palmed off as artistic on the much-abused-by-their-own-consent public, *The tyranny of custom or fashions in art objects and furni-ture in Eu-rope and America.* and prepared by workmen each of whom is a slave to a fraction of the whole of a soulless, mechanically conceived, and machine-executed object, the perfec-tion of which consists in its being produced in the quickest and cheapest manner, and dearly sold as an indispensable portion of some lugubrious or awk-wardly conceived piece of furniture which for the moment is dubbed fashionable. It is utterly impos-sible that such objects should be either artistic or æsthetic, and they are about as poor an investment for human faculties to manufacture and human bodies to use as can be made. For they not only stultify the workman, but they debase invention and demor-alize taste.

The supreme art-principle, *not* to copy nature lit-erally, but instead to render its character-istic action and expression more by a sug- *Supreme art principle.*

gestion of the particular fact than the futile attempt
to repeat its every detail, is very perceptible in Jap-
anese work. In its subtile treatment the native
artist is wonderfully accomplished. In every other
branch of Japanese art there is somewhat to qualify
eulogium; but in the purely decorative, based on their
perceptions and apprehensions of nature, there is little
to make exception at; nothing, indeed, we may say,
as regards their finest examples. The mind loses all
its captiousness in beholding it, and no more ques-
tions its æsthetic genuineness than the body does
those rare sensations of complete health, when sim-
ple being becomes a positive pleasure. This species
of mental and corporeal beatitude is the result only
of those art-creations which are so harmoniously bal-
anced in all their features and functions as to expend
their force less in stimulating thought than in cheer-
ing the mind and putting it in sympathy with beauty
whether of art or nature. There are persons who
take possession of our spirits in the same quiet, inter-
penetrative way, and for the moment fill us with
blissful consciousness of their own happy measure of
being, just as others provoke discussion, or stir up
latent antagonisms. Now the crowning merit of the
best Japanese decorative art is precisely of the former
kind, which is most rare in all art.

The æsthetic temperament of a nation is most
Color and subtly felt in its use of color. Design is
form, their more often circumscribed by particular exi-
relations and gencies of the parent motive apart from the
effects.
purely artistic. In dealing with color the artist can
employ it either as accessory to form, or independent
of it. He has only to consult its relations to his ideal
conception as how best to oppose, balance, graduate,

subdue, heighten, or tone its qualities in order to pro-
duce certain psychological effects either originated in
his mind or suggested by nature. The effects of
color, as of music, in some animals is conspicuous and
not to be always explained by association. They
seem more of the nature of direct causation. Viewed
in certain aspects color can be said to respond to
mental conditions, and the manner of its use or enjoy-
ment to indicate spiritual, sensuous, or sensual pro-
clivities of thought. By itself each color is negative,
like musical notes, although there are tones in both
which conform to states of mind and body. Purity,
coldness, sensuality, brightness, or dullness of tints,
are significant terms co-related to mental and physi-
cal human phenomena. Their roots also penetrate
deep into the spiritual mysteries of humanity. By
spirituality in color I mean the clearness and harmo-
nies of simple, unmixed tints, as shown in the sacred
art of Italy in its best estate, when it portrays heav-
enly beings and things.

Europe passed from this psychological extreme to
absolute materialism in art, going through an inter-
mediate colorless period and one of barren intellec-
tuality. These phases represent extraneous mental
forces rather than independent art-periods. But in
the Orient the use of color seems always to have been
coincident with a passionate æsthetic satisfaction in
it for its own sake, unchanged by time or ideas for-
eign to itself. In Japan, specially, its aspect is that
of a distinct, independent faculty, never soaring above
refined sensuousness, often sensually strong and deep,
most frequently extremely delicate and varied in its
harmonies, in keeping with those seen in the rich
material nature of Japan, and sometimes displaying

a fullness of splendor seldom equaled elsewhere. The Orientals solve problems of color, which, with our enfeebled senses, we never dare consider. They distil, as it were, delicate new tints from nature's gifts, which are the despair of European chemical science, and which we can only liken to happy functional expressions of æsthetic temperament in the objects themselves, as the sun glorifies the clear sky, according to its season and position in the heavens. Their combinations, oppositions, balancing of masses, fineness of gradations, breadth, variety, depths, intensity, clearness, directness, dexterity, boldness, apparent possession of the chemical secrets of nature, self-reliance, and infinity of devices, heedless whether or not they make the structural design or motive play a secondary part, especially as regards the human figure, a practice so contrary to ours, are all calculated to startle eyes accustomed to view the organic form as of first importance in art composition. With all their license, however, no people know better how to accurately illustrate natural history. Their prints of birds, fishes, animals, plants, and insects, are true to life.

Several years ago a Japanese student in Paris, described to me as existing in his country, costly albums of water-colors, done by distinguished artists of former times, but which were now become rare. At last I had the good fortune to see one. It was beautifully mounted with chased silver at the corners, and opened like one of their house-screens, so that it could be extended the length of the entire number of paintings. Their delicacy, truthfulness, subtlety of gradation and drawing, vividness of color, and pure sentiment, were fully up to my informant's words, which, at the time I con-

Japanese albums of water-color drawings.

jectured, were more patriotic than exact. The sub-
jects were chiefly birds, insects, flowers, and natural
objects, and a few imaginative compositions done flat
and shadowless after their usual method; but with a
wonderful characterization of each object, and a re-
finement of touch and close sympathy with its hap-
piest moments, that could not fail to satisfy the most
critical exigencies of this kind of art.

Those highly decorated albums which reveal the
mysteries of fashionable life in Japan, are
more resplendent in color, but somewhat
crude and exaggerated in contrasted masses,
especially if executed under foreign influence, merely
as merchandise. The best of them, however, have
some extraordinary merits. There lies before me a
favorable example printed on finest crape, the crimped
texture helping its tender hue and softness of surface,
and agreeably subduing tints, which on white paper
would be too much accentuated. Invariably, the
first surprise arises from the intensity of the color-
ing, and the extravagant designs which distinguish
the cumbersome costumes of both sexes. The dresses
of any class are seldom of sombre and quiet hues,
although we do sometimes see shades of colors which
the most refined European taste might envy. Gen-
erally, however, the figures on them are taken from
the gayest specimens of the animal or vegetable king-
doms, chiefly birds and flowers, distributed in loose
order, although geometrical patterns and arabesques,
somewhat similar to the designs in Eastern carpets
and Cashmere shawls are common. Extremest depth
of color, no faint toilet tints, thin and evanescent
like hues of confectionery; but got direct by an al-
chemy of fadeless dyeing from natural objects, whose

Albums in printed colors.

sheen they rival, giving a bright sparkle throughout, each figure a complete picture in itself, and in accord with its neighbor, the whole forming moving tableaus in harmonious confusion, birds of paradise displaying their fairest feathers, beds of contrasting and inter-blending flowers. Such is the first impression on the eye of one of these fashion-plate albums,— altogether stronger than is agreeable.

This is only the partial effect. We have equally emphasized background, redolent with the perfume of pink blossoms, the sweetness of young grass, sil-ver flow of clear-running streams, foam and toss of ocean, mysteries of fog-veiled landscape, blue hori-zons crag-pierced, and far-away mountain peaks, lost in dazzling snow, or else elaborately decorated wall-screens covered with histories, romances, and myths, epitomized panoramas of the fabulous ages, half-hid by embroidered draperies of richest satins, descend-ing close to beautiful mattings of uniform hues ; but high-pitched like all the rest, color-eloquent through-out, and sense-exciting as is a passionate overture to a grand opera, every detail indicating an æsthetic fondness for brightest tints.

Words are as futile to describe color as music. A System of coloring. faint inkling of the Japanese methods and effects is all one can hope to give. There is a delicate gradation of the bright tints which con-ventionally represent sky, water, land, or vegetation, which is as frankly genuine as the similar work of our mediæval miniaturists ; often the more wonderful from being printed, and with a vitality of associa-tive impression that may well put to blush the crude-ness and deadness of our chromographs. Forms also are outlined in the flat with an admirable structu-

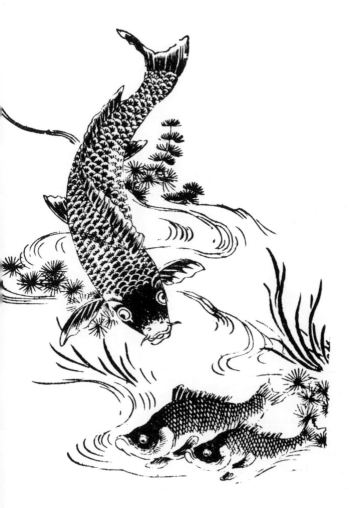

ral correctness and spirit. The generic anatomy of
plants and trees is largely indicated ; the colors of
fruits and blossoms being grouped like musical notes
to produce a visual melody, while the sharper con-
trasts and profound oppositions of costumes serve to
complete the likeness as a whole to a brilliant orches-
tral performance.

What we make of highest importance is the least
to them. Besides being featureless and colorless,
flat in drawing, monotonous in type, the human form
serves only as a lay figure to pose and dress to suit
the artist's wishes ; but, owing to his mas- Mastery
tery over action, he endows it with abun- over action
 and use of
dant character. Inelegant and inaccurate in human
 figure.
modeling, it expresses lively emotions and
supports accessories done with graphic truth. Look
at the aged servant in livery, on all fours, whose spine
is used as a footstool by an elegant lady, on tiptoe,
stretching herself to her utmost to pluck some blos-
soms from an overhanging bough. The crimson blush
of the flowers is surpassed by the deeper glow of the
horizon behind green hills, which rise beyond crystal-
line waters ; while the deep blue, orange, and red
patterns of vine and armorial designs, or checkered
figures, on her rich purple dress are repeated in vari-
ous and equally splendid coloring on the gala cos-
tumes of women menials, one of whom is holding up
a beautiful tea-service of egg-shell porcelain, and the
other presenting a visitor's card on a lacquer plate.
As respects drawing, the upturned head of the old
servant is greatly awry ; but his firm-set lips, com-
pressed eyes and nostrils, painful curve of back, and
firm planting of wrists on the ground, showing vio-
lent tension of muscles, indicate in a naïve manner

the weight of his mistress, who, absorbed in her own action, regards him no more than if he was literally a bit of furniture. Her unsteadiness of balance is ludicrously perceptible, echoed in the half-alarmed and half-smiling watchful looks of the women, who evidently expect her to tumble. At first the brilliancy of coloring of the whole picture obscures the drollery and intensified action of the actors ; but as soon as these delightful qualities are noticed they form a sufficient compensation for defects in other particulars, and force the coloring to assume its relative position in the story.

The same album introduces us to musical soirees, literary and artistic reunions (Japanese ladies, be it known, sketch and paint exceedingly well) ; calls of etiquette, games, moonlit

Scenes in fashionable life.

walks ; coteries of scandal-mongers, whose *finesse* of pantomime is worthy of the best comic acting ; tea festivities ; and the chivalric rescue of two ladies at night, attacked by an armed ruffian, bribed by a rival to maltreat them — the whole forming a graphic epitome of high life in Japan. The short descriptive text is printed on the illustrated paper in color, and forms an ornamental detail in keeping with it. The artist further violates our rules by omitting all shadows. Whenever he attempts anything on our system he loses the fascination of his own. We may smile, on looking out of one of his brilliantly-lighted rooms — for example, that of the musical party — into the dark night outside, to see the blossoms on the trees as distinctly outlined and colored as if the sun shone on them. But he is no fool, for all this. He knows as well as any one how much of them he could see under the circumstances ; but he wants us

to know that the air of that room is filled with their fragrance. To the concert of sweet sounds he adds a concert of sweet odors, and doubles our sensuous enjoyment, at the expense of an unimportant material fact. This is a duty of the artist, founded on an æsthetic consciousness of a far higher quality than any possible fidelity of literal draughtsmanship. In the rescue scene the branches of the tree, partaking of the spirit of the spectacle, look weird and threatening, and its blossoms gleam in the dark like the sinister eyes of an animal of prey. This sort of occult sympathy between the artist and Nature is a striking feature in Japanese work.

Although the elementary principles and practice are so fundamentally sound, they belong to a primary stage of civilization, — right as far as they go, but not going far enough. We must admit they are successful in imparting that refined pleasure which is the end and aim of true art. Two things they teach us: first, to see the selected fact — characteristically always, and often beautifully, even if it be not beautiful in choice; secondly, either to enter cordially and intelligently into its proper life, or, by the cunning of an inventive will, to transform it into another quite distinct from its native sphere. No people more thoroughly understand the respective offices of Art and Nature, and where to draw the boundary between them. They fully comprehend that art has an independent aim; that it exists in virtue of its own being, untrammeled by theories of ethics, political economy, or natural science; and that, while it culls its principles and methods from nature, it has no call to be her servile imitator, or to defer to the prosaic requirements of

How the Japanese understand the relative offices and functions of nature and art.

a merely industrial existence. True, Japanese art has
never learned the use of shadow in relief, or to know
that each positive color is relatively dark or light to
some other of a higher or lower shade of brightness
with which it is placed in connection. Neither are
they familiar with those subtle glazings and luminous
gradations of mingled tints which give perfection to
modeling in color, and spread a warm, transparent
atmosphere over a picture. But they excel in out-
lining and tinting spaces, matching them by the eye
after nature, correct in general tone, and so opposed
as to imbue the scene with an aerial perspective and
the proper sentiment of the season or hour. In this
way we get an objective consciousness of a lowering
day in winter, the air full of latent snow-flakes, or
sparkling with bewildering sunlight ; the warm haze,
or cloudless sky of summer ; twilight mystery, star-
lit gloom of darkest night, cold rays of moon trip-
ping over still waters ; midnight, welcome to weird
visitors from the spirit world and the noisy tug of
noontide life. Each and all of these conditions they
make so clearly manifest as to cause one to pause
before abjuring them to change a system which serves
their art so well for the technics which serve ours so
indifferently. Ruskin's axiom, that no art is vital
and beautiful which does not represent the " facts of
things " (a vague phrase, but meaning, I suppose,
their literal likeness), is often confuted by the Japan-
ese ; for they do produce much that is vitally beauti-
ful without being an exact fact in nature. Carried
to extremes, this disposition furnishes the world with
those ingeniously constructed mermaids which have
puzzled prosaic brains and amused the imaginative.
Their rule is, not to imitate nature as a girl counts

stitches in her worsted-work ; but to make the most of the impressions she leaves on the mind in the whole. This is preferable to giving minute details detected by the eye in a microscopic search, as it were. Neither topographical delineation nor scientific dryness of illustration are emulated by them. Their artistic supremacy mainly rests on their ability to vary at will the forms and combinations of nature, and to invent new ones.

The Japanese artist has his jokes with natural objects as with his gods and heroes ; but he does not systematically perpetrate those horticultural arboreal outrages which the Chinese do in trying to help nature adorn herself. Occasionally some monstrous grotesque prank, like changing a colossal pine into a vessel, with masts, yards, and oars, indicates his love of the burlesque in this direction. But he is more apt to confine his ingenuity to dwarfing trees or rearing monstrous flowers. Doubtless the Dutch borrowed their passion for travestying nature from this Oriental source, developing it into still greater uncouthness, and transmitting their perverted taste to their neighbors. But like everything else they borrowed from the Japanese, they failed to improve on it, and only succeeded in making whatever might be incongruous or ugly, still more so.

Jokes with nature as with his religion.

Supreme facility of expression is as common to Japanese art as the reverse in ours. Immensely painstaking in representing material nature, we too often succeed only in producing its counterfeit and unmistakably labeling it as such. If that be the profoundest art which suggests rather than imitates with the least perceptible effort, then the Japanese

Japanese art expressive and suggestive ; does much with slight means and little effort.

are our teachers. Our art tends to destroy itself by
a fruitless rivalry with nature, and is slain as was
Marsyas for his insane presumption in vying with a
god. We cannot too often be told that the gist of
art is not in imitating nature in view of rivaling her
work, but in studying her methods, laws, and princi-
ples, to the intent to create independent works by
the exercise of the artist's own creative will, thereby
making himself a *creator*.

This organic principle is found in all sound Japan-
ese work. Be the object a flower, insect, animal, fish,
bird, or reptile; a ghost or demigod; dragons, genii,
monsters, or divinities: each exists in virtue of the
will and handicraft of an artist who has acquired his
dominion over material things by studying their oc-
cult laws of being. By sagaciously comprehending
his own relation to nature he succeeds in making
his art an organic, intellectual, and material force in
civilization and interpreter of human possibilities.

Japanese pictorial art has a fragmentary aspect in
the mass. It is better pleased with strong
isolated bits, than connected compositions.
These, however, are largely treated, al-
though seldom put together so as to be a completed
unity of idea and execution, designed in reference to
a central motive and point of view. Instead, we get
a series of panoramic scenes in which each figure has
a more or less independent position and action.
There is no exact perspective of converging lines;
no *chiaroscuro*, or modeling by gradations of light
and shade and ordinarily small attention given to
the laws of proportions or distances as regards single
objects on the page of cheap books. In their place
they give flat surfaces, flat, sharp outlines, and flat

*Its techni-
cal methods
and aims.*

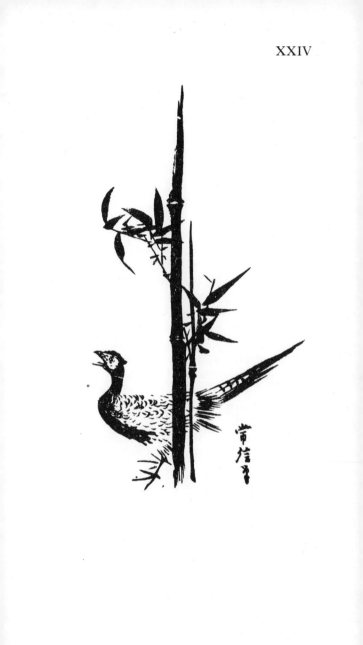

tints. Nevertheless, in more important works, by local massing of colors, an adroit management of horizontal lines, and skillful zig-zags, they contrive to spread out before our vision vast reaches of country and ocean, receding into the far distance or expanding into broad space in an effective manner. Moreover, they are dextrous in securing atmospherical tones indicative of the time of night or day, the season, and the state of the elements, by a nicely graduated system of tinting. Local and passing effects are enhanced by contrasts and combinations of positive, brilliant coloring, such as the blossoms of trees and costumes of the period of the year suggest. Snow scenes, expanses of limpid waters, far-away hills, bounding wide intervals of lowlands, valleys running sharply and tortuously into crags and precipices, large plats of vegetation accentuated by living objects, bridges, boats, and villages scattered in relative distances, the whole with a high horizon-line, illumined by broad stratas of varied warm lights, or broken into patches half buried in mists, alternate objective clearness and suggestive mystery : such are some of the artistic features of a school of landscape in every way opposed to our own, and if with less topographical exactitude of surface detail, of infinitely more simplicity and poetical suggestiveness.

I own an antique album of sketches by various "old masters" of Japan, a little less than four inches square, opening reversely, with thirty-eight sepia and water color drawings on the alternate pages, which are connected together by delicate low-toned gold leaf that also forms a frame to each painting. In tender feeling, delicacy of execution and æsthetic sensitiveness, it is

An ancient album of sketches by their old masters.

of marvelous merit and is quite a compendium of the best points of Japanese genre and landscape art. There are two drawings, which for homely realistic truth and force would do credit to the best Dutch master. One is a man, seated, mending a basket, which looks as if stolen from Teniers the elder, and the other a buffalo, grazing, of splendid action and figure, looking like the large beast itself, yet drawn within the circumference of a silver dollar. A composition in extreme miniature of eight old men grouped in a circle, each of different expression and movement, but all animated by a common feeling, is as well composed and drawn as if done by our best mediæval miniaturists. But the most touching bits are the landscapes. There are foreground scenes of lowlands and forests, backgrounds of distant ranges of high mountains, with intervening fog like a semi-transparent veil, broken into rifts which just disclose tree-forms and hint at other mysteries of nature, and gives a glimpse of an old man sitting in a balcony watching the moon rising over the nearer hills, and silvering the whole spectacle with its pale light.

There is another scene of a village on a bay in the foreground, half hidden in mist whilst the water and opposite coast are in full view ; blue hills farther off, and a vessel receding in the distance, — all the forms and phenomena most beautifully suggested. Suggestion is the highest merit of these diminutive drawings ; they place a rare spectacle before the eye in a brief, telling manner, leaving the imagination as with nature to work out the entire riddle and discover all that is hinted rather than directly shown. Another landscape presents in clear daylight abrupt precipices, covered with wild cherry trees in their

full gorgeous blossoming, overhanging an arm of the
sea on which floats, dream-like, a solitary fisher-
man's boat. In a companion picture, standing on
high ground we look down a gorge in a mountain
over a wide expanse of cultivated plain, through
which flows a placid river towards a forest at the
base of a chain of wooded hills ; far beyond them
rise with gentle sweep against the horizon the peaks
of another range of mountains painted after the fash-
ion, and in those pure azure tints which the knurly
old Perugino taught the boy Raffaello Sanzio how to
use when he first sought his studio.

Now if any of our more scientifically taught artists
can get into as few square inches of paper a more
distinct realization of space, distance, atmosphere,
perspective, and landscape generally, not to mention
appropriate sentiment, I have yet to discover the
fact.

The little casket which holds these artistic treas-
ures is worthy of the contents. It is of the finest
gold lacquer, of the pale, warm hue never seen now
in the new, giving a quiet repose to the eye like a
subdued sunlight, semi-transparent as it were, and as
cheerful in tone as suggestive of life, because of sun-
dry sprays of wild plants in lowest relief tossed with
graceful freedom onto its sides, the flower of one ap-
parently forming the heraldic device of the noble
family to which it once belonged. The inside and
bottom are of the finest powdered gold on a darker
ground, like the milky way in the heavens, or as an
enthusiastic amateur once called it, " the cosmic dust
of an embryonic planet."

The more choice books of designs and albums
receive characteristic names, such as " The Mirror

of Models, by distinguished Chinese and Japanese
artists," "Treasure of Japanese and Chi-

Poetical
nomencla-
ture.nese celebrated Drawings," etc. ; a national
union which makes it a little uncertain at
times to discriminate between their pencils. Mitford
mentions a few of the quaintly pretty appellations
given to noted public beauties of the frail sort, show-
ing that the Japanese mind does not relish the coarse-
ly expressive terms which the Anglo-Saxon fancy is
wont to apply to similar society, and that their lan-
guage, as well as art, is a most prolific treasury of
æsthetic sentiment. I will cite only a few of the
many attractive names bestowed on famous courte-
sans, viz.: "Pearl-Harp, " "Waterfall," "White-
Brightness," which reminds one of Mrs. Browning's
"White-Silence," when speaking of one of Powers'
statues ; "Forest of Cherries," "Brightness of Flow-
ers," as proving that even in sensuality the poetical
love of nature is always uppermost with the romantic
people.

But let us go back to our landscape, where we are
certain to find no drawbacks to pure enjoyment.

Japanese
landscape
art.Look at this tender wash of india-ink rep-
resenting the ocean with junks at anchor
off a forest-covered point, under the shadow
of which, embowered in orchards, nestles a small
village whose windows are aglow with inside lights.
The horizon on the right is darkened by distant hills,
over which the full moon sheds its limpid beams,
fusing the entire scene into poetical indistinctness
that takes the thought at once captive into dream-
land. Much of the indescribable delicacy of effect in
these choice views is owing, without doubt, to the ex-
treme fineness of hue and texture of the material on

which they are designed. And here, before forgetting it, I ought to qualify my previous assertions as to the flatness and want of modeling of Japanese drawings. These remarks, like the similar criticism of the lack of scientific perspective, apply, it is true, largely, and perhaps entirely, to the average common art. But their best draughtsmen, whether in india-ink or color, do when they choose obtain by gradations of either most subtle and truthful relief and accurate generic and specific form.

They are not so happy in depicting abrupt heights, because their system of successive planes of horizon is adverse to these illusions. But they are very felicitous in storm effects, alternating torrents of rain wind driven over vast surfaces, with sparkle of fleeting sunbeams, or disguisings of gray fog broken by scattered trees, house-tops, or ranges of high-land, a vapory morn, or cloudy sun deepening the obscurity rendered more mysterious and full of gloom by the flitter of bat's wings in the faint twilight, birds passing athwart the moon seen as flitting, ominous specks of dark, men as phantoms in the uncanny vagueness of night, oppositions of moonbeams and torchlights, magic twitter of shadow, volumes of rolling mists and abrupt disclosures of forms and lines dissolving instantly into fresh oblivion; a dash of poetical beauty and sympathetic feeling in every stroke, keenest choice of æsthetic conditions, *all* these and much else make up the artistic machinery of detail which is used to deepen the stress of the main motive.

The Japanese reverse the practice of our scenic landscapists; for instead of filling up their work with a multiplicity of accessories laboriously finished, leaving the general fea- They reverse the modern European practice.

tures imperfectly or superficially executed, they add but a few minor motives to the principal ones, either faintly depicting or carefully adding a small number of well-chosen details and rely chiefly on the imagination of the spectator to complete, as it were, the picture, or take in the full measure of its meaning, — an agreeable task, of which the European artist too frequently deprives us. Waves and rocks seem beyond their skill in a strictly realistic sense, but their conventional forms are frankly and sincerely rendered. The spirit and tone of any given spectacle are certain to be largely and unmistakably rendered. Personal idiosyncracies never crowd aside the legitimate feeling of the topic. Always we notice strict loyalty to the motive. This absorption of the artist in his object communicates itself to the spectator. Be it a mere blade of grass, bit of vine, branch of blossoms, jagged plantain leaf, cane-stalk, a shrub bowed down by the wind, bird pluming itself or swooping on its prey, the inevitable stork, fish reposing on his fins, in short, any natural object under any condition of its existence, a Japanese draughtsman is sure to give it genuine characterization and make it appear at its best.

Witness the admirable drawings of tall bamboos, sometimes printed from blocks and sometimes colored by hand! The joints are simply blank interstices left in the drawing, through which the paper shows, while each leaf, disconnected from the stem, would tumble to the ground were it a real leaf. No two indicating strokes of the pencil are alike. A looser, freer system of design cannot be imagined. Yet every part of the plant has its correct physiognomy. Its forms and reliefs are

Drawings of bamboos, etc.

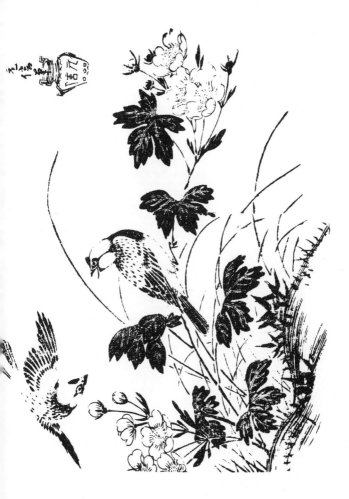

thoroughly shown by gradations of tints and tones; its physiology is simply perfect. No art can be more artless to the eye or exhibit less of what our Preraphaelites call "truth of detail." Yet every one who sees these slight sketches exclaims, "How like nature!" In thus sparing himself the artist has equally spared the spectator, and nevertheless fully realized to his consciousness a vitally true plant, swaying in the breeze and glowing in the sunlight. This is consummate art of its kind, *Consummate art of its kind.* and the skill that produces it can only be acquired by an intimate study of and close sympathy with nature joined to the purest taste and a thorough appreciation of whatever is simple, and true, and beautiful.

I once more repeat, because it is so often gainsaid by modern theory and practice, that it is a specious fallacy to suppose that genuine art consists in a blind adherence to nature. It perishes by this process; for its spirit and *Nature and art as understood by the Japanese artisan.* object are as much creative as Nature's herself, but with an aim which can be reached only by original and independent processes. Nature admits beauty as a secondary element to disguise or make palatable much which otherwise would be terrible or repugnant to man's finite powers. Art has quite another scope, constitution, and desire. The offspring of man's creative faculties, originated expressly for his happiness, subject to his will, depending on his handicraft, it best asserts its power and nobility by independent thought and action, using Nature as a friendly auxiliary and kindred force, but never blindly following her ways or servilely copying her forms. In some sense each has an antagonistic end in view; certainly a primary purpose engendering distinct types and idealisms,

and by consequence, separate rules and laws of being. The perfection of the one is not necessarily the supreme organization of the other. Art's means of winning its ends are even more drawn from the arsenals of human imagination than from the forms and idealisms of nature. Invention, instead of imitation, is its vital force. Whether Art is like or unlike Nature in its constructive forces and models, it is always most fascinating and elevating when least in bondage to her. And it is this perfect liberty, united to docile teachability, which gives intrinsic æsthetic value to Japanese decorative art.

SECTION V.

JAPANESE DECORATIVE AND ORNAMENTAL ART. — ITS PRINCIPLES AND RULES, EXAMPLES, ETC.

IT will be instructive to carefully note some of the chief points of Japanese decorative art, as a lesson to our own artisans, and a guide to a more correct taste and practice than now obtains with us, except with the few persons who make oriental art a special study.

Chief points of Japanese decorative art.

First. The mechanical finish of an article is complete and thorough in every part, not excelled in scientific exactness, and seldom equaled in ingenuity of construction, and what we may call a dextrous application of its utilitarian properties, by the best workmanship of Europe. Experience shows that any closely-fitting object, in itself most admirably adapted to its specific purpose, after centuries of wear, remains nearly as perfect as when it first left the artisan's fingers. Quite independent of their æsthetic skill, these have a nicety of mechanical touch guided by an almost infallible eye, and a practical knowledge of their constructive material, that puts all our hard, monotonous, unsympathetic machine-work to the blush, in those very qualities on which it most prides itself. The human hand trained to highest skill, must of necessity put some of its moving feeling into its work, and which immediately manifests itself to even a careless eye, when seen in company with the tameless accuracy, and meaning-

Its finish.

less forms and finish of that done by steam-labor alone. The subsequent shrinkings, lack of solidity, and general tendency of our objects, as age advances, to get out of order, is too well known to require other mention. Even in our very best and most costly works, it is seldom that equal attention is given both to the æsthetic features and to the mechanical construction. One is quite certain to be sacrificed to the other, and thus the finish, as a unity, is incomplete. Our Japanese artisan deems a well-balanced perfection in each requisite to completeness as a whole.

Second. Each of the ornamental features is designed and finished with uniform scrupulous attention to its motive and object, as related to the mass. While nothing superfluous to the specific aim, and rules of taste which regulate the work in hand is permitted, no part, whether conspicuous or not, is slighted or neglected. Thoroughness and completeness are the rule.

Its thoroughness.

Third. Variety of form and expression is equally a law of construction ; no pairs of objects are precisely alike, unless made to order for a foreign market. Each article has its particular physiognomy and peculiar features, differing from all others of the same family, as one man is unlike another. There are no monotonous resemblances, and platitudes of character, as with most European productions. The commonest object has its distinctive artistic physiognomy, even if it be repeated millions of times, and costing only a penny each ; like the ubiquitous fan, which is so often endowed with a felicitous æsthetic significance that one forgets its use in admiration. Hair-pins, combs, knife-handles, and a thousand other little things of daily necessity, are also

Its variety.

exalted into suggestive and beautiful art, as by a nec-romancer's spell. It requires no inconsiderable æs-thetic culture, fully to appreciate the exquisite taste, enlivened by an inexhaustible fancy of design, with which this class of articles are dowered in their uni-versal marriage of beauty to utility. We doom it, as a general rule, to the celibacy of a barren homeli-ness, treating it as in a condition of perpetual servi-tude, with no possibilities of a claim to our affections or companionship with our understandings. What we do essay as art in this direction, is chiefly given to expensive and useless objects, or superficial and tawdry, which speedily pall on the sight, and con-stantly call for new fashions to keep them even in temporary favor. Japanese ornamental art, on the contrary, like tried friendships, becomes dearer the longer we possess it, while its fecundity is no less a marvel than its perennial freshness, and the perfect-ness of its many-sided life.

In this relation there is no more noticeable feature of their ornament than the decided objection, indeed, absolute dislike of uniform designs and repetitions of details, dividing lines and making counterparts of spaces and patterns. Diapers and frets are sparsely employed and seem to be really exotic art, although when used, made very effective by contrasts and irreg-ularity of masses. Perfect balances and harmonies of unequal parts, and broken up surfaces, are combined with infinite varieties of line and outline, pose, fig-ure, and shape ; ingeniously protesting against even the simplest geometrical monotonies, and distribu-ting them into no end of never-repeated variations and forms, as if the Japanese brain had an instinc-tive hatred of duplicating any decorative composition,

or even article, whether artistic or not; an æsthetic sagacity which comes from its acute observation of the methods of Nature in obtaining the greatest variety and beauty for her creations. Sometimes, though rarely, an object may seem at first look to be an exact likeness of another; but a close inspection will show that even if the general forms and designs agree, the details vary in position, outline, color, combination, or some equally emphatic point; and that the governing principle of variety in all their work still holds good.

Fourth. Perfect adaptation of specific detail and the ensemble of the decoration, or the composition as an entirety, to the definite purpose of the object, or else such a complete independence as to banish all appearance of serviceableness, are obvious characteristics. This organic freedom is so emphatic, that a bit of Japanese porcelain easily finds its true position anywhere as regards its capacity of delightsomeness; whereas a Sèvres or Dresden vase must be put into the exact situation for which it was constructively designed to get out of it any adequate æsthetic satisfaction. In its best estate, it is a frail, insipid beauty, the mere coquette of art; but more often crude, misshapen, and shallow, however disguised in seeming blandishments.

Its principle of adaptation.

Fifth. Pure form does not hold a like superlative position as in classical art of a corresponding character, which relied for its attractiveness almost wholly on graceful shape, especially in its bronze and terra-cottas, and largely in its glass, the ornament being in silhouette, and color and drawing always subordinated to the desired form. Neither did the Greeks go to nature for her purest and simplest forms in ornamental detail, as did the Japanese; but

Pure form.

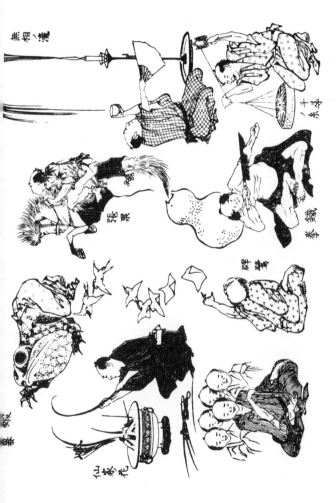

preferred arbitrary and conventional design, at least outside of the human figure, which practice as a rule the latter reverse. So far, however, from neglecting beautiful form, some of the Japanese objects are scarcely less graceful than the Greek, and indeed, in some instances, almost suggest a knowledge of them. But these are exceptions to the general rule, which makes beauty of color-decoration the chief aim. However bizarre and grotesque in ornament and shape, and some is amazingly so, their decorative art is pretty certain to be superior in constructive form, as well as quality and appropriateness of ornament, to anything similar elsewhere not directly patterned after the best antique models. Indeed, in originality, variety, and diversity, they have won a foremost place. The artistic unity of their color-decoration is so harmonious and perfect, that at first we overlook the more purely intellectual delight of form, in the subtle gracefulness of which the Japanese are by no means deficient in capacity, if infrequent in practice.

We attempt impossibilities in decoration, and then wonder why we fail. At Sèvres, and wherever fine porcelain is made in Europe, the artists try to produce highly finished paintings of no end of fine detail, copies of landscapes, historical and genre pictures in oil, or objects from nature, line for line, tint for tint, light and shade, space, perspective, and atmosphere, all treated as if painted on flat canvases, on hard, reflecting, concave, or convex surfaces of mineral texture, without the slighest reference to the destined use or position of the thing itself, or the obstacles which its technical conditions present to the laws of fine-art proper. Curvatures of a vase, or dish, of necessity

Sevres ware and its principles of decoration contrasted with the Japanese.

destroy the perspective of a flat painting taken from
its proper point of view, while its glistening substance
reflects light, kills *chiaroscuro*, prevents aerial trans-
parency, and obstructs those nice gradations of color
and interblendings which give to oil-painting proper
its legitimate illusions. Fine art of this kind has no
more right of place in purely ornamental than has
natural history or science. The artistic and æsthetic
composition of the most expensive productions of Eu-
ropean manufacturers of pottery and porcelain are as
faulty as regards the true character of art, as bad spell-
ing and grammar are to literary composition. Appro-
priateness of composite decoration, each object being
governed by its own rightful law of being and place,
is the crowning merit of the superior Japanese work.
Every pattern is the result of a careful calculation of
its relation to a given whole, causing the object to
conserve its own æsthetic and artistic character, to be
logically consistent in its composition, true in contrast,
and correct as regards everything else. There is no
taint of bastardy in its begetting and make-up. Hav-
ing sounded his sea of limitations and possibilities,
our Japanese artisan knows every rock or quicksand
in his course. This accurate knowledge of what he
may or must not do, joined to his long attempered
skill and feeling, his freedom from academic routine
and mechanism of study, by which the brain may
profit in theoretical and scientific information but at
the expense of skill of hand and original invention,
his simple life and constant reference to nature, or
his own imagination and taste, his perpetual practice
and high standard, æsthetic and mechanical, his
small wages and great pleasure in his task, — all this
combines to make him the genuine and successful

artist. If there be two things more than others that destroy and degrade art and artist, they are extravagant prices, and the forced training of a hot-house system of art education, chiefly based on the idea of helping manufacturers and developing commerce. Anything less direct and true than art for art's sake, *i. e.*, enjoyment, not gain, is certain to vitiate the whole system, and bring it to grief by destroying in the people both their knowledge and capacity of delight in genuine art, and finally extinguishing the true artist.

Art is never more beneficial than when adorning things common and cheap in themselves, within the reach of the average buyer, and Cheap art. in transforming articles of common necessity into suggestive objects of beauty. In this guise any indispensable article may become a missionary of art-culture and propagator of refinement to the multitude. No race excels the Japanese in changing iron, paper, clay, and like substances into things of absolute artistic value and loveliness, moulding and stamping them by slight of hand and cunning of invention into the universal currency of mind, and causing the crude ore, earth, or vegetable, to disclose its æsthetic possibilities. Examine the plastic skill displayed in some of the humblest of forms, as for instance, a cup or vessel fashioned out of clay and made as light and graceful as the segment of a soap-bubble, with an indented edge or side given by an apparent accident or careless touch of finger yet true to life, and with curves calculated to a hair's breadth, strong and tough, and ornamented with faintest relief of plants or insects so delicately and accurately modeled as to seem to be fossil impressions ; and this cup or vessel counterfeit-

ing so well the hue and texture of finest bronze as at first handling to deceive the senses as to its material!

The skill shown in modeling in various substances the forms of nature in a seemingly sponta-

Iron-work.

neous manner is surprising, as is also the ingenuity in suggesting new ones. Perhaps no one common article is made. to undergo the felicitous transformation of a servile use into a precious work of art more agreeably than the ordinary iron or clay tea-kettle. The latter in endless variety are sufficiently cheap and common, but those of wrought and chiseled iron are very rare and seem to point to a lost skill, or else some part of the country of which we have as yet but little information. Here is a remarkable one beside me. Compact, strong, handy for daily use, rough of general aspect and texture of metal, but bearing aloft a silver and gold inlaid handle, with dainty sprigs of early vegetation, whilst the solid sides show in lowest relief, as fine in outline and cutting as Greek gems, water plants and birds, with every minute organic detail exquisitely finished, the latter looking quite alive and ready to step out of their atmosphere of metal into our breathable ether. The sense of animated life is indeed so strong in the birds and the plants that one banishes forever any idea of a base use of the tea-kettle, and consigns it to the companionship of the finest art, royally knighted at the sovereign hands of beauty.

Pottery is especially the art of the people on ac-

count of the abundance and cheapness of

Pottery, the
art of the
people.

the earths of which it is made and the ease of modeling their pastes into any required shape. Besides being well-nigh a universal art, it was the first exercised by men. How far back it

dates in Japan is unknown; but porcelain fäience of some sort was made previous to our era, although not perfected until very much later, perhaps not before A. D. 1212, when a potter named Katosiro-ouye-mon, and the Buddhist monk Tigen, came back from China with the secrets of the manufacture in that country, which they had adroitly mastered.

The decorative arts of China, Corea, and Japan, are so co-related that it is not easy always to distinguish between them. In the outset China, Corea, and Japan. there existed a certain similarity of conditions and motives tending to similar results. Besides these equalizing agencies, there must have been a regular exchange of products, perhaps of artisans, and many articles undoubtedly were made in all three countries after common models and patterns. But notwithstanding so many causes operating for the fusion of their national styles into one great homogeneous one, or to their utter confusion, the latent principles and idiosyncracies of the Japanese were ever getting uppermost. It is easier to detect what in motive and style is indigenous to Japan than to decide whether the object is made in one country or the other, because of the emigration of workmen, or their clever imitations. Propinquity and trade further promoted a mixture of their respective arts, just as later, when European commerce was restricted to Holland, the Dutch took to manufacturing bastard Japanese porcelains, flooding the markets Bastard Japanese porcelains. with them, whilst the Japanese themselves, stimulated by commissions from Europe, adapted many of their own wares to the vagaries of their foreign customers. These mongrel Dutch and Japanese porcelains, although prized by bric-a-brac dealers,

and frequently sold at high prices, are outside of my inquiries. They are not genuine Japanese art and they have little or no æsthetic value. Indeed, most frequently quite the reverse. The greater portion of this spurious art is hopelessly ugly, useless, and inane. Rarely does it exhibit any noteworthy beauty of tint, enamel, or extra technical virtues of paste, whilst as to its general design there is nothing to admire.

In all old countries there is found a class of expensive monstrosities, experimentive failures or artistic eccentricities greatly affected by collectors, but which in reality are the mere garbage of art. The sooner all of them are broken up the better. But the passion for collecting often degenerates, like that of making money, into senseless hoarding, — quantity more than quality becoming the incitement. This is altogether a different pursuit from an intelligent search for the beautiful in art, or for articles to illustrate the history of any particular branch of production. Most values as regards dealers are determined by the scarcity, difficult workmanship, or some intrinsic quality of the material, without any reference to artistic or æsthetic features of the thing itself, or else by the caprices of transitory fashions. Elaborate oriental carvings in jade or rock-crystal are excessively dear, but of small account in art. Some of the most desirable objects in an artistic view, of Japanese make, are both common and cheap, being the ripe fruit of long-cultured æsthetic intuitions without a taint of vulgar merchandise in their constitutions.

Expensive monstrosities.

The folly of collecting without sound æsthetic judgment is often shown in prices obtained at noted auctions, especially in London, where

Collectors' follies.

recently from thirty thousand to upwards of fifty thousand dollars have been given for dainty bits of meretricious painting on porcelain, panels, and furniture, by Boucher and contemporary painters, or for sets of Sèvres mantel ornaments, because they were once the property of a mistress of a defunct "Most Christian Majesty;" their intrinsic value not being more than a few hundred dollars either in an artistic or technical estimation.

Amateurs with more money than perception can commit these follies with immunity as regards their own pockets, but the effect is to sadly mislead the public in its estimate of art-objects.

Eccentricities of amateurs.

How shall any one justify paying the price of a substantial dwelling-house or a gallery of good pictures, for a few frail, ill-shapen, and worse composed pieces of Dresden or Sèvres porcelain, their only merit, besides fineness of *pâte*, being some sleight of design or prettiness of hue, which the first rose we gather or sky we look up at makes us altogether forget, if not despise. True, the flower fades and the sky becomes cold and drear, whilst the porcelain toy still smiles complacently in its borrowed plumage and counterfeit charms. But even then, with its undying simper and mock finery, is it worth thousands of dollars, not to speak of guineas, when for a hundredth part of its cost, a rational amateur may buy equally as fine tints in better forms, decorated so as to suggest or exhibit what is true and comely in nature, or stimulate in himself wholesome emotions and sentiments, instead of encouraging what is unseemly and preposterous as art. For instance, let us examine some of the cheaper Sâtsuma ware as now made in regular tea-sets to suit the foreign market, and which

are far from being the best examples of this particular
branch of terra-cotta and porcelain fäience. The cups
and saucers, light as feathers, are moulded into grace-
fully irregular forms as if made out of the broad leaves
of an aquatic plant resting on their coiled stems be-
neath. All over the fragile, soft, creamy yellow and
almost imperceptible craquelé glaze, the artisan scat-
ters patches of finest gold-dust like tiny constellations
or star-atoms, and throws into the intervening spaces
in colors rivaling their own and with simple truth-
fulness of design, birds, insects, reptiles, or flowers, be-
stowing on the whole vessel an animation of real life
in keeping with its leaf-like organic forms, extreme
delicacy of substance and taste characterizing the en-
tire thing, the larger articles of the set, suitably varied,
being constructed on the same decorative principles.
Just as Nature never makes two things perfectly sim-
ilar, but always in accord with its species, so our
Japanese workman, constantly keeping her work in
view, produces his harmoniously diversified art, and
cheapens it also to its extreme limits that it may ad-
minister to the multitude as well as to the wealthy.

How different his results and system of work from
The vitality
of Japanese
design.
Why. the mechanically fabricated wares of Europe
in common use, with their stark and stiff
purpose, unsoftened by æsthetic ingenuity,
staring in all its prosaic nudity into the eye, and tor-
menting the palate with unmitigated sensations of
fleshly appetites, in lieu of sending the fancy roving
amid the pleasant scenes of nature and leading it a
willing captive into dream-land ! Even in their least
expensive things, the Japanese paint and mould ani-
mal and vegetable life as if they loved to see both
alive and enjoying their existence in their own spon-

taneous ways, instead of showing them inert; portraits of dead or confined and lifeless specimens of either kingdom, toiletted into a prim boudoir grace, glistening with the cosmetics of the palette and suggestive of decay and corruption beneath ; or, as cut or plucked flowers, torn from their native beds to be daintily ribbon-tied and posed as models, wilting their free life away in artfully arranged charms and forced fragrance, like so many frail beauties avariciously awaiting the toyings of their mercenary ravishers. The body-flavor of the naturalistic phase of Japanese decoration is particularly sound and wholesome. To child or philosopher its honesty and truthfulness make up a simple æsthetic diet which leaves behind no qualms of moral or intellectual indigestion, and is at once pleasurably stimulating and suggestive to all the mental and corporeal faculties.

There is a quality of thin glazed Sâtsuma terra-cotta, aptly called " difficult ware," from the care _{Sâtsuma} required in its fabrication. It is quite novel _{majolica.} in idea and very effective in decoration ; consisting of a relief in hard porcelain of highly colored flowers, birds and kindred subjects, scattered on a subdued background as to hue but often emphasized by gold hatchings of the more brittle and lighter majolica or a coarser terra-cotta material. The difficulty is in combining the several sorts of paste into a perfect and harmonious whole. But in putting porcelain reliefs of all degrees of fineness and beauty of design on the less solid terra-cotta foundation and uniting them in baking so that each retains its appropriate glaze and materiality, and fit perfectly together, the Japanese workman is an adept. This unique ware gives one an enlarged notion of the aristocratic possibilities of

the democratic clay and its plastic scope when manipulated by sympathetic fingers guided by inventive taste. By a light touch here, a dainty pinch there, a twist and a toss elsewhere, forms are evolved which almost rival old Venetian glass in versatile lightness and grace; whilst the painter, on his part, pours over them neutral or positive tints in homogeneous disarray, like the spontaneous growths of nature, and over these in raised porcelain he adds the fairest and brightest objects of earth, the whole forming a picture fadeless and indestructible except by brute force.

The finest Sâtsuma perfume vases are models of delicious body coloring, resembling purest cream in tone, or the soft quality of an infant Mongolian skin, embodied in a vitreous craquelé glaze so minute that the unaided eye hardly observes its web-like tracery. A wealth of buds, blossoms, flowers, intertwining plants and vines as free and elegant as if growing in their own soil, and attired in their best, is scattered over them with utmost delicacy of arrangement, amid belts of flying golden mist, like the fleecy glamour of sky of a moist summer's day and bordered by circlets, at base and top, of rich diaper or other conventional designs. Sometimes these vases are constructed in two dome-shaped stories, the upper and smaller one fitting into the open top of the lower, in a ring supported by a species of porcelain net-work in the shape of inverted acute arches, giving additional constructive lightness to the whole, and recalling the general motive of Arabic architecture. The top also has similar perforations, whilst the bigger dome below displays windows or perforations of still more eccentric shape, the spaces between all these openings being filled with scroll-work in gold.

Perfume vases.

Handles and feet of grotesque but not unpleasing heads or masks, complete the vase.

There is another form of vase of this same tender ware still more elegant, of somewhat heavier paste and more compact glaze, with a deeper and more regular craquelé, almost forming geometrical lines, and not dissimilar to the common characters of the Japanese alphabet as their accidental fissures meet. In shape it is very like the " Forty Thieves' " jar of the Oriental tales, or, saving its grotesque, dog-headed knobs with false rings as suggested handles, more classical in outline than is common to see in Japanese pottery. But its chief and most delightsome peculiarity is the wreaths or circles of mingled leaves, flowers, grasses, and branches, globes one might say, for in variety of shape and size they resemble the planets as projected in astronomical maps, only these are floating, and seemingly revolving each on its own axis, in creamy ether, around the majolica firmament on which they are painted. Some are soaring in free space. Others are touching slightly, or eclipsing one another, all self-sustaining, resplendent in color, a few of the flowers being in raised porcelain of a whitish hue, answering to seas or mountains in the planetary sphere, as they catch and reflect the light. Whenever any creamy space of the foundation color is left within these flower-globes, it is dotted with fine gold points forming nebulous clusters of irregular shapes, balancing and making more harmonious the larger but somewhat subdued masses of gold, usually in the form of leaves, that interblend with the greens, purples, whites, blues, and crimsons of the larger flowers and fruits on the edges of the bouquet circlets.

Examples of fine craquelé wares.

Still another vase of this manufacture merits atten-
tion. Its form is simply a segment of a pipe
or spout five inches in diameter and about
fifteen inches high, a daring but successful experi-
ment of shapes as treated. The craquelé is exceed-
ingly minute, the glaze very thin, the paste heavy but
porous, and the color almost like premium spring
butter. But what most distinguishes it is the breadth,
boldness, and general character of the ornamental de-
sign, which is of the vigorous Hoffksaï school ; the
figures, birds and vegetation, being laid on with a re-
markable artistic dash, action, and sense of vitality
that are very epic and stirring in effect, and quite the
opposite of the lyrical sentiment and delicacy of hand-
ling of the other specimens.

Craquelé ware merits a word by itself. It is of re-
mote origin, there being allusions to it in
Chinese writings as early as the second cen-
tury before our era. Very likely, however,
the earliest specimens were of stout majolica rather
than hard porcelain, and were accidentally produced
by the shrinkage of the paste in the oven, as com-
monly happens to cheap pottery, splitting the pellu-
cid surface into curious spaces, with divisions or fis-
sures that resembled spiders' webs, or the polygonal
masonry of Cyclopean architecture.

Be this as it may, these delicate tracings being
found to be to the taste of amateurs, the potters sought
out processes by which hard porcelains that are not
liable to such changes in baking, should be made to
acquire similar fissures in their enamel and receive
diverse forms and colors. To do this it was only nec-
essary to expose the hot vessel suddenly to cold, or
dip it into water and immediately fill the cracks with

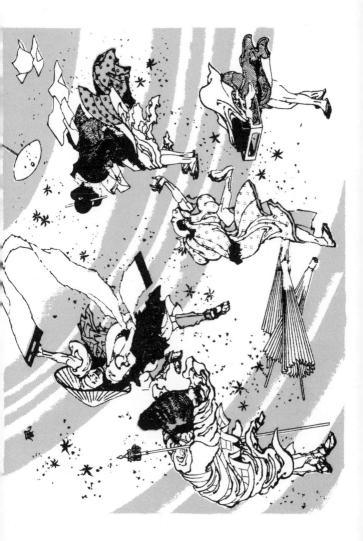

the desired tints. This reads easy enough ; but as the ancient ware of this character always commands extravagant prices in China and Japan, a thousand ounces of silver being sometimes paid for a choice specimen in the latter country, and even more in the former, it is probable that much skill and many failures were necessary to make a perfect article.

I have a craquelé vase or bowl of Japan, of heavy porcelain, of a soft, creamy warm gray, with dark fissures forming blocks of pellucid enamel of the shape of the stones in the walls of the Pelasgic citadels of ancient Italy and Greece, terminating in a purplish-black, wide rim, with a narrow belt of the same color a little below it, forming a sort of hoop to the vessel. The bulge narrows as it descends, and has in it four horses in various movements, forcibly drawn, and in a low relief of clear white and deep blue porcelain, which not being craquelé like the rest of the surface, makes the whole bowl a marvel of technical necromancy. Some of the craquelés are extremely minute and delicate in outlines, but their beauty lies chiefly in the purity of their tones and color, and translucence of their substance.

Tea being the common beverage in Japan, tea-pots figure noticeably in its art. Those sturdy Dutch galliot-shaped models, associated with the earliest reminiscences of our grand- *Tea-pots and services for this national beverage.* mothers, suggesting only scalding drink, and hot buttered cakes, in Japan would be considered as boors, wholly unfit for good society. Here the gustatory function is thrown entirely into the background by ornamental disguises which bestow a specific idealism on even so unpretending an article. These Japanese do have a wonderful knack of getting some poetry out

of every use and substance, and lifting common things into an elevated atmosphere of sensations and thought. Tea drank from fine old China, notably those deep, clear blues of conventional designs fenced in by Greek fret, of shallow curves and graceful dips, and which must be handled with graceful touch when lifted to the lips, has its flavor improved by an occult sympathy with the beauty of the cup itself. This sort is rare now, having been rudely jostled aside by vulgar and pretentious imitations of European parentage, of awkward lines, pot-bellied curve, and grenadier dimensions, hideous in hue and drawing. England and Holland both fail in trying to catch the diaphonous tones of the oriental blues of every shade, which so content the eye by their quiet harmony, and whose effect on the temperament is as soothing as the courteous deportment of the " old school " gentleman.

Easel paintings are not found in Japan, unless we admit into this category recent attempts to imitate ours, all which are striking failures, as are also our experiments in their line. Innovations on either side, by which the practice of the one is guided by the principles of the other, have a common result. Either system must be kept to itself, intact, or wholly abandoned. There can be no happy mixture of the antipodal elements of Oriental and European art, or subordination of one practice to the other, although we may largely gain by studying their fundamental principles and acquiring a knowledge of their materials and technical secrets. Minturn, and the keramic factories at Worcester, in England, Barbédienne, Dech, and Collinet, of Paris, and some other of the chief art manufactories of Europe, of late have pushed invention and adaptation in this direction as

Easel pictures.

far as they could go. But every direct imitation, whether of shape, color, or design, although striking by itself in some instances, and tolerably successful, æsthetically, as an independent object, shows a sensible inferiority in these primary aspects, and in material qualities, when put along side of the original article which inspired it. There is a more successful issue to the adoption of Japanese ideas and technics in wall-papers and wood-engraving, indicating the paths which European industrial art should follow to profit by oriental examples. Japanese art, as a whole, is making, as it deserves, a deep impression on the artistic mind of Europe ; not as an ephemeral fashion, but from conviction of its definite merits in many essential points, and inexhaustible capacity of conferring enjoyment to sensitive tastes. Formerly the Dutch sent their crude designs to Japan to be transferred to porcelains by the native artisans, often no doubt, to their infinite disgust. How heartily vexed they would have been could they have foreseen that a century or two later, this fictitious and mongrel work would be criticised in Europe as of their own invention. Owing to similar mercantile ruses, some of the art fashions of Louis XIV., and the styles in vogue even later in France, must have crept into contemporary Japanese art. But Japan is now taking the ideal Christian revenge of returning good for evil, or, at all events, giving us the choice between the legitimate and bastard work.

European imitations of Japanese work.

Although the Japanese possess no easel-art, their painted majolica and porcelain dishes, plates, or flat bowls, are sometimes so elaborately and beautifully executed as to deserve framing and be hung on walls as a substitute. The

Porcelain and majolica dishes, etc.

most skilled artists are employed on them, and their
compositions are not inferior in color and design to
the best of their albums. There is a class of common
and cheap repetitions made as ordinary merchandise,
but I do not include it in this category. The stand-
ard of the genuine, artistic work, although greatly
varied in style and material, in different provinces,
is remarkably uniform as to excellence, whether
the substance be bronze, lacquer, iron, the precious
metals, clay, finest porcelain, or coarsest terra-cotta.
Motives and treatment are of the same character as
those of the printed albums. In fact, dish, book, box,
utensil, whatever is thought worthy of æsthetic bap-
tism, is held to deserve equal skill and attention.
The inevitable joke frequently finds place ; also, sub-
jects borrowed both from high and low life, religion,
demonology, and tradition. There is seldom, almost
never, any conscious morality or latent meaning in-
fused into these compositions. Perhaps nowhere is
similar art left more entirely free to its own proper
purpose of bestowing supreme æsthetic satisfaction.
If there be any one noteworthy outside element, it
is the mixture of fun and superstition without big-
otry, which seemingly likes to supplement sensuous
enjoyment or artistic apprehension with a laugh.

An " accomplished and lucky tea-kettle " is a favor-
ite topic for the draughtsman. This useful
article has more qualities than we dream of
in our philosophy. It puts forth the heads
and limbs of a badger, covers itself with fur, dances
on tight ropes, and becomes a facetious gymnast, prac-
tical joker, or reckless tormentor ; sometimes a re-
warder of merit or punisher of vice ; but always the
most amusing of goblins, according to its caprice or

Demon tea-
kettle and
other uten-
sils.

affection for its owner. Other articles, too, become bewitched by spiteful sprites, that bring all sorts of misfortunes on those who weakly yield to their beguilements.

The amount of gross machinery of a materialistic ritualism on the one hand, and a benumbing skepticism on the other, render it questionable, in view of the simplicity and spirituality of the aboriginal faith, whether Japan has been substantially benefited by the introduction of Buddhism and Confucianism. Both of these religions vary some, because overlain with a deep deposit of irrelevant dogmas, rites, and irrationalities of diverse origins, hindering mental progress, and burying out of sight those pure principles which first gave them any valid claim on men. Possibly Shintôism, if left alone, would have done no better. Men of all races are ever prone to try to appease their religious doubts and placate their self-created deities by barren words and profitless ceremonies, and to seek relief from the uncertainties and mysteries that encompass them, and which are inseparable from their very existence, in demoralizing practices, asceticisms or sensualisms. We must admit that the art of Japan has a full share of motives derived from the debasement of all of the national creeds. Still, in a large degree, it always kept a healthful hold on nature, and never quite forgot the essential spirit of its earliest faith. Art everywhere, as it foregoes its belief in dogmatic heavens and hell, and fetiches of every variety, naturally falls back on its earliest loves, nature and humanity. Broadened by the freer spirit of modern investigation and cosmopolitanism, it opens to itself a wider, more intelligible and sym-

Perversion of religious rites.

Debasement of motives.

pathetic field, even if for the moment one less ab-
stractly profound or mystic.

Without accepting the religious motives of any art

The whole
world akin
by its art.

as matters of belief, we may nevertheless get
great satisfaction out of them, because in
each there is certain to be a touch of some-
thing that makes the whole world one country. If,
however, reason is compelled to flatly protest against
the special motive throughout, there comes a draw-
back to æsthetic contentment, inasmuch as the unity
of sensations and sentiments requisite for perfect en-
joyment is rudely shaken. Two adverse mental con-
ditions are aroused. That which is rationalistically
dominated either by belief or disbelief, is sure to push
the æsthetically sensuous side of human nature to the
wall, or utterly confuse it, so that the mind is not
always able or prompt to discriminate between the
æsthetic qualities of a work and its other features.

If this one-sidedness of judgment be true of Prot-

Sectarian
judgments
one-sided.

estants as regards Romanists, it holds equally
good of both these classes of sectarians re-
garding all outside religious art, which is in-
vidiously lumped into the one word Pagan. Skeptics
and free-thinkers of all peoples, on their part, regard
all priestcraft and its art, Christian or pagan, as a
hindrance to the rightful development of humanity,
and are least drawn of all towards phases of art
which presume a supreme basis of divine intuition
and revelation. But cultivated minds, no matter
what they believe, or how they worship, can enjoy
objects that appeal to them solely from their artistic
merits and general æsthetic qualities. All art, there-
fore, which has for foundation the common truths and
principles of nature and human life, with its daily

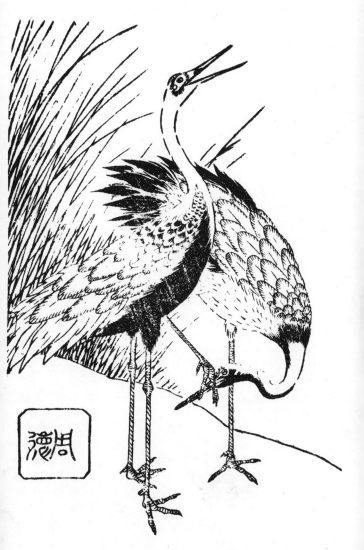

facts, loves, and passions, its poetry and its prose, the wide field of matter and idealization open alike to all, helps fraternize peoples otherwise of antagonistic ideas and interests. Whichever race contributes most to this enjoyable union deserves well of all others.

Adepts in the manufacture of fine porcelain and majolica of every grade, the Japanese display marvelous freedom of inventive design within the limits of a generic taste or style. Methods of decorating fine porcelains.

It is not easy to decide whether the charm of these wares depends more on the translucence of the enameling with its lovely gradations or tones of pellucid white, gray, brown, pink, or red, rarely green, affording frequently on the same dish a delicious, subtle scale or chord of foundation coloring, or the graphic force and delicate execution of the superimposed compositions, often broken up into separate pictures with interposed patterns or borders in diaper, mosaic, arabesques, and, as it were, vocal interludes of birds, animals, flowers, and vegetation, or titbits of landscapes seen through open spaces in walls, and richly decorated draperies and screens in golden scroll-work. From the description it might seem that their style of decoration is overdone, and even barbarous. But in reality it is most delightsome because of its brilliant harmony and endless combinations, contrasts, meanings, and surprises. As compositions, they possess the charm of wit, variety, novelty, and ceaseless flow of spirit in conversation. The mind is constantly stimulated to healthful action and enjoyment. Owing to the translucence of the glazes and the softness of their tints, the eye looks *into* them as into the atmosphere, and does not come to a complete stand-

still like motion against a rock, as it does against the
more opaque and harder vitreous surfaces of Euro-
pean porcelains, with their positive body-coloring,
harsher tints, and general sense of materiality, bur-
dening our æsthetic faculties with a consciousness of
manufacture and the substances employed, so that
the object itself possesses scarcely other interest than
a merely mechanical or shop one, whilst the endless
unvaried repetitions of the same thing or pattern
finally produce satiety and disgust. The one is a
mere toy of the fancy, at the best a cleverly executed
artifice as to decoration and ingenious scientific man-
ipulation, having nothing to say to the intellectual
faculties and scarcely moving the sensuous. The
other conceals its material organization in its æsthetic
expression, just as a sweet smile, or the significant
look of a manly or lovely face discloses at once its
moving spirit and lets us see into the soul's kingdom.
But there must be an infinite, indefinable something
which governs the body to cause this phenomenon.
It is precisely because Japanese porcelain of the best
decorated . character has a soul so far superior to
its coarse material substance, interpenetrating every
pore of its artistic body, that, — if I may be allowed
to compare small things with great, — like finest
music, it lifts a sensitive æsthetic temperament into a
kind of quiet ecstasy or fullness of enjoyment, which
makes all criticism for the time superfluous.

Even more than other Orientals, the Japanese
comprehend the full value and limitations
of gold in decorative art. We are afraid of
it, esteem it showy, garish, vulgar; which is true as
we employ it in our ostentatious, staring fashion,
always either cold and repulsive in tone like dead

Use of gold.

flesh, or a vexing glitter, neither of the shades in common use being the pure tones of the metal itself. Besides, we really do not well know what to do with gold unless to spend it, hoard it, put it on our persons, or in a monotonous way as gilding on things which have no real affinity for it, and if they have, in a style which neither becomes it nor them. Barbarous methods all, more or less.

Now examine how the Japanese employ it, through every gradation of tone, from dull bronzes to brilliant masses, as hatchings, bars, diapers, stripes, dots, mists, clouds, scrolls, arabesques, geometrical patterns, broad masses, high and low lights, in costumes, figures, flowers, in fine, every conceivable variety of decorative design, whether as supplemental form or color, always judiciously balanced and opposed, giving to each object a vital look, changeable, too, just as sunlight and shadow affect nature, alternating its expressions from pure and simple realistic truths to profound or mystical subtleties of suggestion, according as the eye and mind catch the passing look. They understand the psychological correspondence of gold with mind and nature as well as its material relations. Hitherto, having had little use for it, either as coin or jewelry, they have lavished it on furniture, pictures, and objects they dearly love and admire, in solid form or by gilding with unrivaled delicacy of workmanship and understanding of its occult properties and practicable possibilities, thus divesting it of all sordid purposes and raising it from a base bondage to human covetousness to administer to human delight in those shapes of beauty which are a perpetual consolation and delight.

One of the most simple kinds of majolica, in the

forms of ordinary domestic vessels, has raised designs in porcelain of flowers, animals, and other natural objects in their appropriate coloring, on a finely glazed surface of one uniform, low neutral tint, which sets off the superimposed ornamentation in a very effective and agreeable manner. They are so inexpensive that the humblest cottage can have within it in days of gloom and storm, when all outward nature is eclipsed, cheering rays of sunlight, song of birds, fragrance of flowers and other artistic reminders of familiar out-door pleasures, true to nature and with more of the real feeling of normal life and growth in them than can be found in the costliest productions of Sèvres or Saxony. As regards genuine artistic worth, they are to be preferred to the more curious craquelé vases, remarkable for their technical ingenuity, antiquity, and perfection of body-tinting, and for which the native Japanese collectors frequently pay thousands of dollars, their usual color being a rich dark gray.

Porcelain reliefs on terra-cotta or majolica.

The red or Kiŷoto wares, made at the Godijiozaka potteries, with coral-like designs on a creamy-white body, with the slightest perceptible infusion of crimson or pink not deeper than the downy flush of an infant's cheek, in texture suggesting one, no two dishes having precisely the same tone, are exceedingly beautiful. The human figure is largely used in the decoration of the ancient ware, of which the modern is only a cheap and coarse imitation, handsome by itself, but when seen beside the old, undeserving special attention. Of the latter I have before me a remarkable specimen. It is in the form of a flat round dish of a foot in diameter. On the inside rim there are depicted forty-four elders seated in a circle, evidently an

Red or Kiŷoto wares.

academy of wise men discussing a mysterious scroll with owl-like seriousness. The variety of expression, posture, and gesture, the delicacy and accuracy of the drawing, and the beautiful relief more implied than given by the subtle gradations of the red tones of color, make up an inimitable work of art, gravely and largely conceived, yet spiced with a touch of quiet humor. On the outside and the bottom of the dish inside, there are vigorous drawings in glowing red and burnished gold of the national dragons of China and Japan, distinguished by the different number of their ferocious claws. Perhaps this dish was made in commemoration of an international séance to decide some knotty question of international law or philosophy.

My pet dish, however, comes from another manufactory with an undecipherable mark. It is made of an extremely solid, heavy porcelain, The cat dish. of a dull white tone and somewhat coarse surface, with its rim broken up into diversified arabesques alternating with triangular scroll-work in black, red, and gold, and narrow blue borderings. There is a wild luxuriance of morning glories and other clinging flowers rambling over rocks on the inside. From one of the vines there hangs a spider's web from which the insect is letting itself down by spinning a thread in its usual deliberate way. A black cat with a red ribbon on its neck turns its back to it with well counterfeited indifference, while its companion, a spotted one similarly adorned, is steadily watching the approaching insect with a craft superior to its own, magnetizing eyes, claws nervously disposed for the fatal spring, and mouth watering with anticipation of the final crunch. These cats are drawn in the

best style of the Hoffksai school. Gold is used instead
of color on some of the leaves, and liberally in the
high-lights, giving a species of brilliant musical in-
tonation as accompaniment to the gem-like decoration
and the naïve realism of the motive.

In Yedo there is an association of artists devoted
Yedo school solely to painting on porcelains and majolica,
of designers receiving from the various manufactories in
on porce-
lain. the provinces their objects in biscuit-form,
which they decorate and prepare for the market.
This practice renders it somewhat difficult to localize
wares, although it is to be presumed that each foun-
tain-head has its trade-marks and specific style. The
extremely delicate semi-faience known as Satsuma
comes directly from the works of the prince of the
same name, situated near Kagosina. However, ex-
cellent imitations are made by the potter Sampei in
the department of Miodo. Nagasaki ware resembles
the Kiŷoto, but is lighter, less richly decorated and
can be distinguished by its blue medallions or spaces
let into the body-color. But the most highly prized
porcelains, such as are seldom to be found in trades-
men's stocks or amateur's collections, come from the
Hitzen factories.

I have a large Yedo bowl of massive semi-porcelain
which admirably illustrates the severely
Yedo bowl. grand manner of this school of decorators.
It is of elegant proportions and wide flare, of an in-
digo-blue on the outside, with milk-white high reliefs
of ocean surges, tossing jets of sinuous spray breaking
into pearl drops into the blue empyrean, through
which fly in giddy whirl in single file round the upper
edge of the bowl a flock of the " holy birds ;" thóse
sacred, winged beings which symbolize human happi-

ness and longevity. The vase itself seems to spin round in keeping with their rapid, revolving flight, each with a different and forcible movement, suggesting a cosmic spectacle in the dawn of creation. Inside, this scene is repeated in flat with reversed colors, as if the shadows of the birds outside struck through the intervening clay, and repeated the motive in an even more mystical sense, giving the appearance of the gradual disappearance of the storks into the infinite, whence they had come to do the bidding of their Creator in the service of man.

Here is another example of Yedo porcelain of a much finer paste and of the seventeenth century, ornamented in the purest naturalistic style. It consists of a lower globe, flattened at top and base, in which rises a much smaller and flatter one, supporting a wide-spreading top, equal in height and double the diameter of its supports, the combination forming a singularly novel and gracious vase. The limpid whitish enamel is speckled with faint gold bars and hatchings. A narrow upright ridge, carrying in red the old Grecian fret-design, protects the broad, shallow lip or mouth, inside which are branches of fruit-laden and blossoming trees of raised enamel, sheltering birds of brilliant plumage. The convex side of this palm-like, drooping mouth, is decorated with wreathlets of rarest flowers and blossoms, intertwined and interspersed amid flecks and bars of faintest gold, caressing the milk-like porcelain, as if they were so many flying kisses from Flora's fragrant lips, or suggesting unseen fairies sporting in the white pasture and tossing aloft their tiny garlands.

Separated by a narrow red band, the lesser globe is broken up into a raised enamel sea, lashed into

Yedo vase.

dense blue and foam-white fury by a typhoon, amidst the wrathful waves of which sports with ominous joy the demon-like dragon, supreme lord of its destructive powers, golden-eyed, crimson-bellied, with back green-spotted, horns erect, and hideous countenance bright with malicious imaginings and ferocious intent : strange contrast to the poetical fancy and type of Nature's sweetest gifts and most peaceful moods below, and a wilderness of luxuriant vegetation of an Eden-like growth on the convex side of the upper portion of the vase.

I commend thus heartily the keramic wares of Japan because, besides their positive artistic merit, they are comparatively inexpensive. To an amateur who is not enamored of expensive technical qualities and elaborate workmanship alone, or the excessive rarity so precious to antiquarian eyes, they afford an ample field of selection from which to gratify his æsthetic longings at prices, which, taking into consideration only their real beauty, variety, skill of fabrication, and taste in decoration, are beyond competition in the kindred works of any other people. Fine-art may be cheaply produced if a people only know that costliness is by no means its indispensable quality. The real point is to secure truth and beauty, be their cost little or much. No nation solves this problem more facilely and completely than the Japanese. Specimens of this keramic industry are brought to Europe and sold for a few dollars, or at the most a few pounds sterling each, which both in their mechanical and artistic execution are superior to objects of the same materials made in the most renowned potteries of Europe costing ten, and sometimes a hundred-fold more. In cultivating

Keramic ware in general. Its qualities.

his taste the collector should make artistic beauty his first and chief guide, heedless of considerations as foreign to it as uncut leaves, misprints, omissions or redundancies, the number of the copies extant, quality of the paper or type, or any of those artificial features which make up a bibliomanist's delight, are to the merits of the literature itself. As a general rule, one should not look twice at any of the pseudo-artistic objects made in Europe and sold cheap, for in ninety-nine cases out of a hundred they are not worth the glance; whilst in Japan, whenever the European practice has not overpowered the native, the reverse holds good. There is something in almost every object made on the old principles of their art-workmanship to interest, for the Japanese took too broad a view of it to confine the good and tasteful only to costly articles and make whatever was æsthetic and refining accessible solely to the wealthy classes. Far from this! Like the ancient Greeks,—and I cannot repeat it often enough, — beauty, after their kind bear in mind, was the first consideration, be the object common or uncommon, destined for poor or rich ; the best the thing could bear or the artisan give, and at smallest cost, was the aim. It is needless to say that the main principle with us is to make an article expensive, as ladies esteem their toilettes according to the maker's bills, heaping up, not artistic treasure, which is more often comprehended in inexpensive simplicity, but burdensome labor of hands and a confusing plethora of material and design.

For a brief period still it may be possible to obtain good and cheap things in Japan, but their master pieces of a costly character are less plentiful than we were led to imagine when

<div style="text-align: right; font-size: small;">Fine work dying out in Japan.</div>

the overturn of the feudal system and consequent impoverishment of many noble families led to the dispersion of their artistic treasures. The Japanese themselves now say it is easier to find their best works in Europe than in their own country. Without doubt they will yearly become more difficult to obtain anywhere, on account of their absorption into museums and notable collections.

The best art-period in China is that of the Ming dynasty, from the latter part of the fourteenth century to the middle of the seventeenth, and which also corresponds with the Japanese.

Best art-periods in China.

The movement was a complex as well as universal one, and evidently led to a partial eclecticism among all the races interested in Asia and Europe. How else can we account for the not infrequent traces of intermixture of forms and designs to be seen in their ornamental art, while their motives are as widely apart as ever? Some of the Japanese and Chinese bronzes have either an unmistakable classical or renaissant cachet; others Hindoo and Indian. Here is a vase whose graceful outline savors strongly of Greece or Italy, whilst the ornamental relief is purely Asiatic. An inscription on the bottom reads "Dynasty of the Great Ming Emperor Siian Tsung; title of his reign Siiam Te"—equivalent to A. D. 1426-1435.

The facility with which bronze and metals generally are wrought into plastic forms is on a par with the skill shown in clay. They

Metal-work.

manage to implant into these hard, inflexible, unelastic substances, particularly bronze, those vital qualities which most prominently characterize organic life; as, for instance, softness, flexibility, elasticity, repose,

action, expression, — that is to say, their semblance
to a degree that excites in the spectator a psychologi-
cal consciousness or reflection of these phenomena, so
that the particular object suggests live and not inert
matter to his senses. Particular examples of this
subtle force of vitalization infused into metals, are to
be seen in the vegetation, birds, animals, and figures
generally, which decorate those quaint, antique, com-
plicated vases, half-architectural and half built up
after the natural growth of the mineral and vegeta-
ble kingdoms, wholly *sui generis*, prodigiously realis-
tic in design and action, and yet not without certain
poetical significance, or profound associations with the
laws and forces of nature. The stealthy creeping and
serpent-like movement of spine, silent, elas-
tic tread, magnetic gaze and half-pause, and Bronzes.
half oscillation of body of tigers as they make their
way through yielding foliage or over sun-burnt rocks
in quest of prey, are magnificently given. Every
portion of the cold metal glows with the excited sus-
pense of anticipated movement. Equally elaborate
modern ones are now made at Owada ; but with less
truth of nature, more caprice of design, intricate and
costly ornamentations in silver or gold, and more
labor expended on high, superficial finish, than on
the accuracy of form and vital action which distin-
guished the old work.

An old artist was able to turn a piece of bronze
into a leaf-shape cup with a stem-handle so real-
looking as to suggest the impromptu art of a thirsty
boy drinking from his vegetable cup at the first spring
he finds. Frogs with their young on their backs, or
snakes attacking and swallowing them, their whole
natural history clearly legible on their ugly frames,

are not less naturally rendered. How superbly patient the old herons stand on one leg, sleepily awaiting their marine prey, and how nicely the artist poises his tall-legged bird on the broad leaf of an aquatic plant, with every part of its delicate anatomy admirably delineated, its stem serving as the handle to the whole ; nature and invention in masterly accord, and the art so simple and true that you involuntarily anathematize all those clumsy castings of storks which are now done to foreign orders, to the degradation and ruin of the native art, and in themselves horrible enough to drive the splendid ancient birds to commit suicide ! Grand and venerable grues, resplendent in their clear, dark patina, which was long supposed to be a cunning varnish, but modern chemistry has found it is a pure bronze of eighty parts copper, four tin, two zinc, and the remainder lead, which last assures the exquisite polish. But these noble birds bid fair to be as effectually exterminated as was the dodo, and as soon will be the prairie buffalo.

The grandest statuettes of ancient Japanese bronze that I know, are two demi-gods, or warriors, whose figures I have not been able to find in any album, or to see their counterparts in any public or private collection. They are of massive antique bronze, of a rich, lustrous, dark brown, excessively solid and weighty, and stand upright on bowlders of irregular rock, dotted with cryptogamous plants. The total height is three feet four inches, their figures being in proportion short of six heads. But they have powerful muscular development and Herculean frames, small hands and feet, fine features, massive throats, large craniums, and deep chests, all indicating prodigious strength and ample

Two remarkable ancient statues in bronze of demi-gods or heroes.

brain power. Highly-wrought fillets of metals hold back their luxuriant hair, and set it up in flame-like masses above their heads, giving to them a demoniacal majesty. Each is clad in strong armor to below the waist, and flowing from underneath it as sleeves and skirts, there are rich stuffs, in the one violently agitated and blown out by a strong wind, and in the other hanging in heavy folds, both taking graceful curves and forms. Buskins cover their feet, and trousers of thick ornamental stuffs, tied at the knees, protect the legs. Over their hips there are overlapping coats of mail of the most ponderous make. Tightly-drawn silk cords gird in the waist, whilst lightly flowing scarfs give an air of grace and lightness to the whole body. A wave-like beard adorns one of their chins, and the other is smooth-shaven. Its possessor holds upright in his right hand a double-edged sceptre-like sword, in an attitude of a military salute, whilst his left hand is closed with the two forefingers extended in a warning or derisive manner. His attitude is serenely self-reliant, omnipotent, defiant, and concentrated into reposeful expectation. The equally stalwart companion grasps in both hands a long halbert-shaped weapon with a double movement of prepared attack or guard ; his huge frame poised on the right foot, and the left drawn backwards in support, every limb in lithe tension, ready for any effort. The contrast between the watchful quiet of the warrior of the sword, and the implied vigorous action of the latter figure, is magnificent. Each is perfectly balanced on the precise moment, so precious in Greek art, when complete repose is to be transformed into supreme effort, and the mind pausing as the pose takes in at one glance a whole history.

The sculpturesque details and general breadth of modeling are Michael-Angelesque, particularly the masks on the shoulders, which fasten together the breast armor, and as wholes, keeping in view their special types and motives, these statues can challenge comparison with best classical and mediæval work. Lastly, their faces are irradiated with laughter, lips apart disclosing irreproachable teeth, one figure mockingly with its silver eyeballs turned upwards with sinister derision, whilst the opponent's eyes are jovially wide-open, looking directly forward, and his features convulsed with honest merriment; both affording contrasts of features as significant in expression as in attitudes of bodies. The material qualities of the bronze, color and execution, are alike exceptionally fine, and the infusion of vital force into the dead metal unsurpassable. It seems actually to ripple with the emotions, and be alive with the deep constrained intent of the two actors of an unknown drama. Possibly they are the guardians of the next world; if so, they are far handsomer and more genial than the ordinary effigies. Apparently, they are fifteenth century workmanship. One has an inscription or ciphers in old characters.

There was a family called Goroza as specially adept in all metal work as Cellini was in Italy, and whose skill was transmitted through nine successive generations of artists; a fact without known parallel in the art-history of any other country.

The family of Gorozas, the Cellinis of Japan.

But it would require many volumes to adequately describe the noteworthy objects of this branch of art-industry alone. We will now glance at the cloisonné enamels, another form of metal-

Cloisonné enamels.

work, which is already well-nigh ruined, or at all events so degenerated from its best days as scarcely to warrant mention, if judged solely by the average specimens of modern manufacture. As nearly as I can ascertain, the best were made a few hundred years ago, and almost rival the egg-shell porcelain in lightness. They consist of mineral pastes of all colors, let into designs made by finest metallic lines and divisions set on to a thin metal base ; the pastes being subsequently ground down to a perfectly smooth surface and then polished. These designs are largely geometrical and conventional, of infinite variety of forms, but also of figures, flowers, and any natural object, forming mosaics, at times so minute that the unassisted eye can with difficulty discern all their intricate lines and patterns. They are kaleidoscopic in variety and brilliancy ; but with a subdued splendor in the best specimens, which recalls the lower-toned light of evening rather than the effulgence of the day. The diversified and beautifully balanced forms and tints are held in their places by dividing lines of minutest golden threads, and quite justify the simile once applied to them of " star-atoms " and " crushed worlds." But vessels of this description are extremely rare. At least I have not seen a dozen in as many years. Those of a heavier make, combining conventional and realistic patterns, with broader and more striking masses of color, of less refinement of invention and construction, are not uncommon. In them we have dragons and other mythical creations, of flaming tints, on background of lapis-lazuli or indigo-blues, spring greens, blood-red crimsons, delicate pinks, or dull whites, with geometrical or vegetable borders to correspond, arabesques and diapers, all blazing with

gold, either as bounding lines or as the stars in the
firmament. One of the most striking of these extrav-
agant but elegant compositions, on a large dish, two
feet in diameter, is a large fish, apparently a salmon,
the emblem of fecundity, perseverance, and strength,
leaping up a high waterfall, whose white waters foam
and tumble against a sky of purest azure, unrivaled
in its clear tone, except by the far-famed " blue of
the heavens," only seen in perfection in the finest
Chinese enamels of the Ming period. The forms of
the cloisonnés of either nation are not remarkable for
grace, except occasionally of general contour. Not
infrequently they are ungainly and awkwardly con-
structed, sometimes squat and globose, at others pre-
ternaturally tall and bulbous. The vases are the most
ill-formed, while the bowls and dishes are of the com-
mon shape of such articles. Elephantine and tortoise-
like, invariably bizarre, as if there were some subtle
correspondence between the constructive materials
and these qualities of their general anatomy, seems
to be the law of their artistic organization. But
whenever we do find fine specimens there is about
them an unmistakable atmosphere of general loveli-
ness and purity of tints, as cheerful in a room, to the
mind's eye, as are the corresponding colors of the
heavens to the senses in the mellow light of a perfect
day. There is about them a double sense of hope and
repose ; an unceasing perfume by correspondence of
whatever is symbolically pure, innocent, and desirable
in nature ; a comforting assurance, even if apocry-
phal, of something sounder and better than material-
ity in store for us ; an effect which must be felt on
some sympathetic chord of our being to be compre-
hended, and which words refuse to transmit. A freak

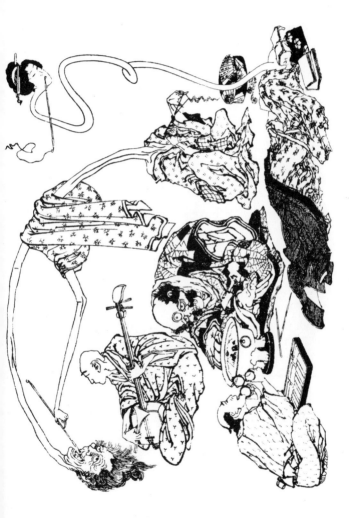

of imagination ; fancy's fire-works, you say, and I will not gainsay it. But the art that can put any mortal into a more hopeful and believing mood than his usual one deserves well of God and men.

Technically viewed, perhaps, the most surprising achievements are to be found in the combinations of refractory or antagonistic materials into an æsthetic unit of perfect finish and harmonious beauty. These attempts must of necessity often fail, but when successful are miracles of artistic ingenuity and manufacturing skill which may well be the despair Enameled porcelain. of the European workman. I refer to those porcelain vases which are veneered with an enamel of metal and mineral pastes fashioned in the same manner as the cloisonnés just described, and so cleverly united and with such a homogeneity of design, as to obliterate as it were all dividing lines of material substance, giving to the entire vessel the appearance of a simple whole. Indeed it requires closest inspection to detect where the enameling ends or the porcelain begins, their several distinctive qualities being wrought into so novel and complete a mechanical and æsthetic agreement.

Scarcely inferior to them in delicacy and difficulty of workmanship are the inlaid silver, bronze vases with scroll-work designs and others borrowed Inlaid silver. from nature. Less complicated as regards substances, but more specifically artistic as regards their aim and invention, they possess a velvet-like smoothness of surface and a delicate patina which is very fascinating to the eye and touch, whilst their entire execution leaves nothing to be desired in this species of niello-work, if we may so call it when it consists of burnished silver let into a dark ground of composite metal of an equally high polish.

On no one article have I seen a more lavish expen-
diture of skill and taste than on a Koto, a
sort of lute or horizontal harp of thirteen
strings, seven feet long and one wide, rest-
ing at the ends on very short supports, the body curv-
ing into an extremely flat arc and made to be played
on with the musician seated on the floor, the fingers
being protected by ivory guards. The black lacquer
box in which it came, looking not unlike a coffin,
bears the arms of one of the great daimios, Prince
Haki. It is an instrument worthy of the ladies of
the highest rank. The utmost resources of Japanese
finest workmanship and best·trained taste have been
freely given to it. All the materials are rare and
costly. Its supporting pedestals are of minute Indian
mosaic pattern in ivory and pearl. The gracefully
curving sides are of low-toned ancient lacquer, with
flowers in gold-dust and bronze ground set in edges
of ivory and jade, and an intervening one made of
thinnest layers at a cross-wise angle like the strands of
a rope of beautiful stones, of which there are thirty-
six in alternating layers of color to each inch of frame-
work. The upper edge, separating the ornamental
base from the naked, rich-brown wood-work of the
Koto itself, where the strings vibrate, is a continuous
band of inlaid silver of the Greek fret pattern on
ebony. Each end of the musical instrument forms a
distinct portion or picture by itself, but harmoniously
terminating the leading artistic motive, which evi-
dently is to carry out in most precious materials and
loveliest æsthetic forms the ideas and sensations that
are embodied in sweetest music. It is impossible ac-
curately to describe the beauty and fineness of the
decorative workmanship. On a bed of tortoise-shell

The "Koto"
musical in-
strument.

framed in mosaic borders of rarest stones, ivories, metals, and mineral pastes, cut so fine that a magnifying glass is requisite to clearly trace out all their intricate designs, there is to be seen in high relief, floating through the air, playing the lute, with her rich garments trailing gracefully behind her, our old friend Ben-zai-ten-njo, the inventor of musical instruments, the accomplished Queen of Heaven; and a beautiful, spirited and graceful effigy the artist has made of her, with her waving costume of ebony and gold. Her face, arms, and hands are of highly-wrought silver, of rare sculpturesque expression, whilst her magnificent head-dress is of the richer metal.

The other end terminates in the dragon of the typhoon, Tats-maki, in heavy relief done in gold ciselure exquisitely wrought in a sea of silver, set in a precious frame similar to the Queen of Heaven, terminating in the finest possible lacquer-work with decorations of various colors and tones in flattest relief. The strings, which in themselves are works of art, pass into the body of the instrument at either end through little star-shaped wells of silver. In fine, it is an embodiment of the romance, mystery, magnificence, and variety of decorative splendor of the Arabian Nights' Entertainments. The time, patience, nicety of touch, keenness of sight, and artistic invention displayed seem more the work of fairies than of human beings. In absolute perfection of mechanical execution it is on a par with its artistic excellence, and the imagination would fail to conceive anything superior, of its kind, done by the artisans of any country. This is strong talk, I am aware, but I will rely on the Koto itself to maintain my words before any jury of highly-trained artisans or accomplished artists which may be found in or out of Japan.

Those who are acquainted with Japanese lacquers only by the ordinary specimens of commerce can form no idea of the perfection of this industry as it existed two centuries since, or even of what can be done to-day if specially called for. As bases for the lacquer crust, ivory, paper, metals, porcelains and other substances are used besides woods, and it is perhaps the commonest and cheapest, as well as the dearest and most elegant of all the methods of decoration. The tone of the oldest lacquer in pure gold is singularly subdued and chaste, fascinating to the eye as virtue to the mind. It exhales an atmosphere of repose and contentment, casting a spell over the senses as if they were suddenly let into a purer sphere of sensuous existence and objective delight than their common one. The subject-matter of the finest lacquer cabinets and cases is usually taken from the national histories, romances, and myths, and placed on panels set into the frame of the object. Sometimes the figures, done in bronze or the precious metals, are of miscroscopic smallness, but as perfectly modeled and chiseled as if done by a Cellini. Objects of natural history, flat or in relief, are executed with equal spirit and truth. But the attractiveness of best lacquer work does not end with the figure composition. The body-tones of gold in which forms of nature or curious invention in under or higher tones of light and graduated tints, come and go, as the eye happens to catch them, like objects slowly dissolving or reforming in a soft gentle haze, gives a pleasure without alloy, because there is no direct imitation or realism, and yet an infinite, dream-like suggestion of the purest and best bits of Nature in her most poetical moods. When are added to this æsthetic satisfaction

<div style="margin-left:2em; font-size:smaller;">Japanese
lacquer.</div>

an equal completeness as regards the mechanical finish of the article, its perfect lustre, smoothness, joining, and whatever else is included in the tool-part of the fabrication, then there is a double pleasure which rarely is to be had elsewhere in like degree. And this pleasure has a greater fullness from the absence of any signs of impatience, manual toil, or defect in handicraft. Thought and labor are disguised in an apparently spontaneous action or perfection, such as a free Nature suggests in her best inspired moods. This nearness to, yet independence of nature, is the one fundamental truth of best Japanese work above all others which all foreign schools should strive for, if they aim at developing a genuine decorative art. The Aryan races have accomplished great things in other forms of art, but in this respect they can still go to school with profit to the " heathen Japanese," possibly the " Chinese."

I fear my descriptions have already wearied my readers, but in conclusion, permit me one word on the special topic with which I be- Sculpture. gan my topic, viz., Japanese sculpture. Statuary, in the European meaning of the word, they do not possess any more than they do easel paintings or fine architecture. But those qualities of expression, repose and movement, to which we may add characteristic form, which are seen in the large images, are similarly manifested in the smaller. This is conspicuously exhibited in the finest ancient ivory Ivory carvings. There are several that I have ings. seen which are models of psychological and realistic truth. One is the venerable Shiou-Rô, the patron deity of longevity, about ten inches high, carved out of a fine bit of ivory, with his faithful grue, his head

drooping and leaning against his master, who sustains himself by the aid of his tall pilgrim's crook of bamboo. The features of the bird and the long, silky-textured, white beard of the old man, are admirably cut, advantage being taken of the color-tones of the ivory to emphasize parts, aided doubtless by an almost imperceptible tinting, whilst the flowing draperies show an almost Greek ease and freedom of contour. This work is inscribed on the bottom, " Precious Treasure of Taka-suki," which was one of the residences of the famous Siogoon ruler, Taïko-sama, A. D. 1586–1591.

Another ivory, somewhat taller, represents a hunter at the foot of a large tree holding down with intense muscular effort a wounded wild boar, to which he is about giving the final stroke. His pet monkey, of a most Darwinian countenance, is leaning over between two branches, holding up one of the legs of the beast with the look, " If I let go it is all up with my master," most legibly written on his anxious semi-human face.

The third is of a full-armed warrior seated at the base of an upright rock in deep contemplation, unconscious of impending danger. Above him a large serpent projects his head out of a crevice in a threatening action, whilst his long, sinuous body winds itself in and out of the holes in the rock, twisting itself around it so naturally as to seem to be in actual movement. The boar, snake, monkey, and the armor in both these statuettes are effectively tinted, and each anatomical and organic detail accurately cut from life.

Who knows but that Japanese art has now fulfilled its purpose and nothing remains to it except to die,

or be transformed into something entirely different. If this be so, it can depart full of honors and with agreeable memories. For has it not enlivened the lives and softened the manners Fasi, the artist sculptor. of countless millions of men during decades of centuries? And more! In its very advent it conferred a great boon on humanity. We read that just before our Christ came to the earth, the sculptor and worker in fäience and porcelains, Nomino-Soukouné, hearing of the death of the reigning empress, hurriedly carved some images in stone, and taking them to the emperor, persuaded him to put them into the tomb instead of immolating her favorite servants as was the custom, to wait on her in the next world. From that time this cruel rite was abolished, and as a commemorative distinction, Soukouné ordered to change his designation to

<div style="text-align:center">

FASI,

THE ARTIST.

</div>

APPENDIX.

I.

LEST my assertions in Section I. regarding the religious toleration of Japan, and the final persecution and exclusion of Romanism as brought about by its own aggressions, be questioned, and also the peaceful polity of the government, I cite the following extracts from the " Revue des Deux Mondes " of 15 July, 1875. They are taken from an able article in " Les Mœurs et le Droit au Japan," by George Bosquet, commissioned by the Japanese government to codify their laws and introduce the study and practice of the Code Napoléon, so far as suits the exigencies of the country. He began his work by a profound study of the history, polity, and customs of Japan, and in the above article gives a clear synopsis of their chief features: —

" Déjà," he writes, " sous le prédécesseur de Yéyas avaient commencé les persécutions contre le christianisme *provoquées par l'attitude même de ses adhérens.*" " De toutes les religions c'est la seule qui soit exclue par les Cent Lois de la tolérance universelle." Page 255.

" Le gouvernment doit pour aider le peuple donner la paix à l'etat." " Le considérer avec des yeux de mère." Art. 98, Cent Lois.

While the European governments, acting on the contrary principle, were decimating their populations and plunging them into the depths of untold misery, Yéyas, the soldier-legislator, and greatest man of his country, brought to an end all civil dissensions, and " assured to his people two centuries and a half of profound peace," and this too without destroying their martial spirit or weakening their industrial energies.

In enumerating the virtues of the Japanese I ought to have emphasized more particularly that which is next to godliness, namely, cleanliness, and in which they present a striking contrast to the Chinese, with whom filth reigns supreme even in Pekin. Suffice it to say that all visitors bear testimony to the native politeness of even the lowest classes, whilst I am assured by those who come into contact with the more intelligent and educated, that in perfect good breeding and refined courtesy they excel the most polished European gentlemen; and that cleanliness is on a par throughout with politeness. How long these two virtues will stand the strain now put on them by contact with foreign manners and the radical overturn of all their old training and ideas, remains to be seen. Already the public which formerly prostrated themselves in the dust before a daimio, now curtly pass him erect with uncovered heads, and are imitating the brusqueness and independence of not the best patterns of foreign manners they see. So rapidly is the crude imitation of foreigners extending to the perversion of some of their own admirable traits, that an imperial decree was lately issued to recall to the population of Tokio, some of the most elementary rules of civility and respect to authority.

A word regarding the Greek fret. This ornament coming first to our notice in the archaic pottery of Greece and Etruria of 700 years B. C., it came to be called Greek by distinction. Its origin, however, far antedates all Grecian art. In ancient Egypt it was the crux-ansate, symbol of immortal life. It is a sort of four-footed cross, and always had a mystic significance. In the East and Japan it is a combination of the clawed cross and is a symbol of Buddha, known as Swastica, or Sçavistika, but it is much older than this religion, and in the most remote antiquity passed as the sign of happiness. Thus to the eyes of the ancients this pleasing ornament, besides its æsthetic value, carried with it a grateful wish or significance which must of itself have added an intellectual and moral zest to the object which bore it, quite independent

of its artistic merits, and yet harmoniously combined with them. Modern art having lost all mystical language is shorn of a large portion of art's legitimate speech and influence. Hence its slight hold on humanity, and its being relegated to the functions of mere sensuous delight or intellectual, technical surprise and edification, a far inferior position to its primitive one.

II.

LAND OF GREAT PEACE.

Japan was conquered by its present rulers B. C. 660, fixing their capital at Kyōti. From this period for nearly 2500 years there has been, so far as I can learn in their history, but one foreign war, the brief and futile invasion of Corea by Taiko Sama, who reigned A. D. 1582–1598. During this long period there were feuds among the military clans, and for two centuries, the fourteenth and fifteenth, almost incessant civil war, until the country was finally pacified and the executive government centralized in the person and family of Japan's greatest historical character, Iyeyasŭ, who made Tokio (Yedo) his capital. His policy, continued by his successors as the shagouns or lieutenants of the Mikados, maintained complete peace in Japan externally and internally for nearly three centuries, or down to their recent overthrow and restoration of the actual power into the hands of the lawful dynasty. Nothing, therefore, is plainer, as compared with other countries, than that Japan is justified in calling itself the "Land of Great Peace."

Some writers fear that "in the presence of the superior aggressive races of the West, Japan must fall like the doomed races of America and Hawaii." (W. E. Griffis, in "North American Review," April, 1875.) But I have a lively hope to the contrary, in view of the profound appreciation of the constituent elements of a durable and lofty civilization displayed by the reigning Mikado, his advisers, and the press of Japan. The editor of the "Choya Shinibun"

thus defines the basis of true civilization : " The Americans and Europeans are enlightened people, and do not without cause call us semi-civilized. But what is the meaning of civilization ? It surely is not limited to the possession of fine houses, fine dresses, and to sumptuous living. It is not confined to a flourishing state of arts, of manufactures, or machinery. It means an advance in knowledge and politics, a reverence for religion, the proper estimation of good character, and the observance of good customs." Terse golden truths which we Americans and Europeans need to keep constantly in mind quite as much as the Japanese, as a counterpoise to an unscrupulous devotion to mere material interests. When the resources of nations are chiefly invested in " a good character," then may we be certain of universal peace and a permanent material prosperity, but not before ; and Christian people are indebted to a pagan press for this reminder of the essence of their own religious morality as the only sound basis of the prosperity they so ardently desire.